MW00799677

SNOW, WAVE, PINE

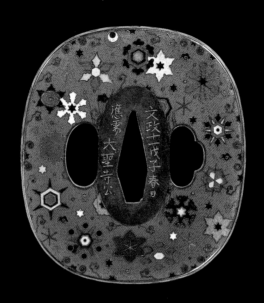

KODANSHA INTERNATIONAL
Tokyo • New York • London

SNOW, WAVE, PINE
Traditional Patterns in Japanese Design

Photographs and captions
Sadao Hibi

Text
Motoji Niwa

Translation
Jay W. Thomas

Distributed in the United States by Kodansha America, Inc., and in the United Kingdom and continental
Europe by Kodansha Europe Ltd.

Published by Kodansha International Ltd., 17–14 Otowa 1-chome, Bunkyo-ku, Tokyo 112–8652, and
Kodansha America, Inc.

ISBN 978–4–7700–2689–7

First edition, 2001
15 14 13 12 11 10 09 08 07 10 9 8 7 6 5 4 3

www.kodansha-intl.com

CONTENTS

NATURAL PHENOMENA

IMPLEMENTS AND STRUCTURES

GEOMETRIC PATTERNS

PREFACE

Traditional Japanese patterns are an important part of the fabric of life in Japan.

Patterns continue to thrive amid modernization and westernization. Nowadays they are used to decorate not only such traditional items as kimono, but also all manner of Western-style clothing or tableware. Essentially there are very few everyday, familiar objects that are not sometimes patterned with these traditional designs. Even today, they remain an indispensable part of life.

Throughout history, each period has produced new patterns. During the Jomon period (10,000–200 B.C.), for example, dynamic streak marks and spirals began to decorate pots and jars. The aristocracy of the Heian period (A.D. 794–1185), on the other hand, enjoyed elegant, refined patterns, often depicting natural scenery. The increasing democratization of patterns in the Edo period (A.D. 1603–1868) can be seen from the fact that kabuki—a new form of dramatic entertainment that had great mass appeal—brought new patterns developed and popularized on the stage.

Though we know little at this point about individual makers of patterns, one thing is certain: that all existing patterns are the product of long experience and development. Thus they serve as a record of the cultural and aesthetic history of Japan.

This book is designed to show something of the rich variety of traditional Japanese patterns that can be seen on a wide array of objects. I hope that this book will bring to the attention of readers around the world the remarkable stylization and artistry of these patterns.

—Sadao Hibi

PLANT PATTERNS

Plant patterns appeared much later than patterns employing points, lines, and rope figures, making it difficult to find examples of what can definitely be called plant patterns from the Yayoi period or earlier. It was not until the Asuka period that cultural influence from the Asian mainland that included the use of plant motifs began to be felt, as Chinese and Indian patterns, as well as those from Greece, Rome, and Persia, flowed into Japan by way of tools, Buddhist articles, pieces of cloth, and architectural items.

Early imports included lotus blossom, *hosoge*, and *karabana* patterns. The Tenpyo period saw the proliferation of Japanese-style patterns, such as peony, chrysanthemum, pine, plum blossom, autumn flower, paulownia, cherry blossom, and lily patterns. As weaving, dyeing, and painting techniques were developed during the Kamakura and Muromachi periods, the patterns themselves were refined and by the Edo period had achieved a high degree of brilliance.

Today, patterns based on plants found in the West, such as tulips, clematises, and cattleyas and other orchids, are used on Japanese and Western-style clothing, accessories, and the like.

AUTUMN FLOWERS

One of the most resplendent designs, the autumn flowers pattern depicts a variety of flowers that bloom in the fall, including bush clovers, eulalias, and pinks. The flowers are depicted growing in bamboo fences, and butterflies, dragonflies, and sparrows are often seen in the sky. The pattern first appeared during the Nara period and developed more fully during the Heian period. It was employed in *makie* lacquer, on *kosode* short-sleeved kimono, and in the *yuzen* dyeing process.

1

1 Autumn flowers

2 Autumn flowers (lacquer tray)

3 Autumn flowers (*makie* perfume box)

4 Fences among autumn flowers (*karaori* No robe, 18th c.)

5 Autumn flowers (hand-drum)

6 Autumn flowers (teapot)

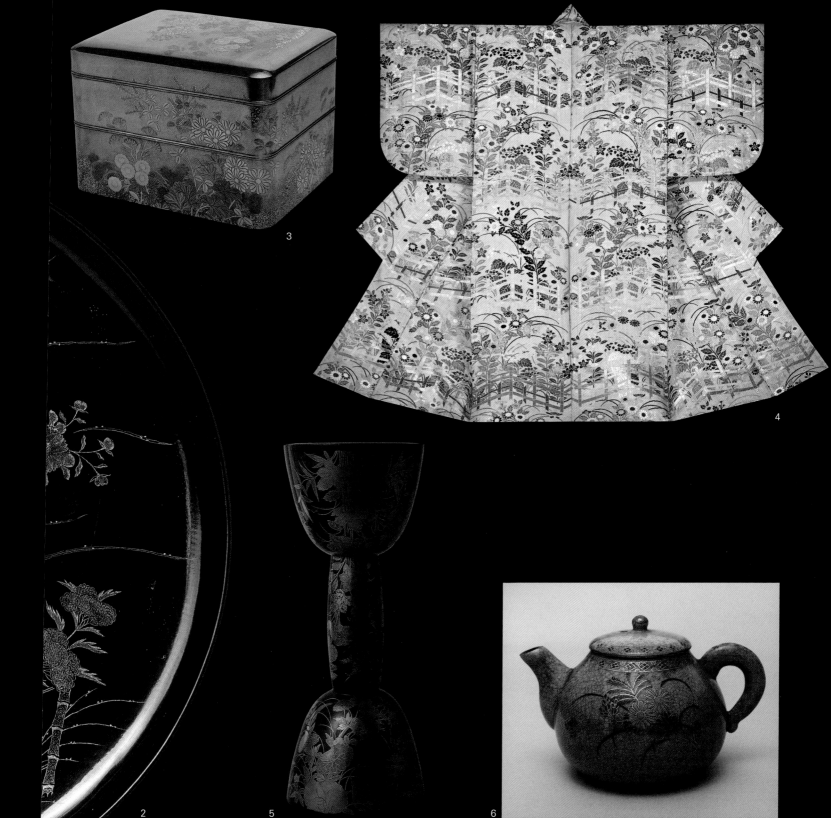

3

4

2

5

6

RABBIT-EAR IRIS

The rabbit-ear iris is a perennial plant resembling the blue flag. Its beautiful flower is used in patterns, where it is often depicted in great proliferation, and on crests. An excellent example of the pattern is seen in *makie* on the Edo-period artist Ogata Korin's inkstone case.

Noble families of the Heian period planted rabbit-ear irises in their gardens, and the flower is mentioned in literary works of the period, including *Tales of Ise* and Sei Shonagon's miscellany, *The Pillow Book of Sei Shonagon*.

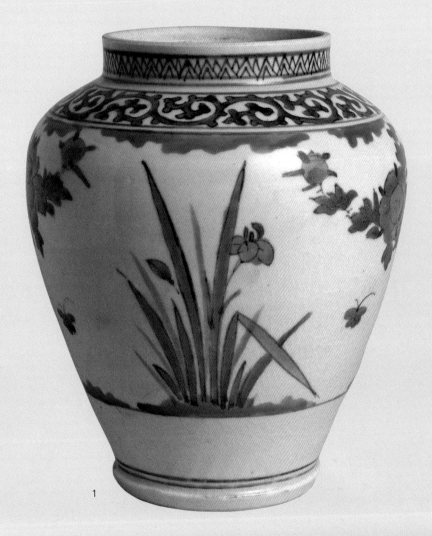

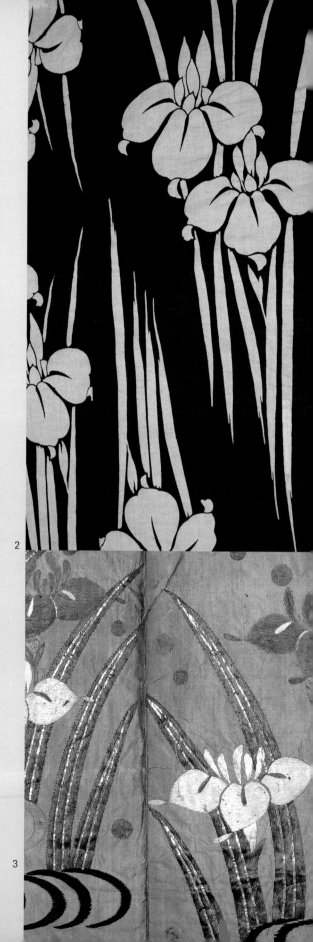

1 Irises (vase)

2 Irises

3 Irises and Kanze ripple motif (detail of *kataginu*)

4 Irises (tea bowl)

5 Irises (shells)

6 Irises and eight-plank bridge (*makie* inkstone case by Ogata Korin, 17th–18th c.; National Treasure)

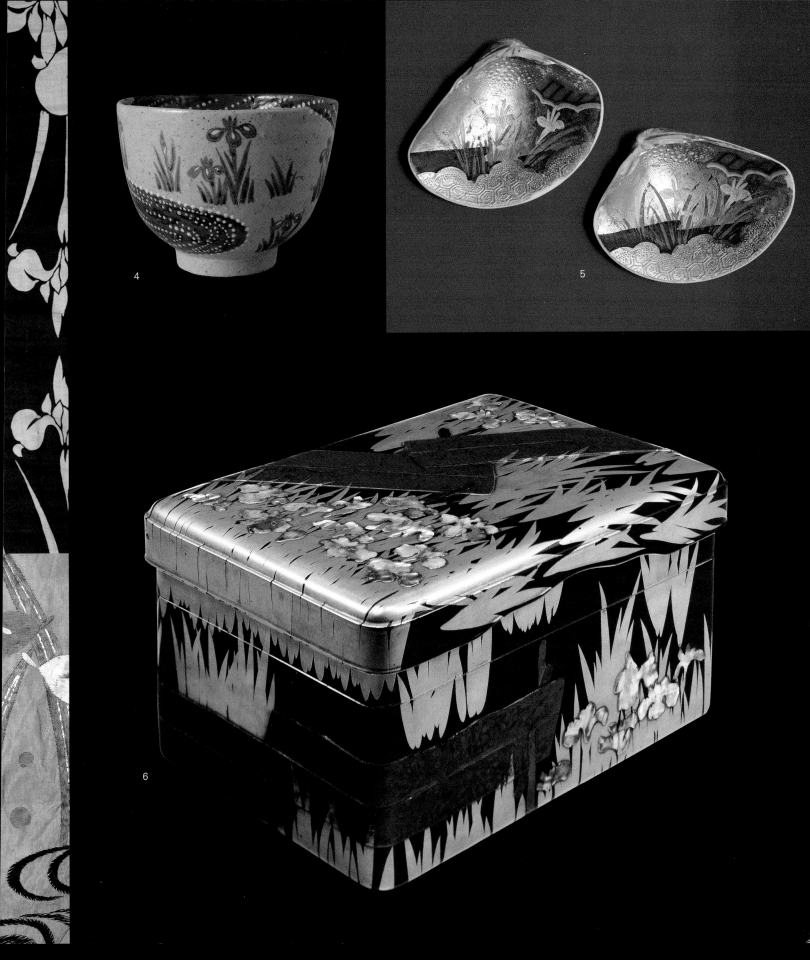

WISTERIA

Wisteria, a large tree with beautiful clusters of flowers hanging from vines, is symbolic of long life, prosperity, and good fortune. The rich variety of traditional patterns based on wisteria includes the "twirled wisteria" pattern, with the vines wrapped around circularly; "wisteria waves," with the flowers and vines in wavelike formations; and "wisteria trellis," with the flowers hanging from garden trellises. There are also wisteria court patterns. Wisteria patterns have been used on ceramic items, textiles, and other media. Family crests patterned with this flower are among the most traditional in Japan.

1

1 Wisteria (detail of *makie* chest, 18th c.)

2 Kujo wisteria

3 Wisteria (fan)

4 Wisteria

5 Wisteria, pine trees, and maple leaves (detail of kabuki robe)

6 Wisteria (detail of No robe)

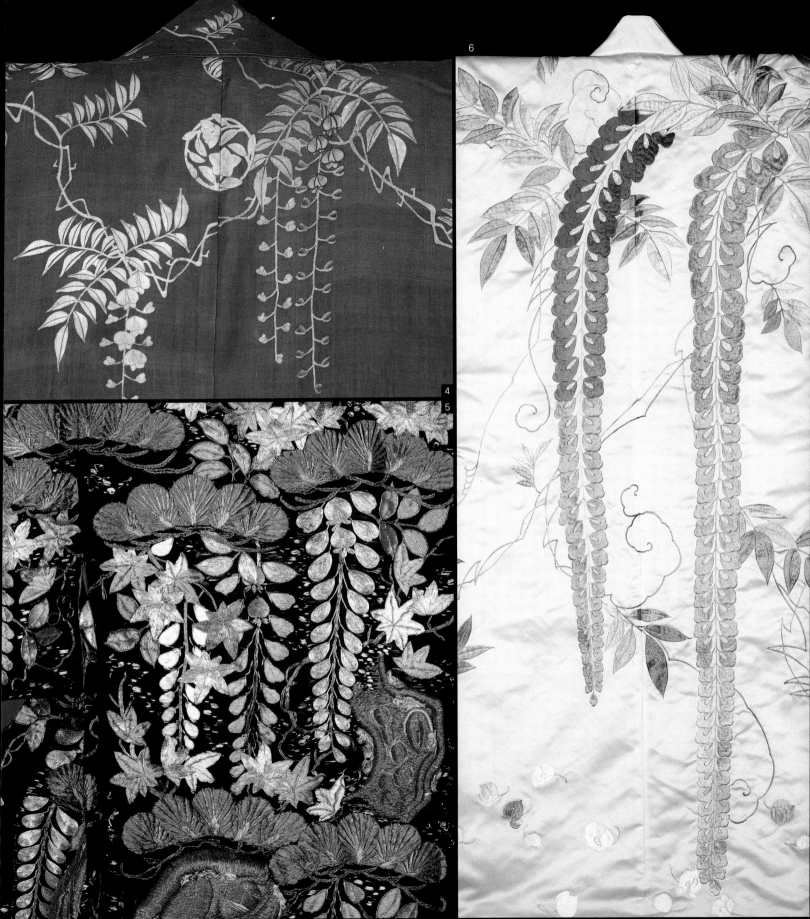

RICE PLANT

Because of its importance in the Japanese diet, rice has been highly revered as a creation of the gods and thus has not been depicted to a great extent on textiles and craftwork. The plant is, however, fairly commonly used as a crest on the worship hall, *torii*, and flags of Inari Shinto shrines (the most numerous type of shrine in Japan), where rice itself is revered. There are about thirty styles of rice plant crest.

1 Rice plants and rat (sword guard)
2 Rice plants (lacquer cosmetics box)
3 Sparrows with rice plants

1

2

3

EULALIA

The eulalia blooms in profusion in the autumn, its head eventually turning white and withering. Eulalia patterns are found widely on clothing and accessories.

The eulalia is offered to the moon goddess on the nights of the fifteenth of the eighth lunar month and the thirteenth of the ninth lunar month. Both these occasions are in the autumn; the fifteenth of a lunar month is the night of the full moon. The plant is also commonly arranged in vases and made an offering with chestnuts and persimmons.

1 Eulalias, chrysanthemums, and butterflies (*karaori* No robe, 18th c.)

2 Eulalias, chrysanthemums, and butterflies (*kosode* short-sleeved kimono)

3 Eulalias (*makie* smoking equipment holder)

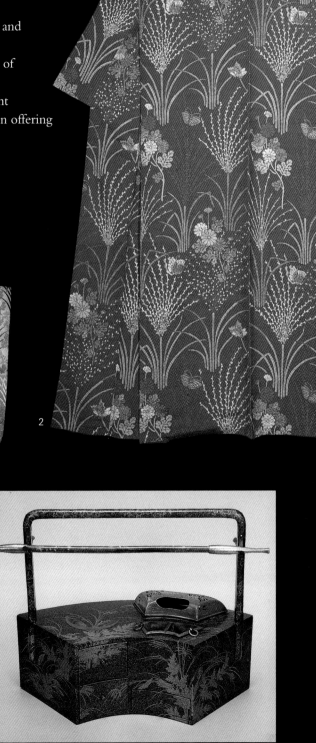

MAPLE LEAF

The beautiful red leaves of the maple tree were first used in textile patterns during the Momoyama period, often with running water, pine, and mist figures. The pattern has been used with various techniques including Kaga *yuzen* dyeing and Okinawa dyeing, as well as on Nabeshima ware and Dohachi ware.

1 Maple leaves (*makie* comb and hairpin)

2 Maple leaves

3 Maple leaves and autumn flowers

4 Maple leaves

5 Maple leaves

6 Maple leaves and water

7 Maple leaves and ripples (detail of *nuihaku* No robe)

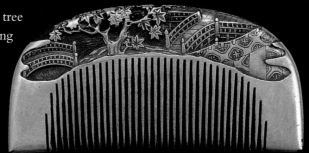

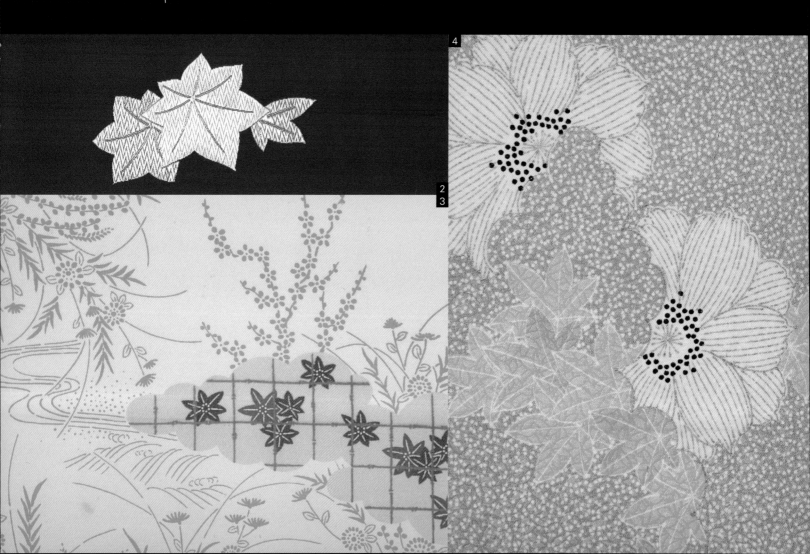

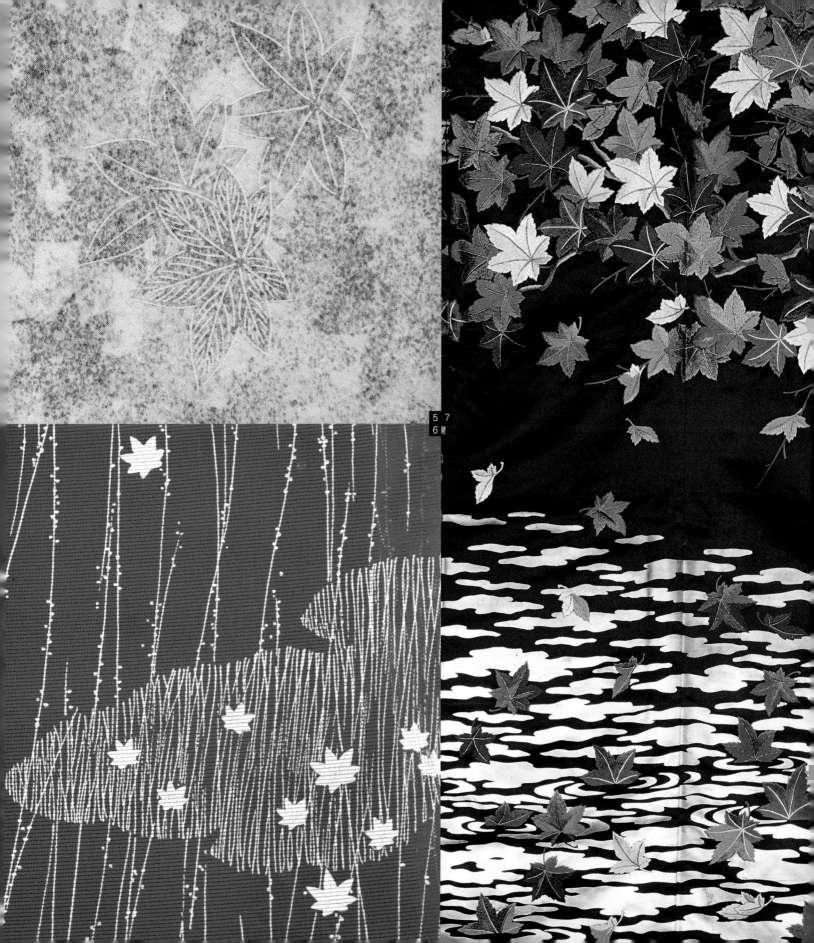

ARABESQUE

The word for arabesque in Japanese, *karakusa*, refers to a "Chinese" (*kara*) plant and, by extension, to any plant with a foreign appearance. The pattern, not of any particular flower, combines complex *karabana* leaves and tendrils. Peonies, Chinese bellflowers, and chrysanthemums may also be mixed in. The pattern appears on imperial articles at the Shosoin, a building that is part of Todaiji temple, in Nara. It was also used on nobles' ceremonial clothing during the Kamakura and Muromachi periods. Having undergone numerous changes throughout history, the arabesque pattern is still seen today.

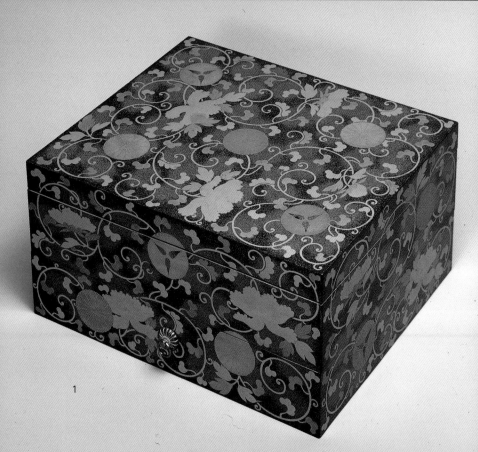

1

2
3

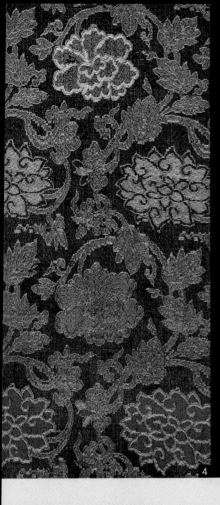

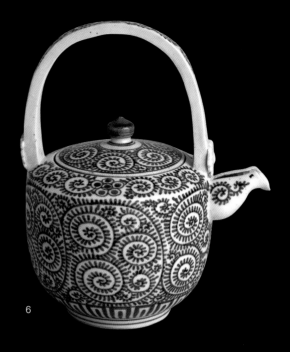

6

4

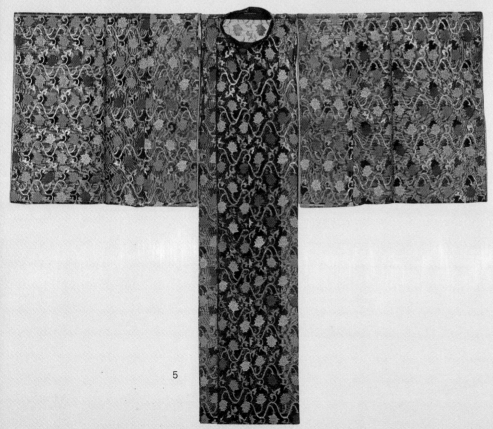

5

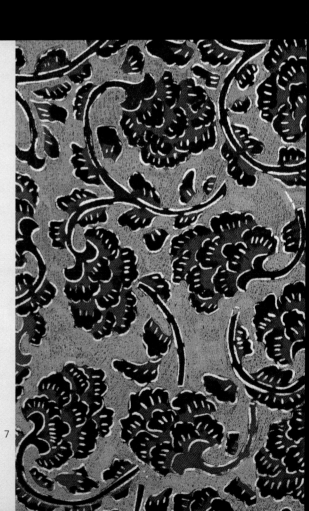

7

CHRYSANTHEMUM

In addition to the flower itself, chrysanthemum stems and leaves are used to form patterns, and the plant is often used in combination with other patterns, such as flowing water, the moon, or hedges, to form an elegant vista.

A symbol of superior character, the light of the sun, long life, and virtue, the chrysanthemum has been respected since ancient times.

A sixteen-petaled chrysanthemum forms the crest of Japan's imperial household, and variations on this shape have been used for different branches of the imperial family.

1

1 Chrysanthemums
2 Chrysanthemums (tiered food box)
3 Chrysanthemums (saké bottle)
4 Chrysanthemums (saké keg)
5 Chrysanthemums
6 Chrysanthemums (lidded lacquer bowl)
7 Chrysanthemums (fan)
8 Chrysanthemums (comb and hairpin)

2

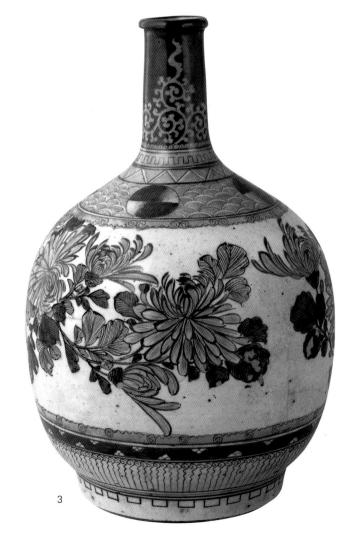

3

4

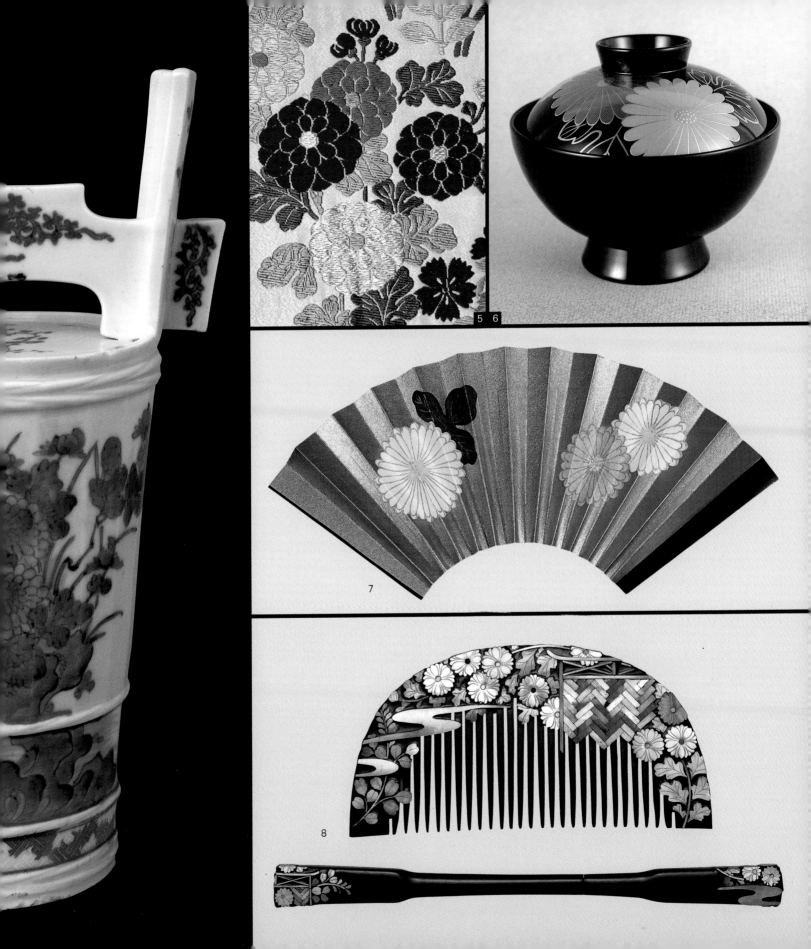

5 6

7

8

PAULOWNIA

In the lore of ancient China, a phoenix singing in a Chinese parasol tree was a sign of the coming of a wise and virtuous emperor. The tree thus took on a sacred character. When this story was brought to Japan, however, the tree used to depict it was a similar local one, the paulownia. Considered an auspicious tree, the paulownia is often seen in patterns with bamboo, chrysanthemums, and cranes, and is used widely in family crests.

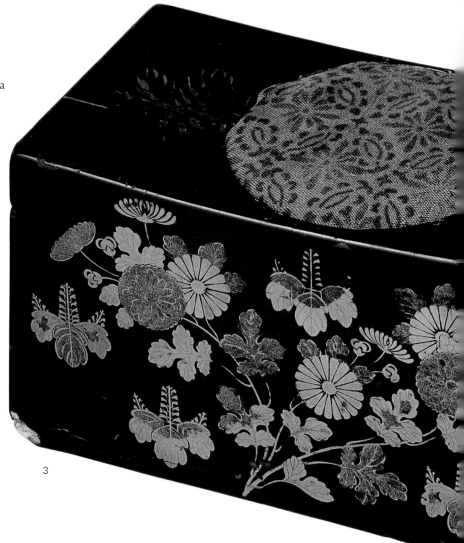

3

1

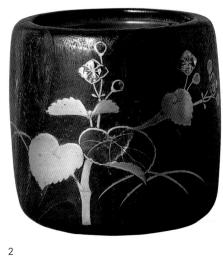

2

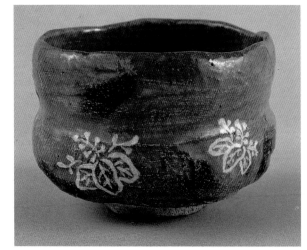

4

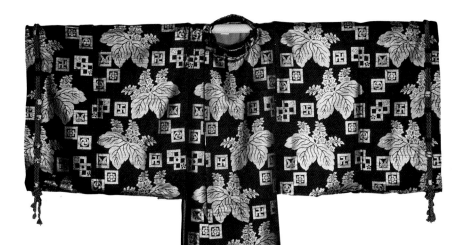

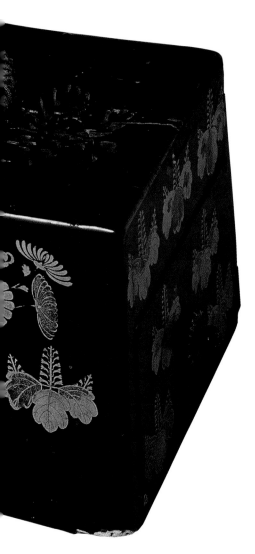

1 Paulownias (plate)

2 Paulownias (wooden *hibachi* brazier)

3 Paulownias and chrysanthemums (lacquer pillow)

4 Paulownias (tea bowl)

5 Paulownias (comb)

6 Scattered paulownias (*kariginu* No robe)

7 Paulownias and waves (*kosode* short-sleeved kimono)

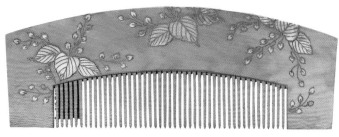

5

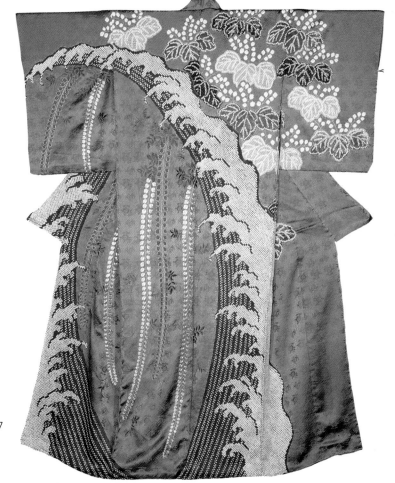

7

BAMBOO

Shown with straight, curved, or intersecting trunks, bamboo is patterned in various ways. It appears in combination with other plants, tigers, and rocks, and in more elaborate patterns depicting old legends. A combination popular in Japan is the sparrows-in-bamboo pattern, which derives from the frequent appearance of nest-building sparrows-in-bamboo groves.

Bamboo, along with pine boughs and plum blossoms, is one of the "three friends of winter" and is considered a good omen. *Take*, the Japanese word for bamboo, is homophonous with Chinese characters used in words for "warrior" and "bravery," and sounds like the words for "tall" (*takai*) and "hawk" (*taka*).

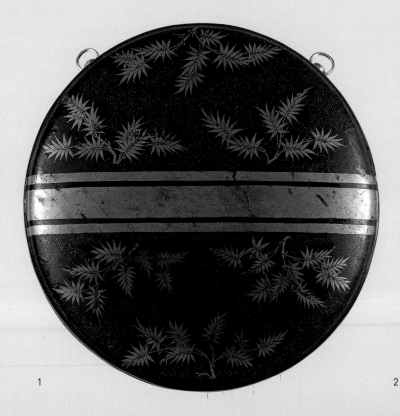

1

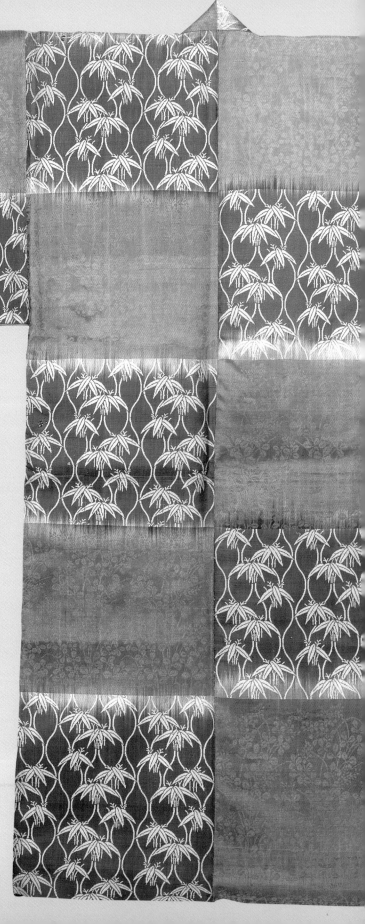

2

26

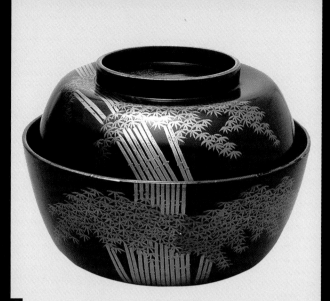

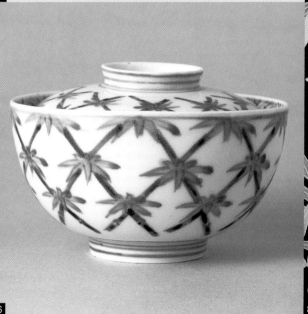

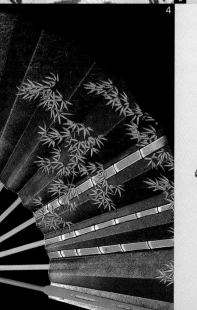

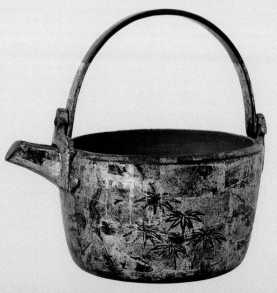

1 Bamboo (*makie* mirror case; Important Cultural Property)

2 Bamboo (*atsuita* No robe, 18th c.)

3 Bamboo

4 Bamboo (fan)

5 Bamboo (lidded *makie* bowl)

6 Bamboo fence pattern (lidded rice bowl)

7 Bamboo (lacquer pitcher)

8 Bamboo and waves

PLUM BLOSSOM

The plum blossom (*ume*) blooms in the latter part of the winter. The flower was beloved by the Heian period scholar Sugawara Michizane, whose writings on it remained an inspiration for later generations. A favorite theme of early painters was a plum tree with bush warblers singing on its branches.

Plum blossoms may appear as stylized five-petaled *umebachi* patterns or in the Korin plum blossom pattern, named after the Edo-period artist Ogata Korin. The plum blossom is one of the elements of the "three friends of winter," the others being pine and bamboo.

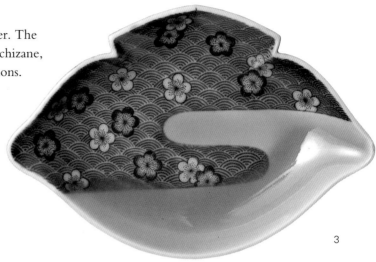
3

1

2

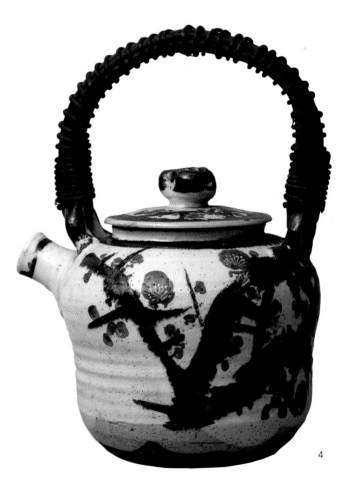
4

1 Korin plum blossoms

2 Plum blossom (lidded *makie* bowl)

3 Plum blossom and overlapping waves (plate)

4 Plum blossoms (teapot)

5 Scattered plum blossoms (saké cup holder)

6 Korin plum blossoms

7 Plum blossom (*noren* shop curtain)

8 Plum blossoms (tea-leaf container by Nonomura Ninsei, 17th c.; Important Cultural Property)

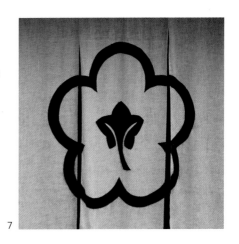

7

5

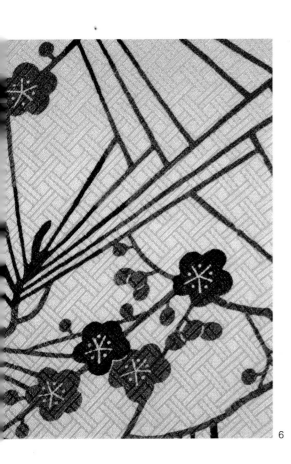

6

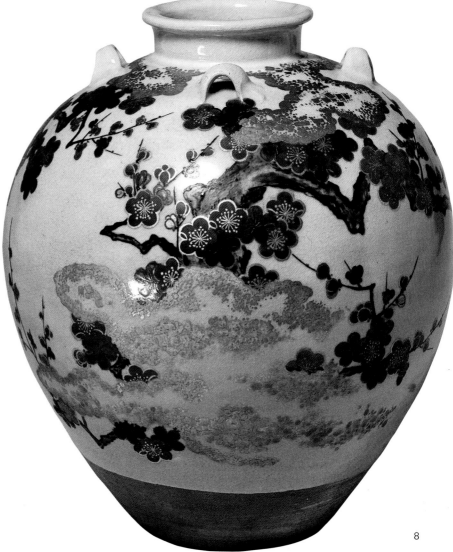

8

HYDRANGEA

The hydrangea pattern depicts the plant's four-petaled flowers and elliptical leaves in great proliferation. The pattern began to be used during the Heian period, and several excellent examples of it are seen on Kiyomizu ware and Kutani ware.

The hydrangea is valued because the flowers go through seven color changes during their life cycle. The hydrangea was introduced to the West by Philipp Franz von Siebold, a German physician who lived in Japan at the end of the Edo period.

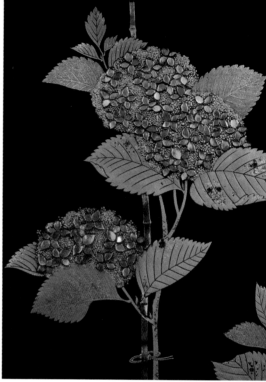

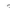

1 Hydrangeas

2 Hydrangeas and tortoise shell pattern (lidded jar)

3 Hydrangeas (detail of *makie* box, 17th–18th c.)

4 Hydrangeas and clouds (*maiginu* No robe, 17th–18th c.)

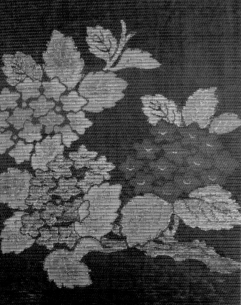

1

2

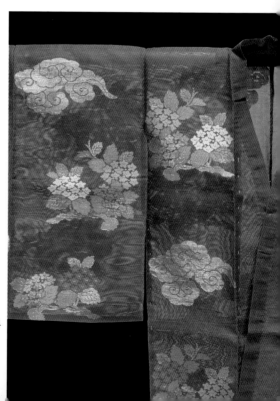

4

GRAPE

Although grapes were found in Japan in very early times, it was not until the arrival of Buddhism that they appeared in artwork. The first grape patterns depicted the vines in arabesque and net-mesh style, excellent examples of which are found in the Shosoin and Yakushiji temple, both in Nara. During the Momoyama period, grape patterns were made in *makie* and on ceramics and No costumes, sometimes with squirrels and humans.

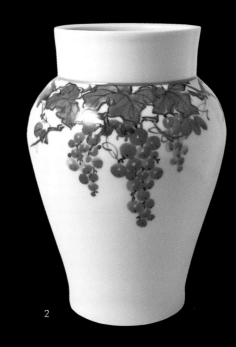

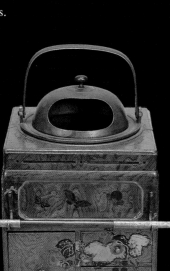

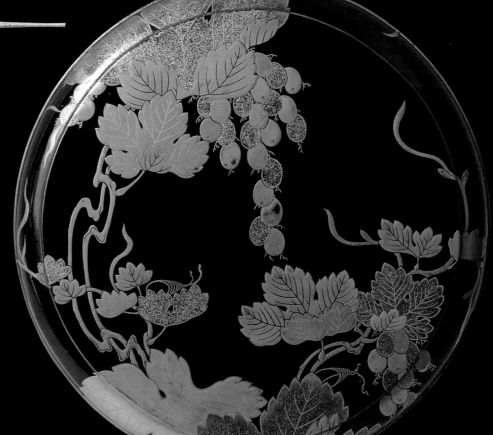

1 Grapes and butterflies (smoking equipment holder)

2 Grapes (jar)

3 Grapes (lid of *makie* box)

CHINESE BELLFLOWER

The Chinese bellflower, with its single-petaled light purple and white flowers, was offered to the gods in ancient times. A Chinese bellflower pattern may depict only the flowers strewn about, or may include animals and other plants seen in autumn fields. The old Toki family of warriors took the Chinese bellflower for its crest, *toki* being one name for the flower.

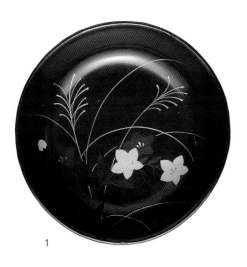

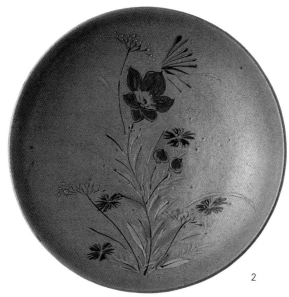

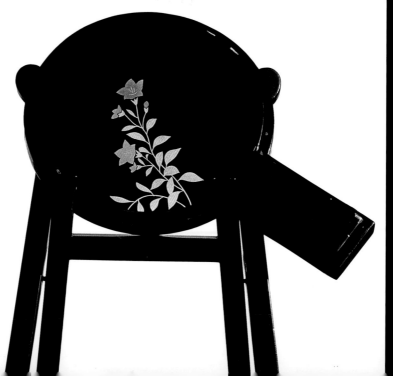

1 Chinese bellflowers and eulalias
 (lacquer tray)

2 Chinese bellflowers and pinks
 (plate)

3 Chinese bellflowers (mirror case)

4 Chinese bellflower

5 Chinese bellflowers and bamboo
 (*katabira* summer kimono, 18th c.)

6 Chinese bellflowers and
 arabesques

7 Chinese bellflowers

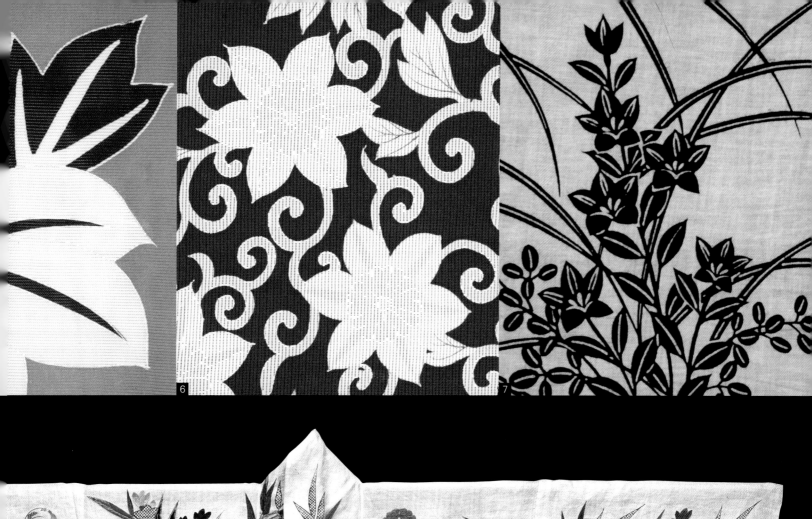

6

7

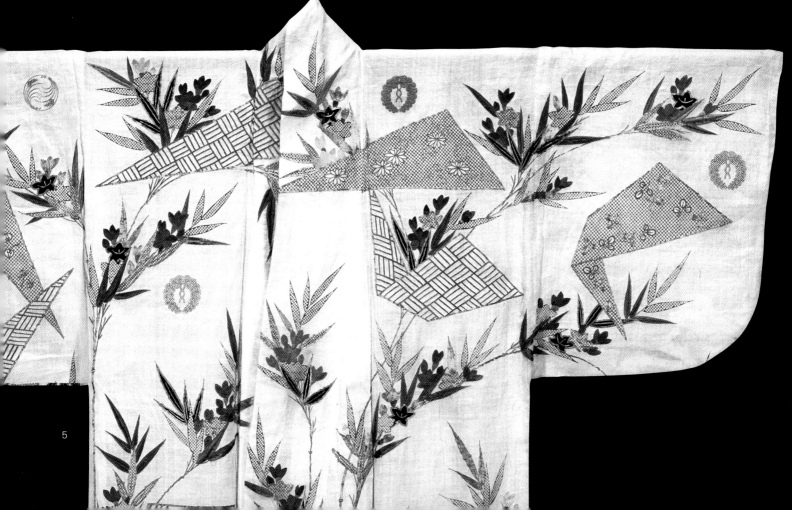

5

CAMELLIA

The camellia has been employed in patterns for its showiness and variety of forms—single and double petals, plain and speckled blossoms. Some designers have probably avoided the flower, however, since its tendency to drop suddenly from a branch is thought to be a bad omen. *Tsujigahana*-dyed cloth fragments depicting the camellia and Kamakura wood carvings of it are preserved today.

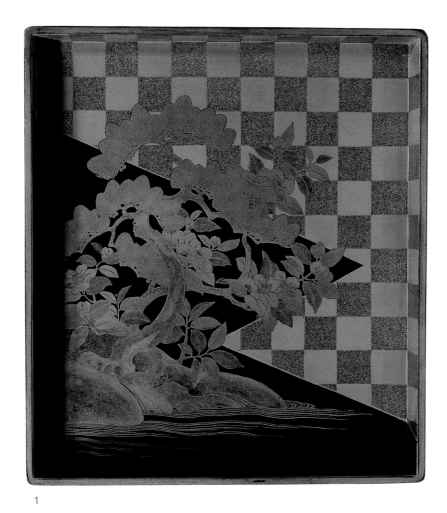

1

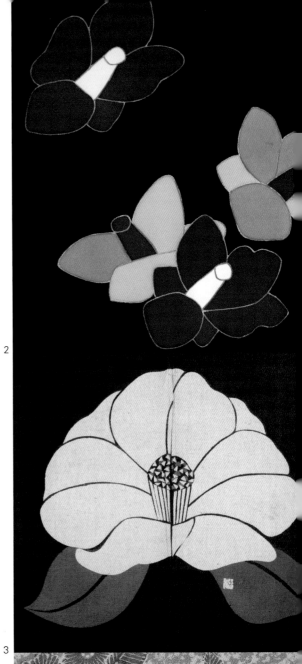

2

3

4

1 Camellias and pine trees with checks (*makie* tray)

2 Camellias

3 Camellia (*noren* shop curtain)

4 Camellias

5 Camellia (plate)

6 Camellias (plate)

7 Camellias (plate)

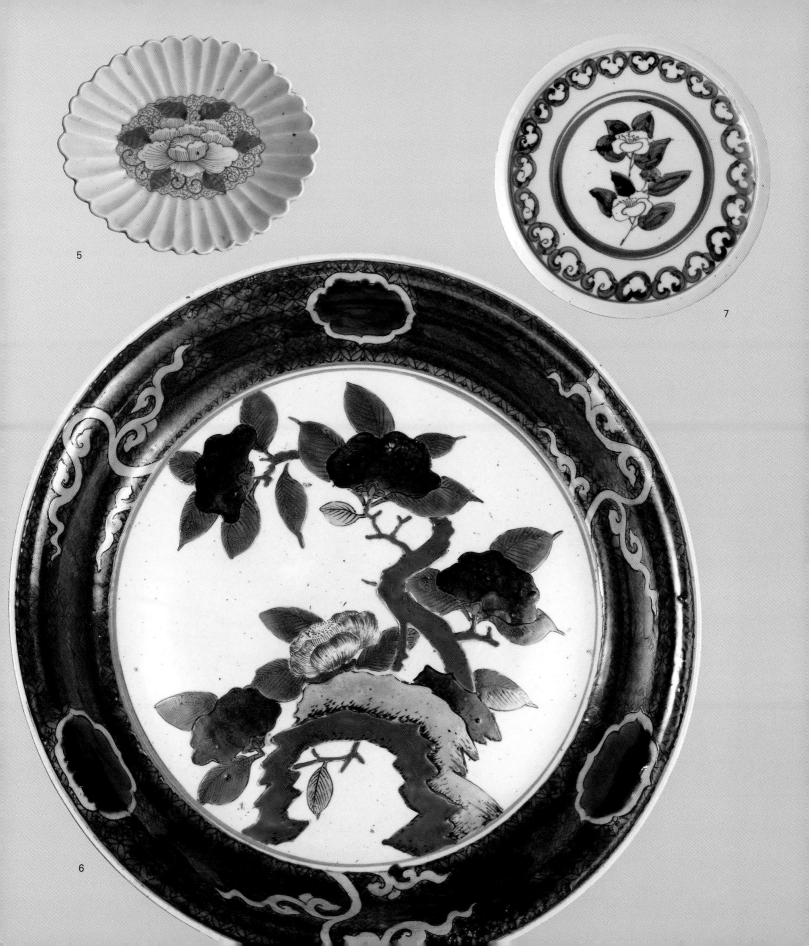

5

7

6

PEONY

A symbol of nobility, peonies were the flower of the Chinese empress and were often depicted on the houses, clothing, and personal effects of nobles. Peonies often appear with lions, an excellent example being the pattern found on the dais for the Buddha's image at Kenchoji temple in Kamakura. A number of other well-known peony patterns exist, with some including other flowers, animals, and natural scenes. There are also some patterns that have a narrative element.

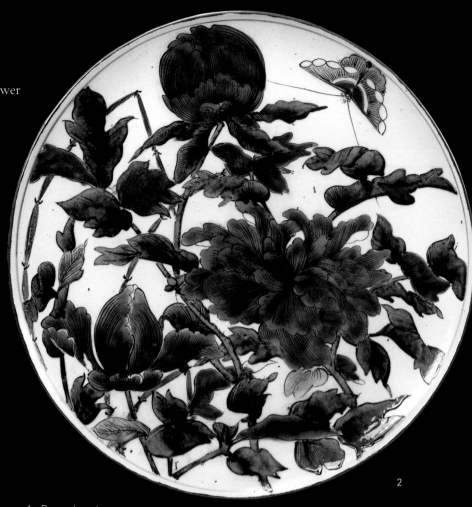

2

1 Peony (vase)

2 Peonies (plate, 17th c.)

3 Peonies (comb)

4 Peonies

5 Peonies

6 Peonies (detail of *obi* sash)

7 Peonies (detail of *uchikake* kabuki robe)

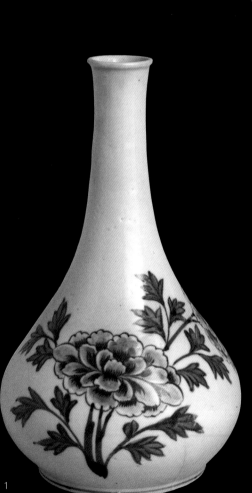

1

3

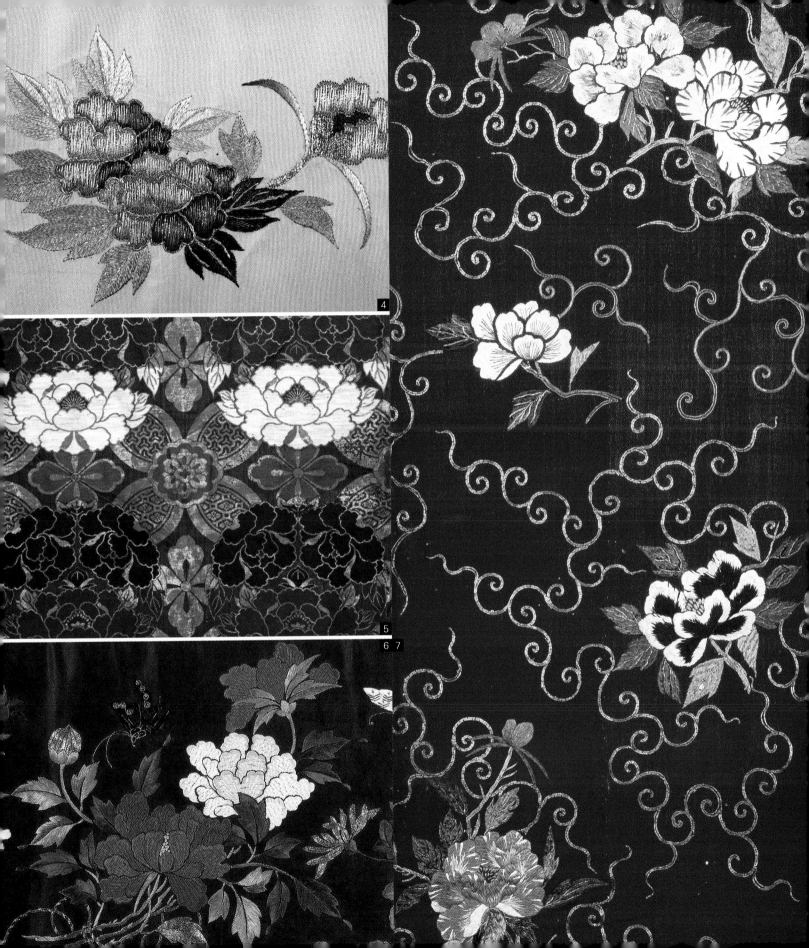

IVY

Ivy appears in various ways in patterns, often in
autumnal red and intertwined with other figures,
and is commonly seen in arabesque patterns. Ivy
is also popular in family crests.

1

3

2

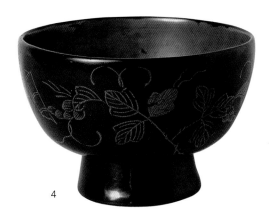

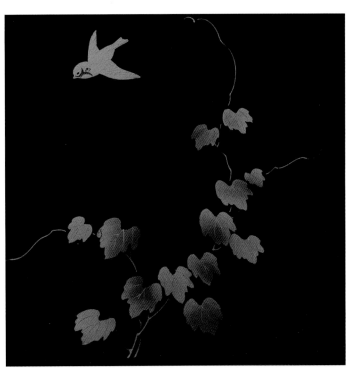

1 Ivy

2 Scattered ivy and chestnut branches (*choken* No robe, 18th c.)

3 Ivy (comb and hairpin)

4 Ivy (lacquer bowl)

5 Ivy (water jug)

6 Ivy and bird (lacquer plate)

7 Ivy (smoking equipment holder)

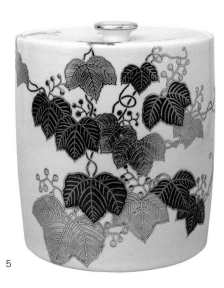

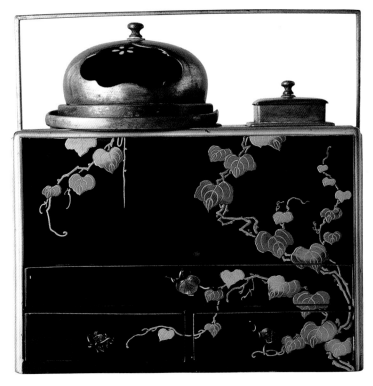

PINE

Since ancient times, the pine (*matsu*) has been revered as a tree of long life and good fortune. It appears often in a variety of patterns: the tree alone; pine needles; pine nut; and Matsubara, a place known for its pines. Combinations include the "three friends of winter" (pine-bamboo-plum) and those with chrysanthemums, peonies, cranes, boats, or rocks.

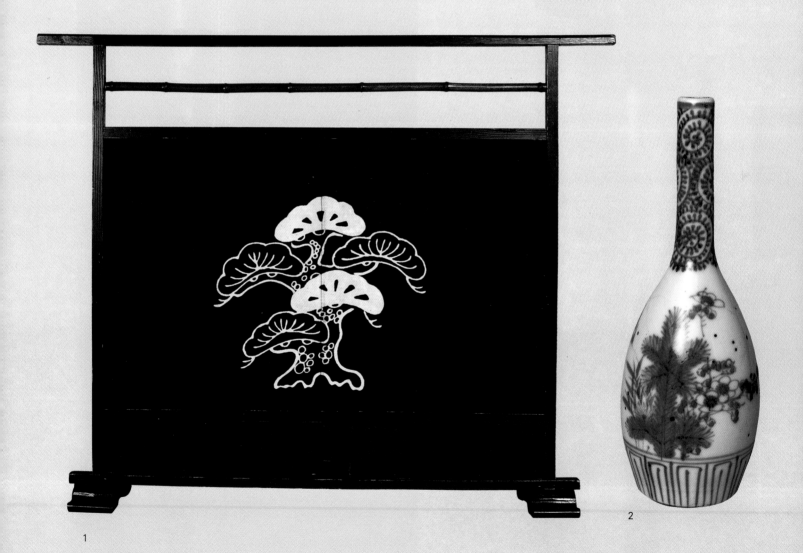

1

2

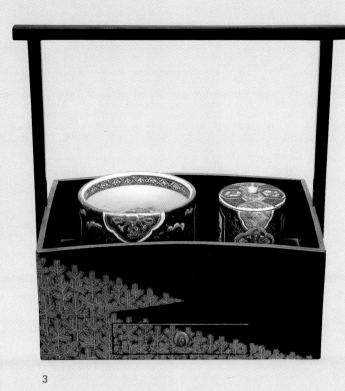

3

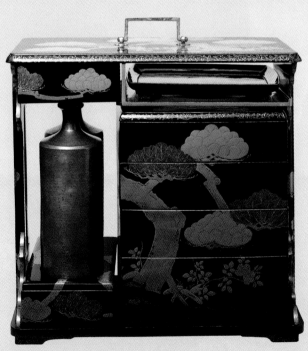

4

5

6

7

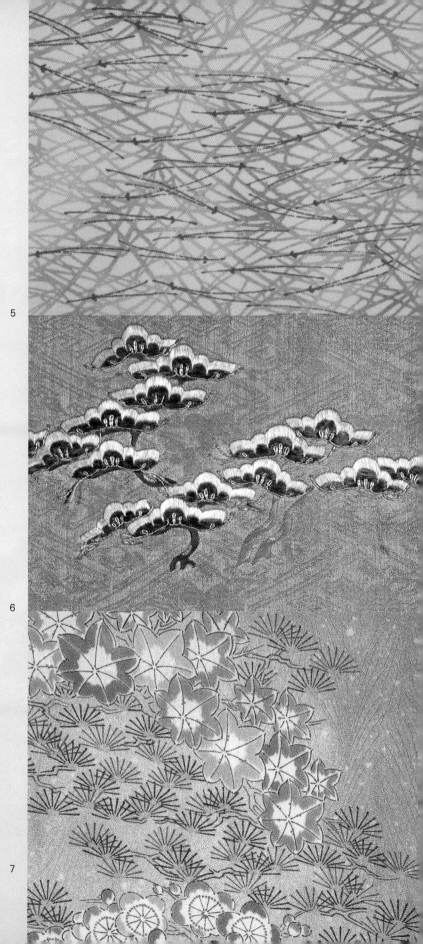

CHERRY BLOSSOM

The blooming and scattering of cherry blossoms was strongly tied to the samurai aesthetic, in that these warriors wished to die and be mourned in the same manner as people lament the falling of the blossoms at the end of their season. This aesthetic pervades the consciousness of the Japanese people in general.

The cherry blossom is always tied to other elements of nature, celebrating its blooming with mountain greenery, flowing rivers, the morning sun, and the darkness of the night. The Japanese word for "flower" (*hana*) often refers specifically to cherry blossoms.

1 Cherry branches (fan)
2 Cherry blossoms (detail of *kitsuke* kabuki robe)
3 Scattered cherry blossoms (lid of tiered food box)
4 Cherry branch (gold lacquer saké cup)
5 Cherry blossoms (*kosode* short-sleeved No robe)

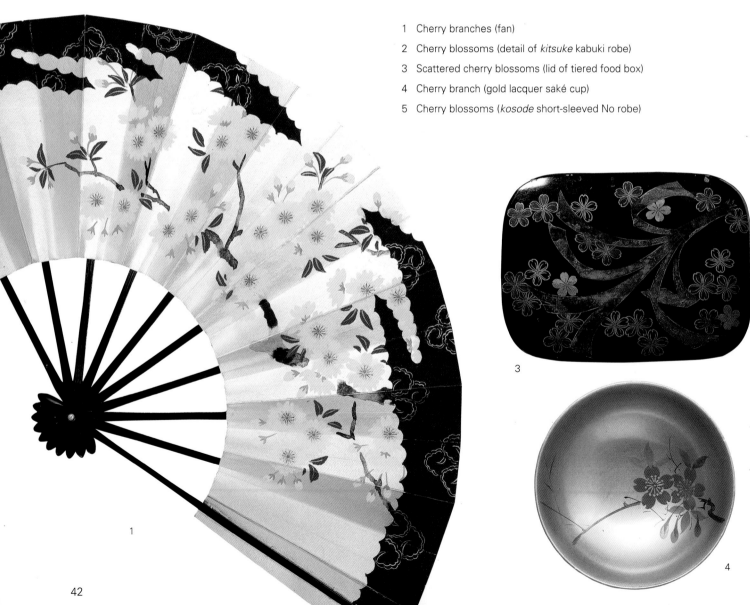

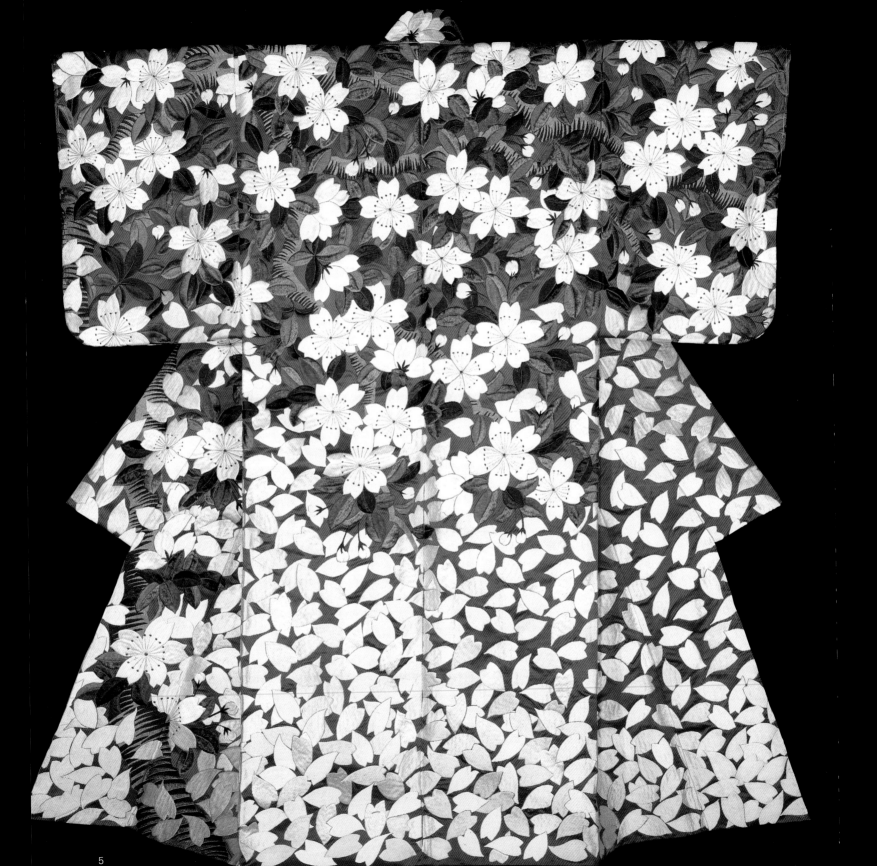

5

FLOWER-AND-BIRD

Flower-and-bird patterns depict various combinations of flowers and birds; sometimes the species are identifiable, sometimes not. The predecessors of these designs were Buddhist patterns introduced from the Asian mainland during the Asuka and Nara periods, such as the "lucky bird" and arabesque figures, which were brought over together. Sometimes fanciful renditions of peacocks and phoenixes are seen in the patterns.

1 Flowers and birds (lidded jar)
2 Flowers and birds (comb)
3 Flowers and bird (lidded lacquer bowl)
4 Cherry blossoms, chrysanthemum, and
 sparrows (mirror; National Treasure)
5 Flowers and birds (lidded jar)

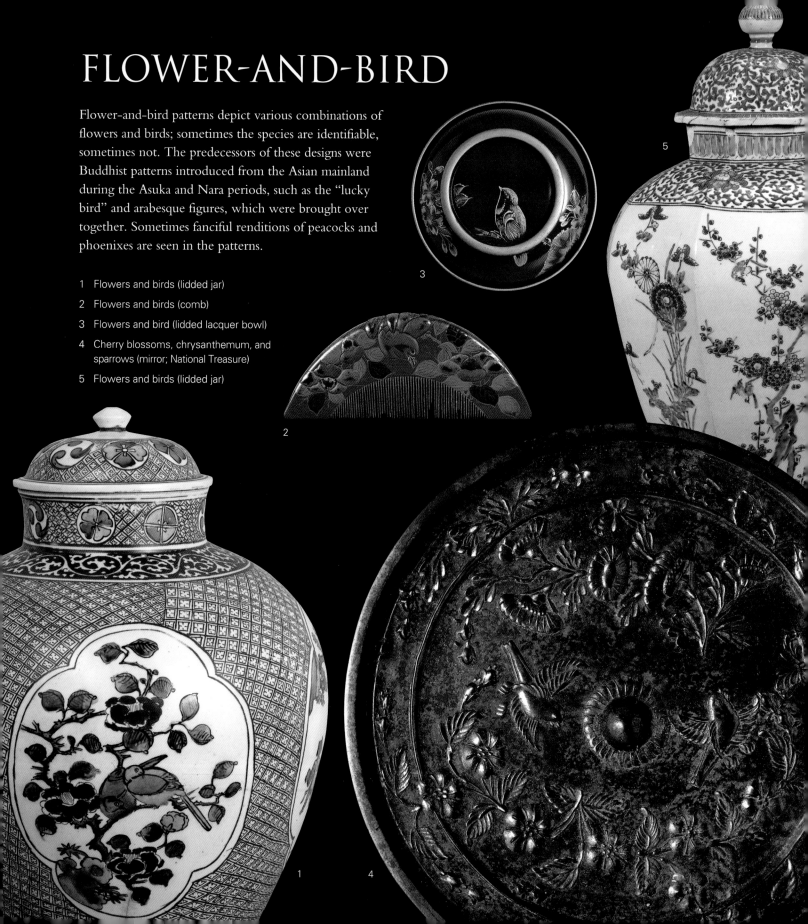

ANIMAL PATTERNS

Whereas plant patterns are generally balanced—even symmetrical—and ornamental, patterns depicting animals can exhibit great vibrancy, and frequently have religious, magical, or narrative meanings. Like plant patterns, however, many animal patterns are beautiful and considered auspicious: notable examples are the cranes-and-turtles, lobster, sea bream, plover, and wild goose patterns.

Animals appearing in patterns may or may not be native to Japan. The early Japanese received images of one sort or another of animals real and imaginary (or imaginary renditions of real animals) from China and India, often transmitted along with Buddhism. These imports included lions, tigers, peacocks, and dragons. The lion as conceived by the Chinese was rather different from the one native to Africa, as will be seen in the examples in this section. Tigers and dragons appear together, symbolizing suzerainty over heaven and earth. Other typical Japanese patterns have dragonflies and butterflies as subjects.

DRAGON

Dragons were said to live underwater, though they occasionally ascended into heaven, a transformation that became a metaphor for advancement in the world. Dragons are depicted in various ways—with scales, with wings, with horns and beards. An unusual variation is the rain dragon, a lizardlike animal said to be the cause of rain. In patterns, the rain dragon is stylized to look like a cloud.

2

1

3

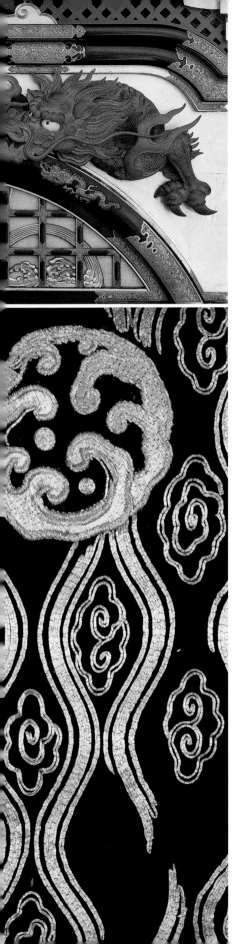

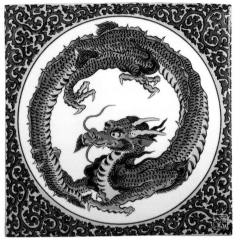

4

8

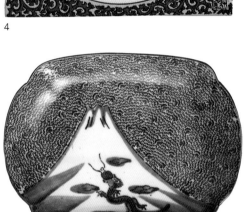

5

1 Round dragon with clouds (*obigoromo* kabuki robe)

2 Dragon (relief on portable shrine)

3 Detail of 1

4 Dragon and arabesques (ceramic decorative tile)

5 Dragon and Mount Fuji (plate)

6 Dragon (bowl for traditional Japanese sweets)

7 Dragon (bowl)

8 Dragon (ceramic decorative tile, 18th c.)

9 Dragon (bowl for traditional Japanese sweets)

10 Dragon and clouds (lidded rice bowl)

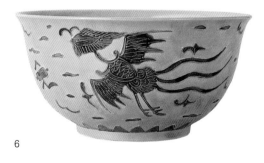

6

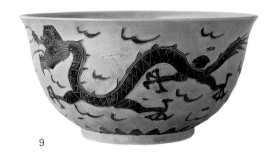

9

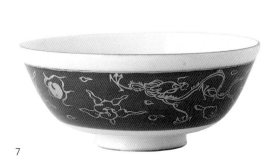

7

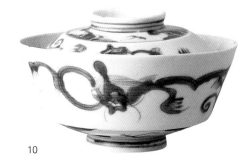

10

TIGER

Though tigers are not native to Japan, artwork depicting them is quite accurate and vivid owing to the many implements and Chinese books brought over from the Asian mainland that contained drawings and descriptions of the animals. Tigers often appear with dragons, bamboo, rocks, or the sun.

1 Tiger and bamboo (plate)

2 Tiger and waves (*makie* incense case, 17th–18th c.)

3 Tiger, bamboo, peonies, and paulownias (*makie* inkstone case)

4 Tiger and bamboo

5 Tiger (splashed pattern)

6 Tiger and dragon (*yoten* kabuki robe)

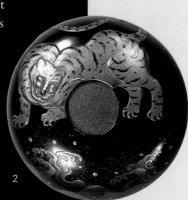

2

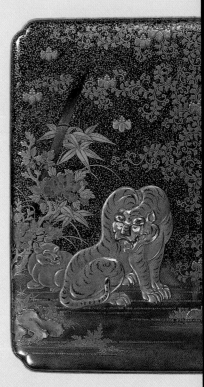

3

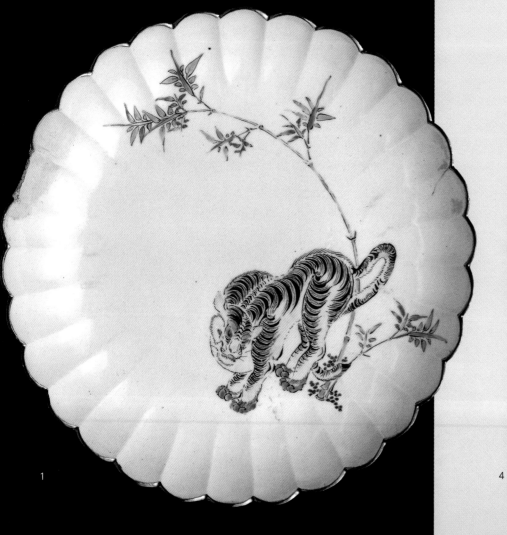

1

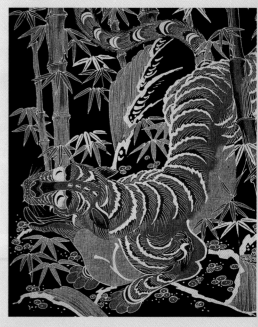

4

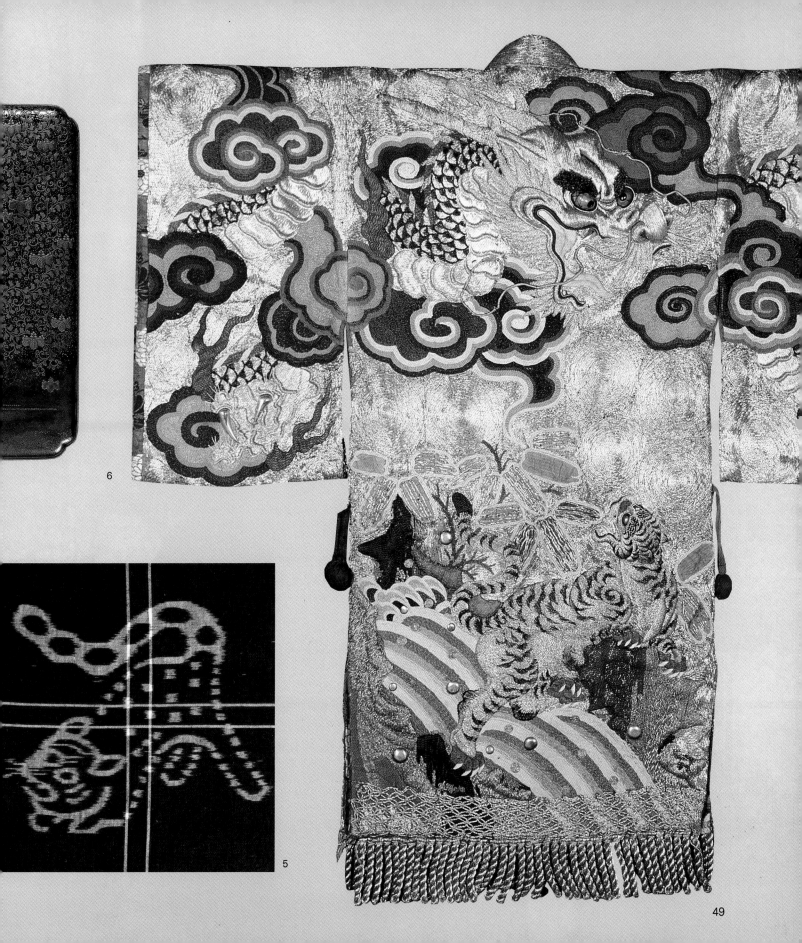

6

5

49

LION

The first lion patterns came from China. Yet, as no one there had ever seen a lion, the representations of the beast, called *karashishi*, or Chinese lion, look rather mythical. Due to the lion's reputation, even in early times, as the "king of beasts," patterns using the lion are found on the buildings, clothing, and implements of kings, to symbolize their authority. Peonies, another symbol of nobility, are often seen in combination with lions.

2

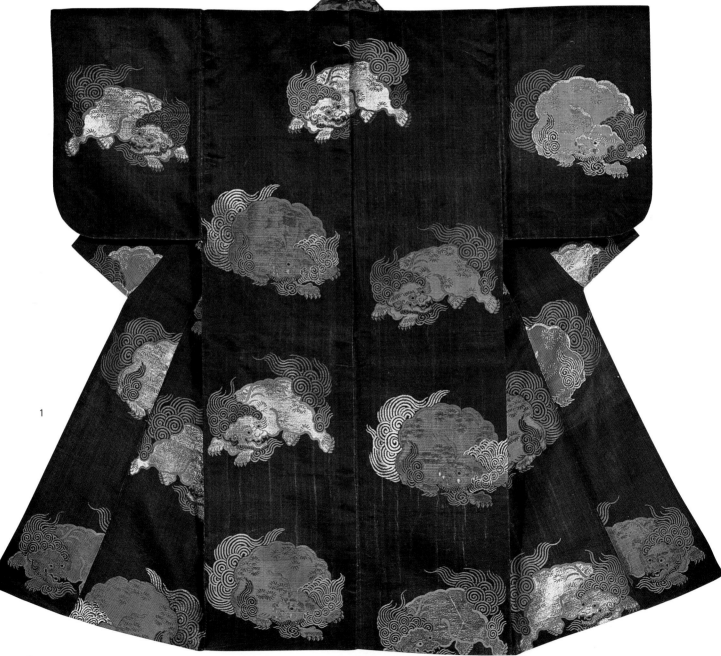

1

3

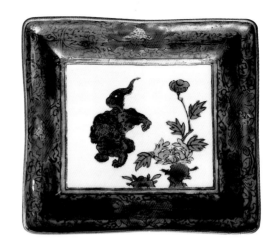

6

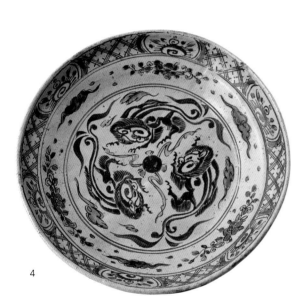

4

7

1 Scattered lions (*atsuita* No robe, 17th c.)

2 Lion and drum (splashed pattern)

3 Lion (plate)

4 Lions (plate)

5 Lion and peonies (*soba* noodle cup)

6 Lion and chrysanthemums (plate)

7 Lion (letter box)

8 Lions

9 Lion

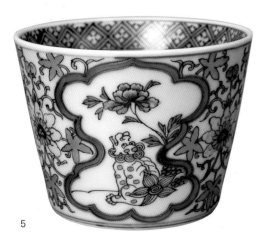

5

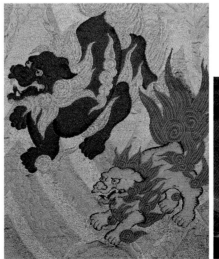

8

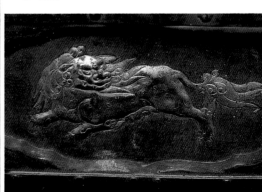

9

51

DOG

Artistic renderings of dogs in Japan often have a religious or magical meaning. Two examples are the guardian dogs at shrines and temples, and paper-doll dogs, considered to be efficacious in warding off evil and assuring safe childbirth.

1 Guardian dog (detail of hand towel)

2 Dogs among flowers (detail of *obi* sash)

3 Two dogs (tea cup)

4 Dog (tea cup)

5 Dog, birds, and flowers (plate)

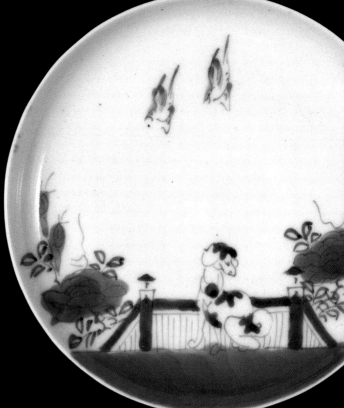

5

3

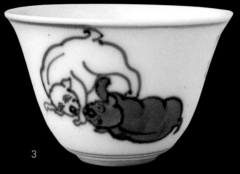

1

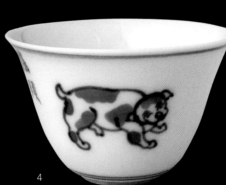

4

2

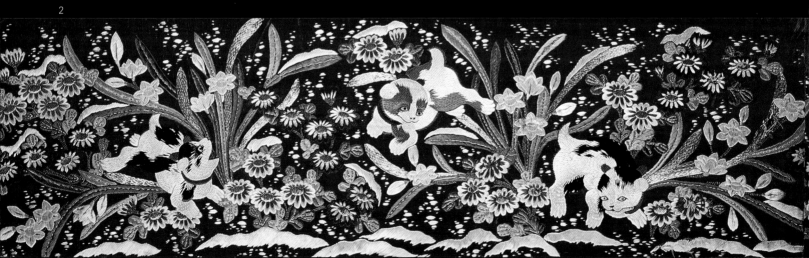

RAT

In the Orient, house rats and the like never evoked the feelings of revulsion common in the West, but rather were traditionally an honored animal. The rat is a messenger of the god Daikokuten and is one of the twelve animals of the Oriental zodiac. In Korea, these animals, seen as twelve carved images, represent deities. As might be expected, rat patterns are seen most often during the Year of the Rat.

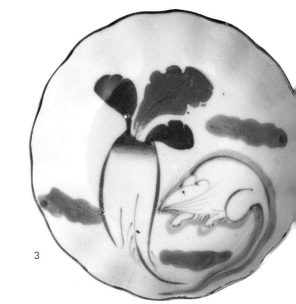

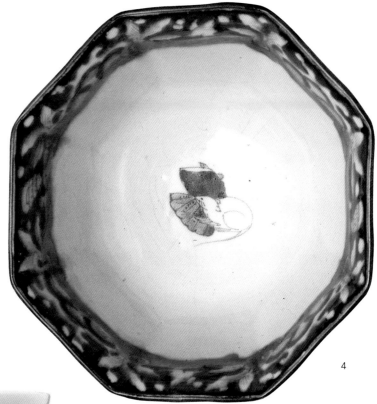

1 Rats (*makie inro* medicine container)

2 Rats (rice bowl)

3 Rat and Chinese radish (plate)

4 Rat and shells (bowl)

RABBIT

Rabbits are depicted on ancient Chinese copperware. In Japan, rabbit patterns eventually became popular; rabbits were often shown in combination with flowers, the moon, and waves. During the Momoyama period the trader Suminokura Ryoi brought back from China a gold brocade showing rabbits squatting, which is now a masterpiece known worldwide. Considered good omens, rabbits were frequently used in family crests.

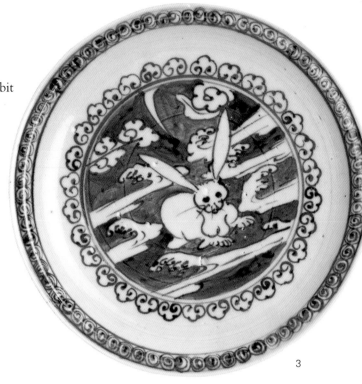

3

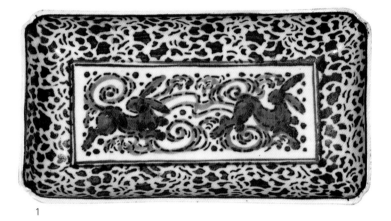

1

1 Rabbits and waves (plate)

2 Rabbit and moon (lid of smoking equipment case)

3 Rabbit and waves (plate)

4 Rabbits and autumn flowers

5 Rabbits and waves (*kosode* short-sleeved kimono)

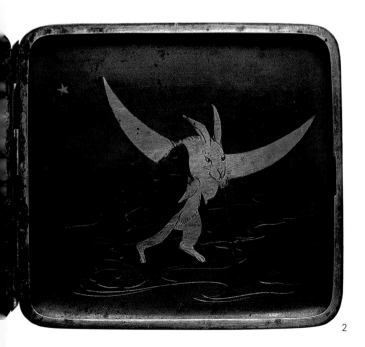

2

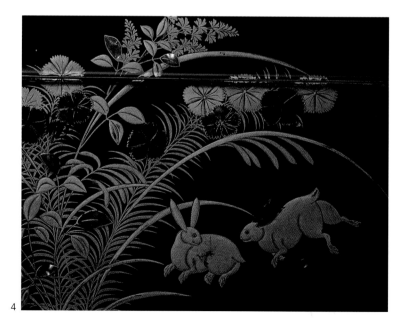

4

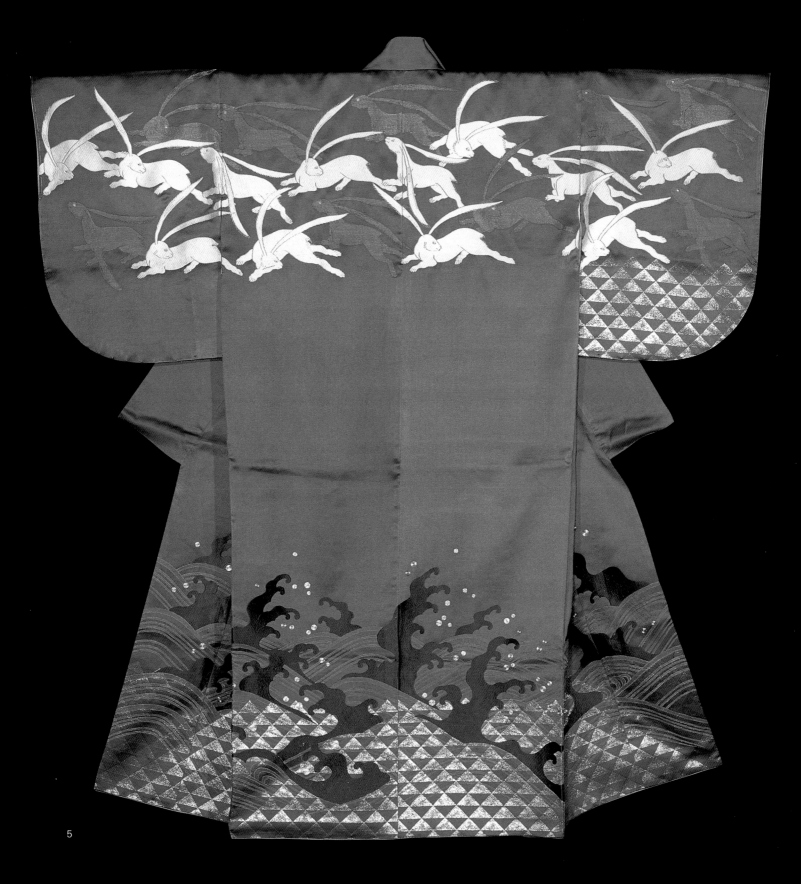

5

CRANE

The crane has traditionally been considered a sign of long life, victory in battle, and good tidings, and so as a pattern is used for happy occasions such as weddings and births. The bird is even considered a messenger of the gods.

Various patterns exist, such as the two-standing-cranes pattern (the birds in their mating dance) and those with the birds flying or alighting. Cranes are sometimes used with turtles or the pine-bamboo-plum combination. Occasionally, they are featured in more elaborate patterns depicting traditional stories involving cranes. Cranes on figured paper (*chiyogami*) also form a pattern.

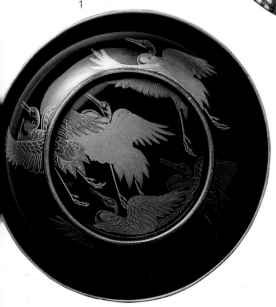

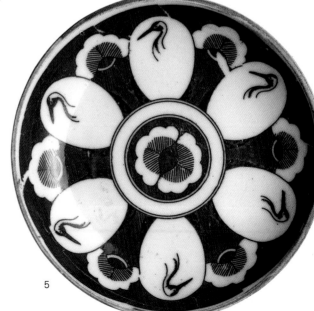

1 Cranes in flight (lid of *makie* bowl)

2 Crane, pine trees, and moon (plate)

3 Rounded crane

4 Cranes and clouds (saké bottle)

5 Cranes and pines (plate)

6 Cranes and clouds

7 Cranes in flight (comb)

8 Facing cranes

9 Crane (plate)

10 Crane (splashed pattern)

11 Crane (lidded rice bowl)

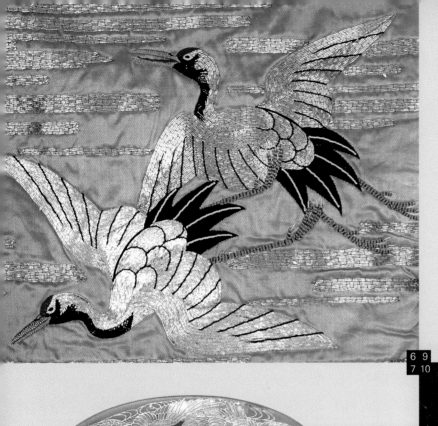
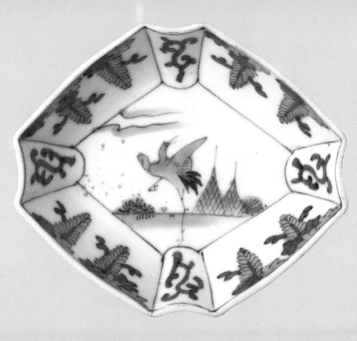

6 9

7 10

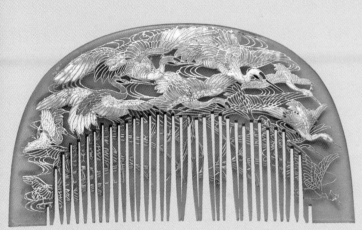

8 11

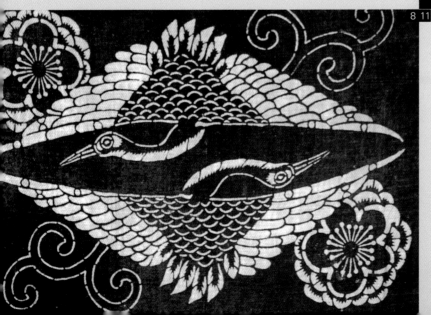
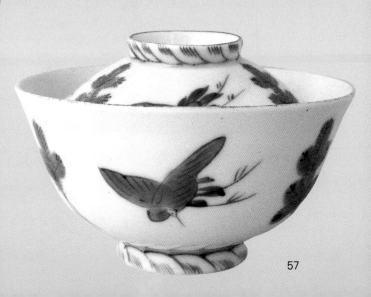

57

MANDARIN DUCK

Famed for their "marital" faithfulness, mandarin ducks in patterns are usually depicted in pairs. Due to the attractive shape of the birds, these patterns are often very beautiful.

Hunters shoot the male of a pair of mandarin ducks first and then wait. The female will fly down to be with her mate, making an easy target.

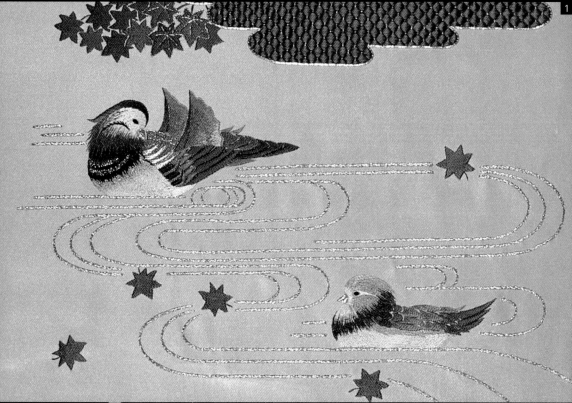

1

2

1 Mandarin ducks, maple leaves, and waves

2 Mandarin ducks, bush clover, and peonies

3 Mandarin ducks and Kanze ripple motif

4 Mandarin ducks, plum blossoms, camellias, and narcissuses (plate)

5 Mandarin ducks and plum blossoms (*makie* saké cup)

6 Mandarin ducks (lacquer tray)

3

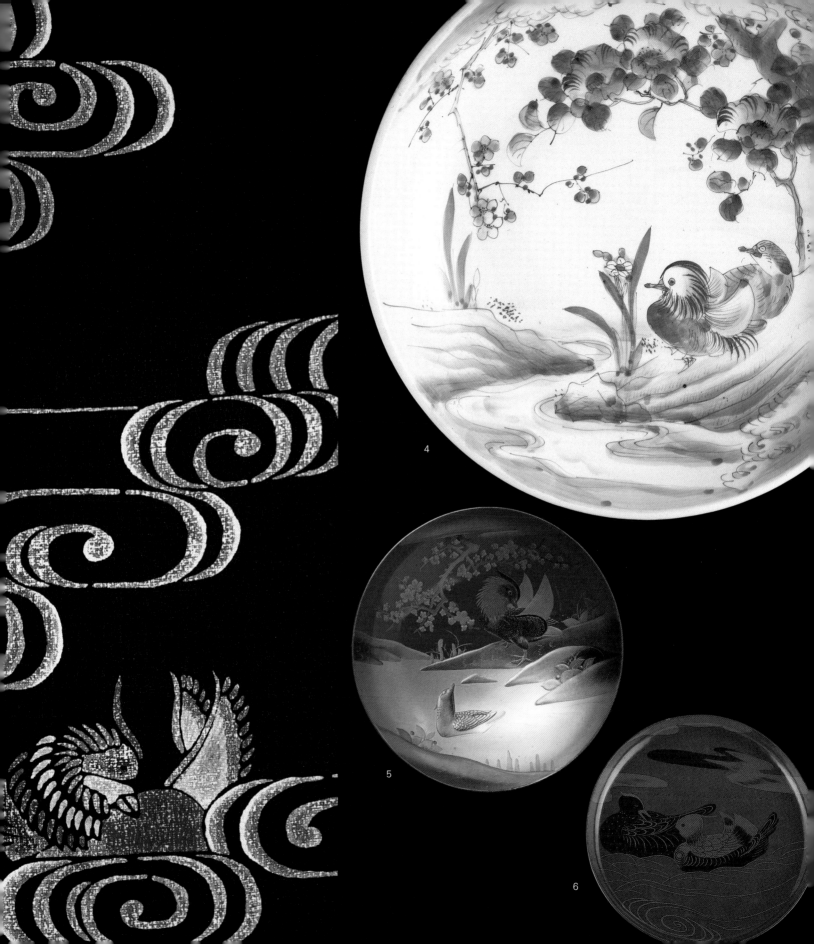

4

5

6

CHICKEN

Because chickens have traditionally been so common in people's daily lives, patterns depicting them are seen on many objects, including ceramic items, textiles, and toys. An interesting pattern is one of cockfighting.

1 Chickens and flowers (detail of wrapping cloth, 18th c.)

2 Cockfighting (plate)

3 Cock

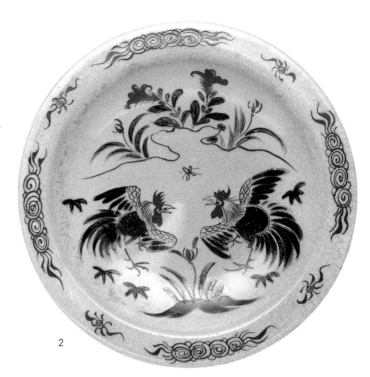

2

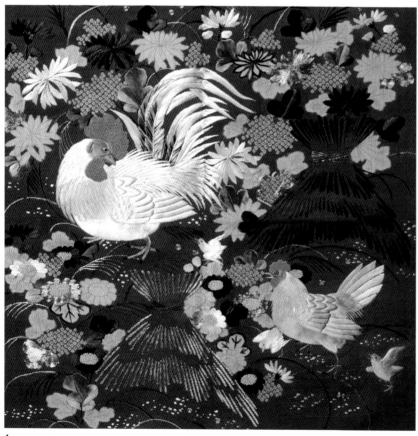

1

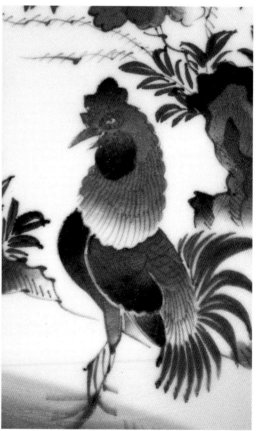

3

SPARROW

Sparrows-in-bamboo and sparrows-in-rice-plants are common patterns. The same combinations are used in family crests as well. This little bird is used as the subject in patterns on children's toys and clothing.

Another pattern is the tongueless-sparrow pattern, taken from the tale of a sparrow raised by a kindly old man. When an old woman catches the sparrow eating her laundry starch, she cuts off its tongue and drives it away. The old man goes out searching for the sparrow's home and, upon finding it, receives a basket of jewels. The old woman then goes to the sparrow's home expecting the same. She too is given a basket, but upon returning home she discovers that it is filled with snakes and poisonous insects.

1 Sparrows and bamboo (*surihaku* No robe)

2 Facing sparrows

3 Sparrows and bamboo (splashed pattern)

4 Sparrow and bamboo (bowl)

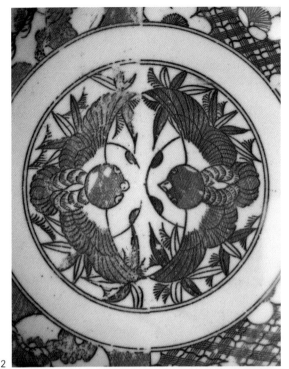

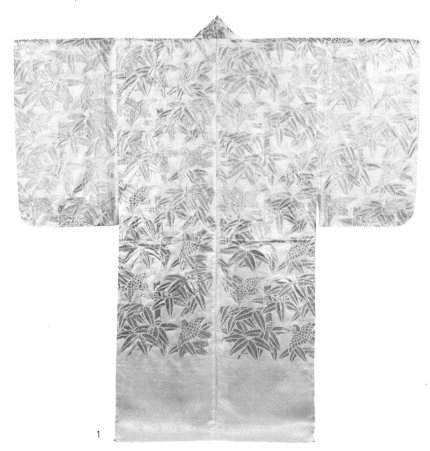

BUSH WARBLER

Although the little bush warbler (known in Japanese as *uguisu*) hides itself in the shade of the forest, its beautiful song is clearly audible as it echoes through the mountains. The bird is most often depicted with plum blossoms, frequently in *makie*.

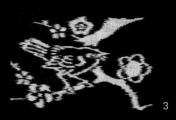

3

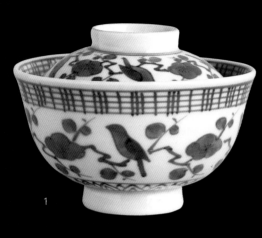

1

1 Bush warbler on plum branch (rice bowl)

2 Bush warbler on plum branch (plate)

3 Bush warbler on plum branch (splashed pattern)

4 Bush warbler on plum branch (plate)

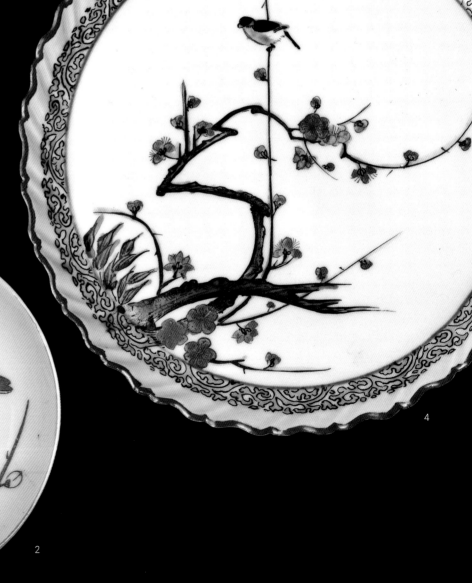

4

2

SWALLOW

For centuries swallows have built their nests under the eaves of people's homes, after flying north in the spring to produce and raise their young. Common patterns include swallows-among-willows and swallows-in-rain. Swallows are also seen in family crests.

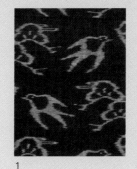

1 Swallows and pines (splashed pattern)

2 Swallows and willows (comb)

3 Swallows in rain (*haori* and *kitsuke* kabuki robe)

4 Swallows, flowers, and butterflies

5 Swallows and willows (detail of *yukata* cotton summer kimono)

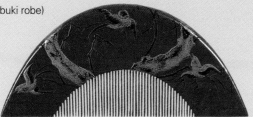

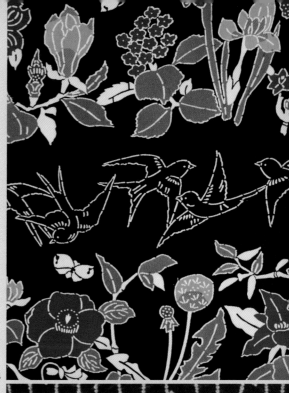

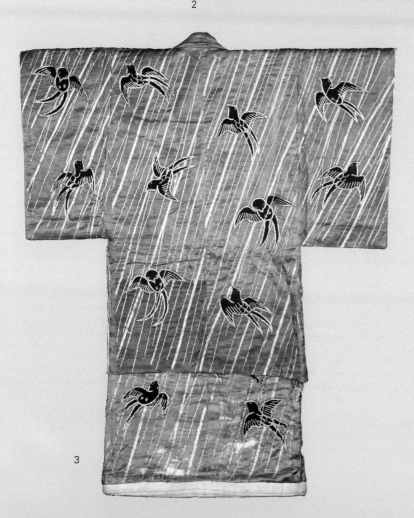

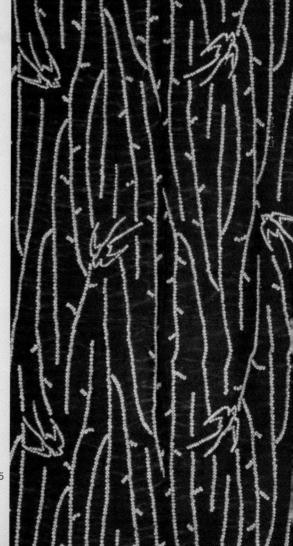

BAT

Considered a sign of good fortune and longevity in early China, bats appeared frequently in patterns, usually with other figures, such as coins or clouds. The same positive meaning was brought to Japan, where bats were used in both patterns and family crests. Examples of the latter include the informal crest of the Ichikawa Danjuro family of Kabuki actors and the corporate crest of Nippon Oil.

1 Bats (kabuki robe)
2 Bats (plate)
3 Bat (cigarette case)
4 Bats (No hair band)

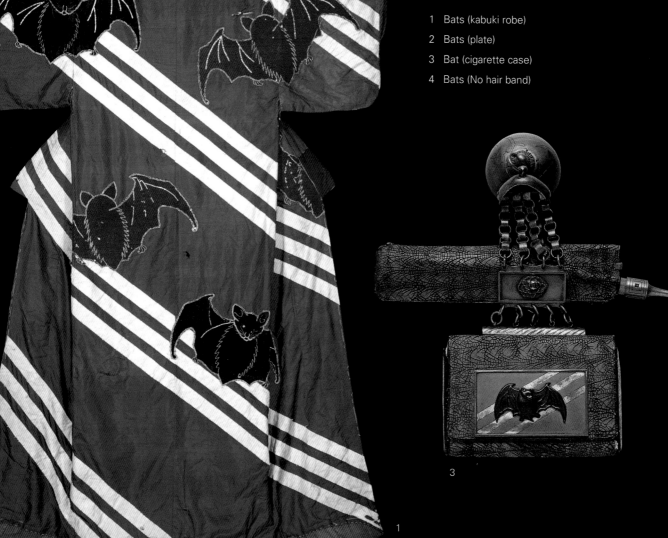

PHOENIX

The mythical phoenix is a symbol of nobility and auspiciousness. In China, a phoenix singing in a Chinese parasol tree was considered a sign that a virtuous ruler was going to be born. The phoenix thus became an imperial symbol and was used on the clothing, personal effects, and buildings of the Chinese and Japanese emperors.

A number of objects with phoenix patterns may be found at the Shosoin and at Horyuji temple. In later centuries, artists and craftsmen put phoenixes on ordinary objects. Examples include Old Kutani ware plates, the saké bottles of seventeenth-century potter Sakaida Kakiemon, chests, and *yuzen*-dyed cloth.

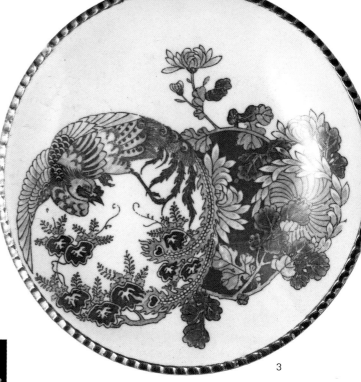

3

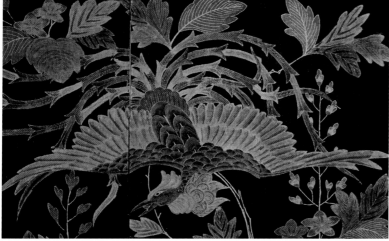

1

1 Phoenix (*tsutsugaki*-dyed cloth)

2 Phoenix

3 Phoenix and flowers (plate)

4 Phoenix and paulownia (*makie* writing-paper box, 17th–19th c.)

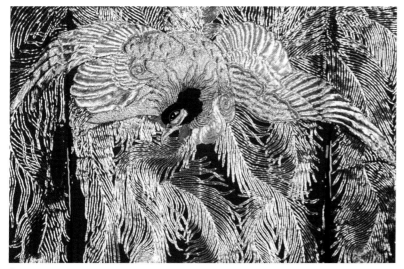

2

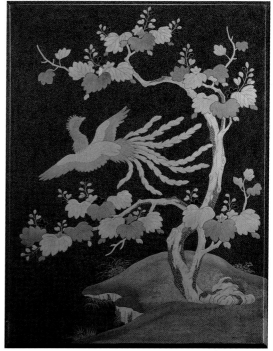

4

PEACOCK

The Japanese first saw peacocks on Buddhist artwork from China. Early Japanese peacock figures include those on a chest, embroidery, and a bell at the Shosoin. In the Kamakura period and later, beautiful peacock designs appeared on bottles and Buddhist implements, and were sewn, dyed, and embroidered on *kosode*, *obi* sashes, and other items.

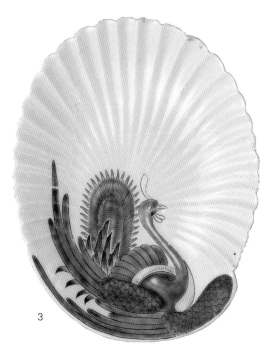

3

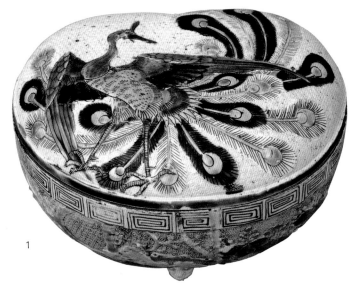

1

1 Peacock (incense container)

2 Peacock feathers *(makie* box)

3 Peacock (plate)

4 Peacocks and peonies

5 Peacocks and plum blossoms, bamboo, camelllias, and chrysanthemums

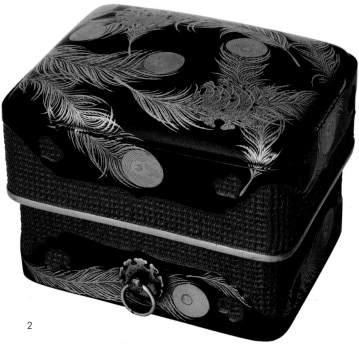

2

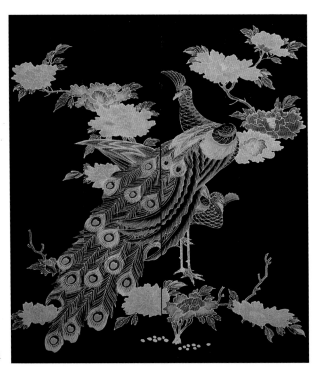

4

5 ▶

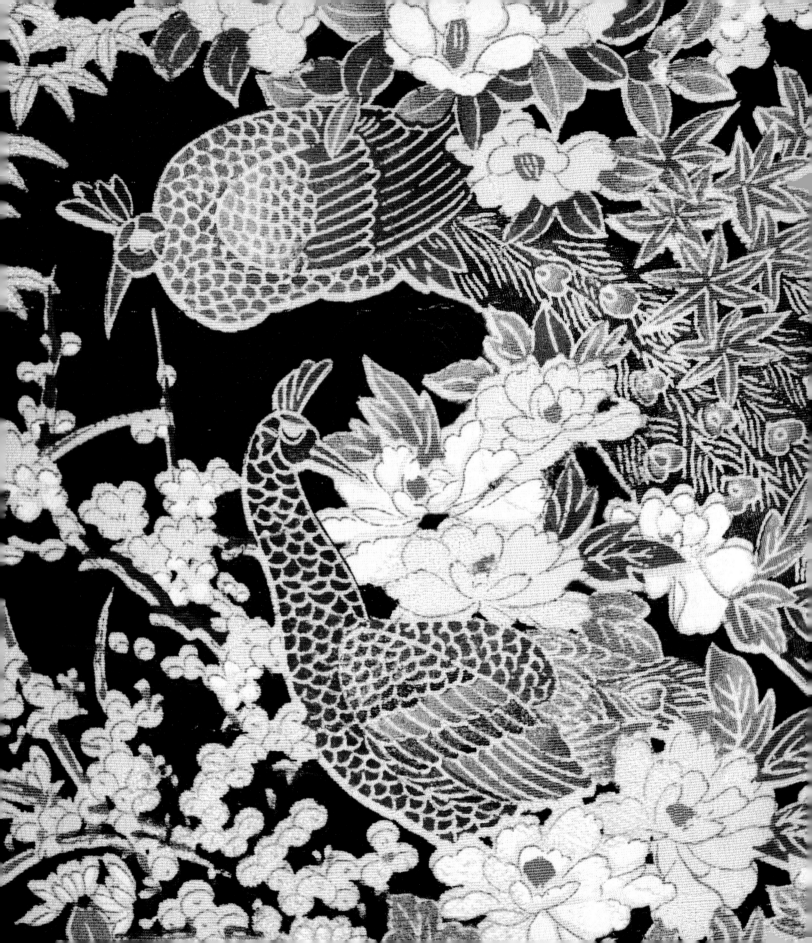

PLOVER

Plovers dancing on the beach have been a favorite subject of artists. A famous Heian-period chest with plovers done in *makie* is found in Konkobuji temple, in Wakayama Prefecture. Later depictions of the bird are virtually always in the plovers-in-waves pattern. This motif is used in family crests as well.

1

2

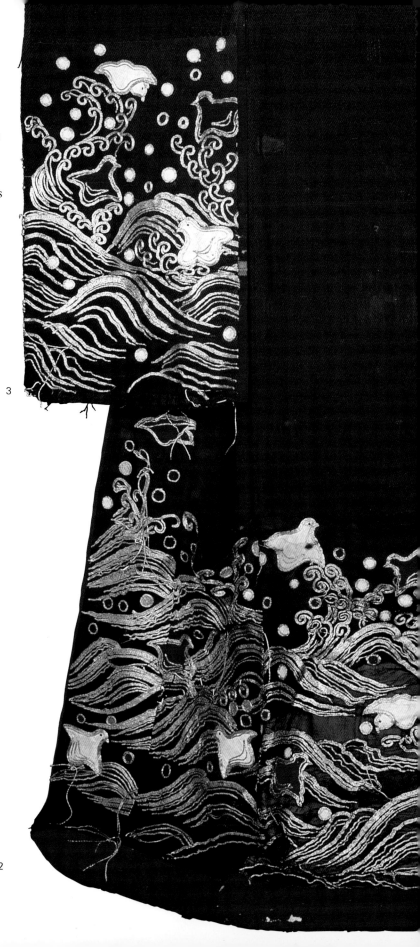

3

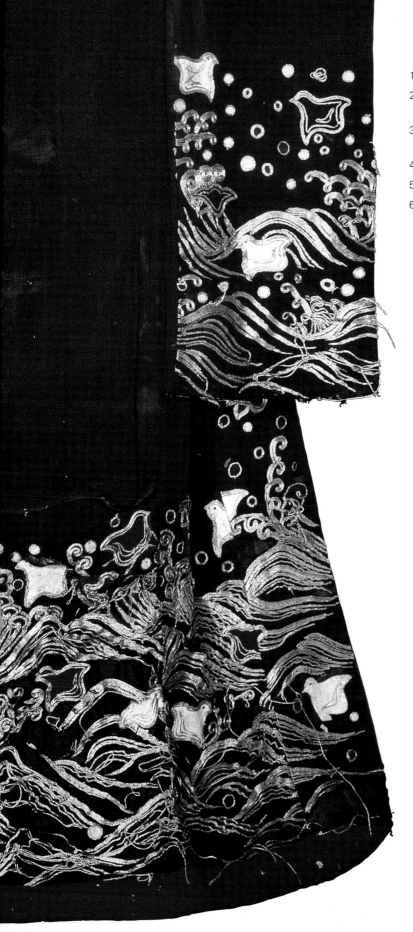

1 Plovers and waves

2 Plovers and waves (*makie* tiered food box, 18th c.)

3 Plovers and waves (long-sleeved kabuki robe)

4 Plovers and waves

5 Plovers (saké cup basin)

6 Plovers and waves (plate)

4

5

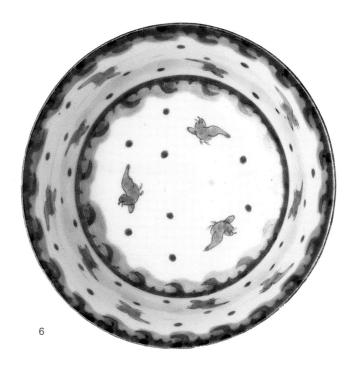

6

WILD GOOSE

Often depicted in patterns in flocks, wild geese are considered bearers of happiness. They have been used in numerous family crests.

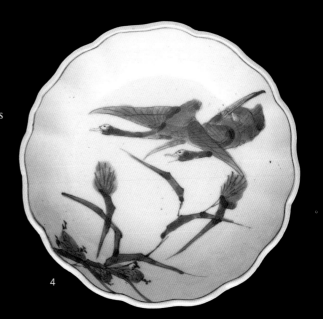

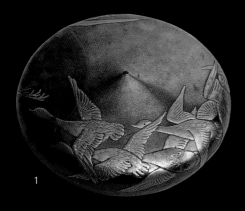

1 Wild geese (*makie* incense container)

2 Wild geese (detail of hand towel)

3 Wild geese

4 Wild geese (plate)

5 Wild geese and reeds (unlined kimono, 18th c.)

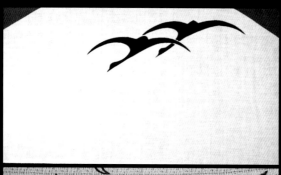

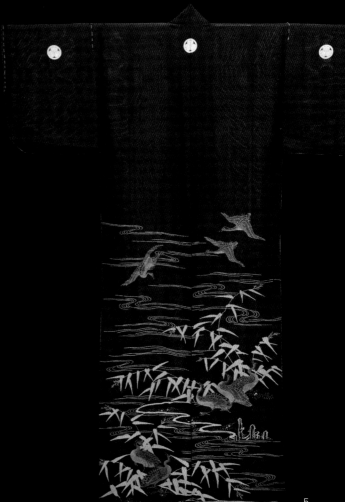

HERON

Alighting on rice fields, herons are an exquisite sight, one that has been recreated by many artists over the centuries. Unlike cranes, herons can be found near human habitation. Numerous examples of heron patterns exist, including those done in *makie* and gold brocade.

Some shrines have heron dances, at which the "herons" (human dancers) are considered messengers from the gods.

1 Heron (bowl)

2 Herons (cup)

3 Herons in reeds (detail of *kosode* short-sleeved kimono, 19th c.)

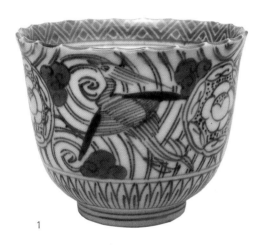

1

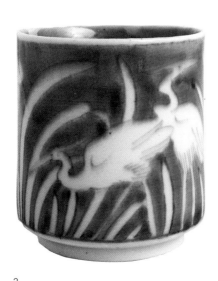

2

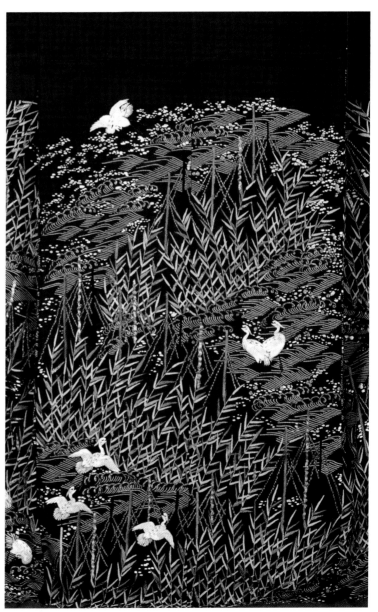

3

HAWK

The hawk is often considered the king of birds in Japan, perhaps because the more stately eagle is relatively rare. Warriors (*take*) especially liked the bird because of its name (*taka*), and visually striking patterns of warriors hunting hawks are typical. Banners with hawks are used for festive occasions, and hawk feathers are seen on family crests.

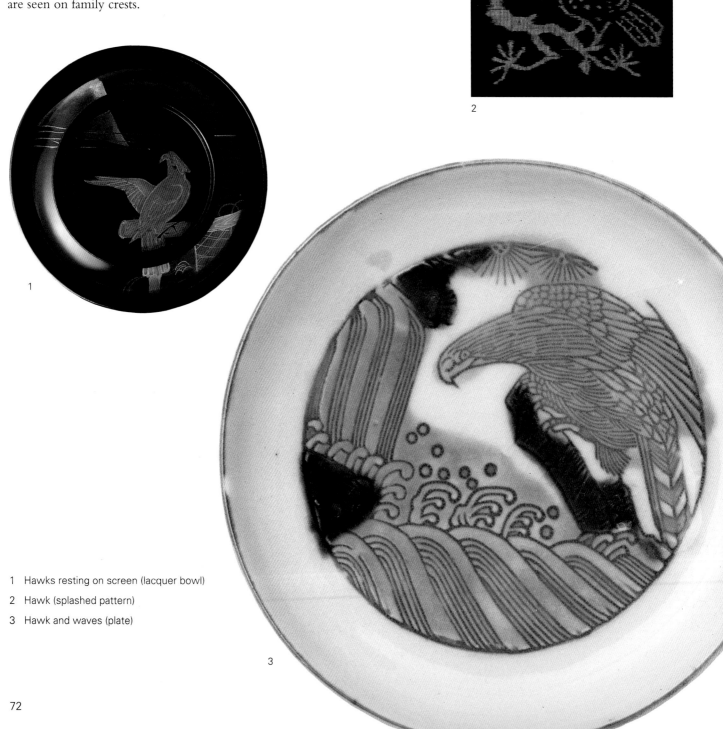

1 Hawks resting on screen (lacquer bowl)

2 Hawk (splashed pattern)

3 Hawk and waves (plate)

TURTLE

Since ancient times, turtles, along with cranes, have been considered a symbol of longevity. In the Orient, the god of the north is represented as a turtle, and in Japan the gods often descend on the back of a turtle. In addition to patterns depicting the turtle itself, there is the well-known tortoise shell pattern.

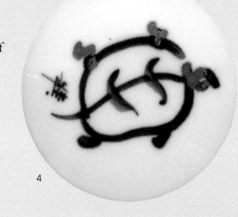

1 Turtle (metal fitting)
2 Turtle (*tsutsugaki*-dyed cloth)
3 Turtle (splashed pattern)
4 Turtle (plate)
5 Turtles (lacquer tiered food box)

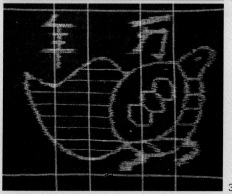

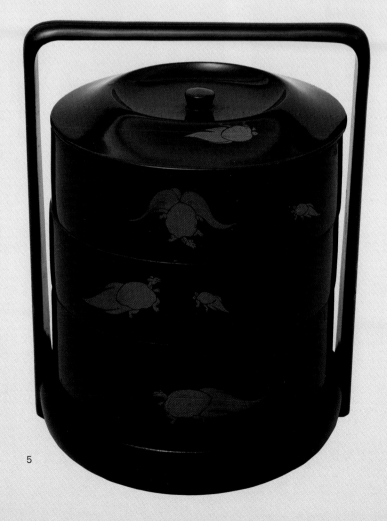

GOLDFISH

Goldfish are native to China and were brought to Japan during the Muromachi period. Since that time, numerous beautiful varieties have been bred in Japan, and many have appeared in the work of artists.

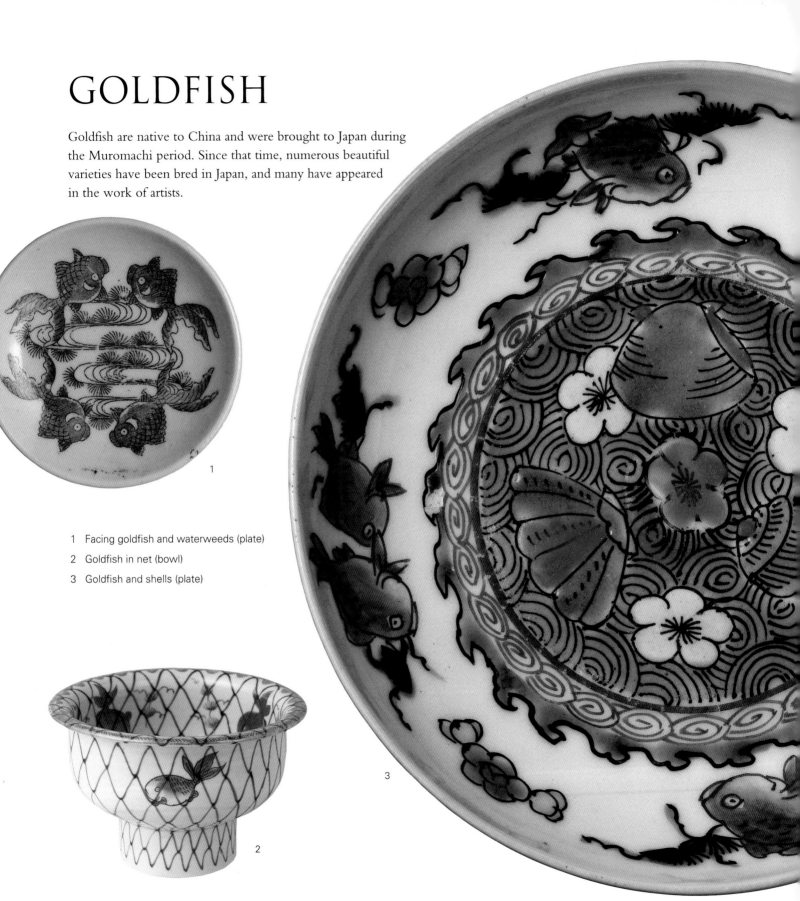

1 Facing goldfish and waterweeds (plate)
2 Goldfish in net (bowl)
3 Goldfish and shells (plate)

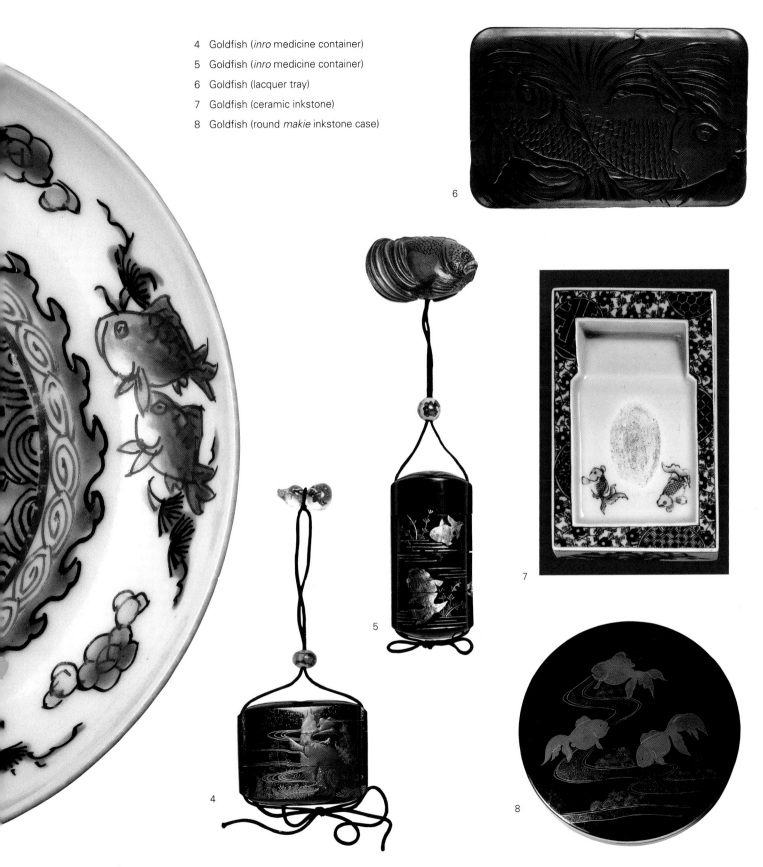

4 Goldfish (*inro* medicine container)

5 Goldfish (*inro* medicine container)

6 Goldfish (lacquer tray)

7 Goldfish (ceramic inkstone)

8 Goldfish (round *makie* inkstone case)

SEA BREAM

Mentioned in the *Manyoshu* and sacred Shinto songs, the sea bream has always been considered the "king of fish" by the Japanese. Sea bream symbolize joyous occasions, such as weddings, as the sound *tai*, "sea bream," comes at the end of the word for auspicious events, *omedetai*. Sea bream are seen on patterns with the god Ebisu fishing for them and on "great-catch" banners. The crest of Okita Shrine in Tottori has two sea bream facing one another within a bamboo ring. The fish are said to be the incarnation of the ancient god Kotoshiro-nushi.

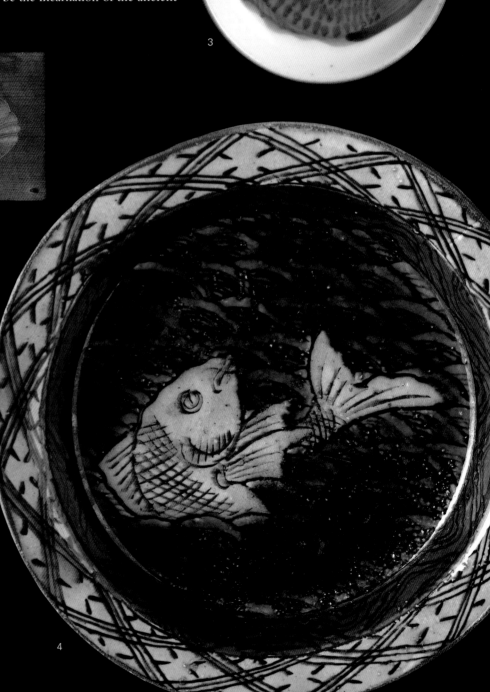

1 Sea bream (wooden mold)
2 Sea bream (ornament from a portable shrine)
3 Sea bream (plate)
4 Sea bream (plate)

LOBSTER

Because of its bent shape, the lobster represents old age and long life. Just as lobster is traditionally eaten at the New Year, the lobster pattern is associated with that holiday as well. Lobsters are most often depicted as leaping powerfully from the sea. (A pun is sometimes made on their name. They are called *ise-ebi*, with Ise referring to the province where lobsters, *ebi*, are commonly caught. A homonym, *isei*, refers to "power" or "spirit.")

The word *ebi* also refers to shrimps and prawns. Fine patterns employing small shrimp are also seen.

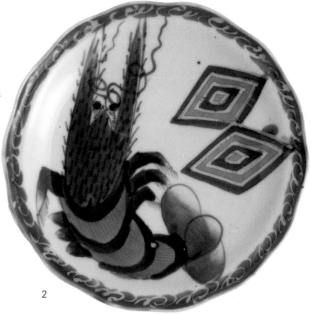

2

1 Lobster (*uchikake* kabuki robe)

2 Spiny lobster (plate)

3 Spiny lobster (splashed pattern)

4 Lobster (tea bowl)

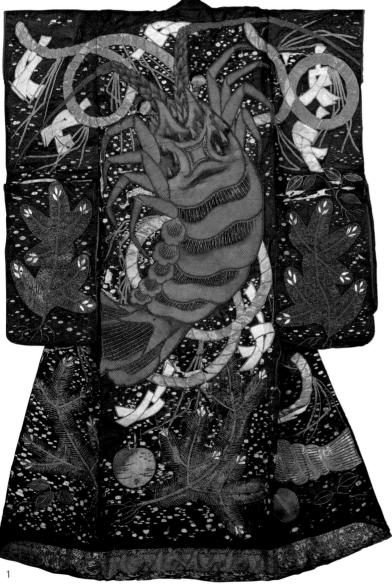

1

3

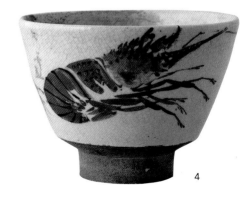

4

CRAB

The crab is considered by many to be a majestic animal and was representative of the authority of early warriors. A *katabira* with a crab figure on a light indigo background, said to have been worn by Tokugawa Ieyasu (1542–1616), is found in the Tokugawa Art Museum, in Nagoya.

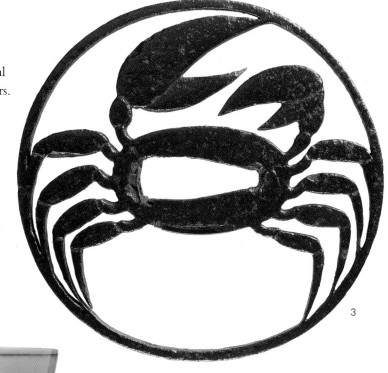

1 Crabs (No hair band)

2 Crab with persimmon branch (bowl)

3 Crab (sword guard, 16th c.)

4 Crab and koto (*makie* inkstone case, 16th c.)

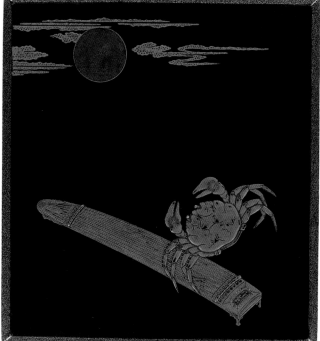

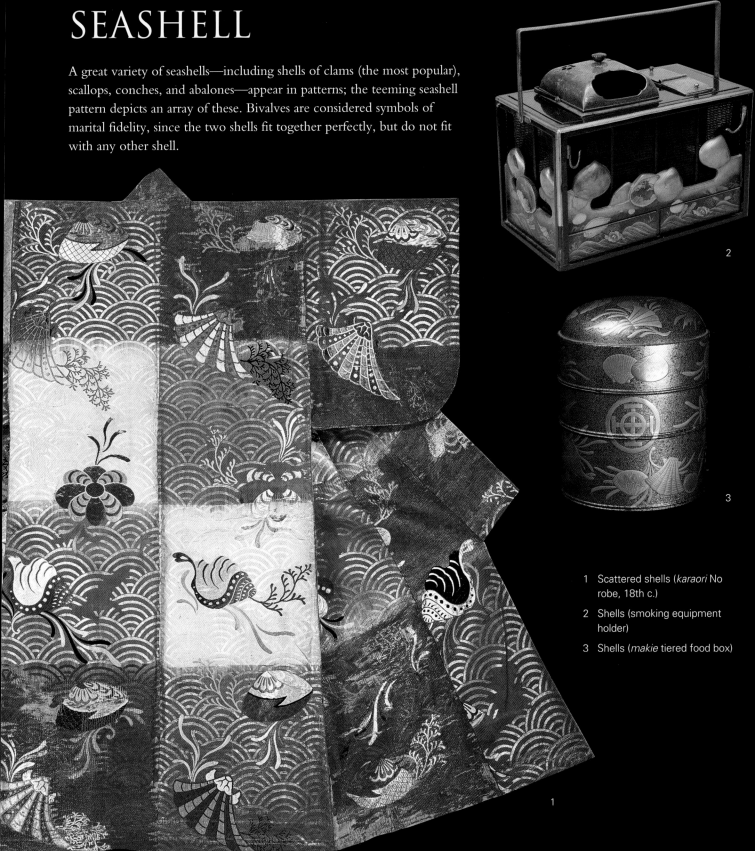

SEASHELL

A great variety of seashells—including shells of clams (the most popular), scallops, conches, and abalones—appear in patterns; the teeming seashell pattern depicts an array of these. Bivalves are considered symbols of marital fidelity, since the two shells fit together perfectly, but do not fit with any other shell.

1 Scattered shells (*karaori* No robe, 18th c.)

2 Shells (smoking equipment holder)

3 Shells (*makie* tiered food box)

BUTTERFLY

Butterfly patterns include those with butterflies flying together, taking nectar from flowers, and flying at night. In any arrangement, these beautiful insects give a very strong impression. The often-used combination of flowers and butterflies produces a strikingly vivid mixture of color and pattern.

A number of interesting old tales concerning butterflies exist. One is of a noblewoman of the Heike who drowned herself in Dannoura (off the coast of present-day Yamaguchi Prefecture), after which her spirit was transformed into a butterfly.

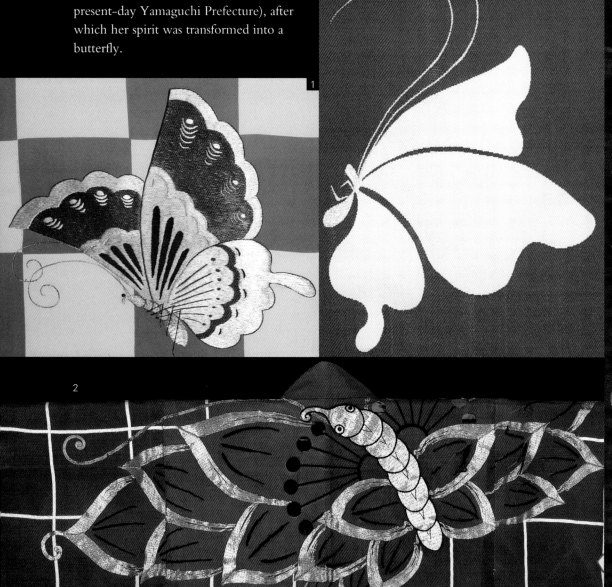

1

2

3 5
4 6

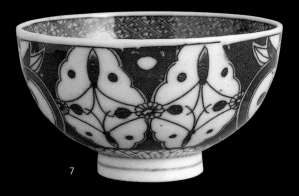

1 Swallowtail butterfly (detail of *obi* sash)

2 Butterfly (detail of kabuki robe)

3 Butterflies

4 Swallowtail butterfly

5 Butterfly (splashed pattern)

6 Butterfly and flowers (detail of *obi* sash)

7 Facing butterflies (rice bowl)

8 Butterfly (comb)

9 Butterflies (*makie* box)

10 Butterfly (*inro* medicine container)

7

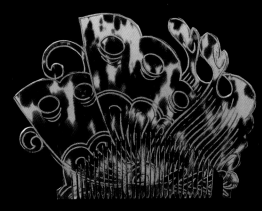

8

10

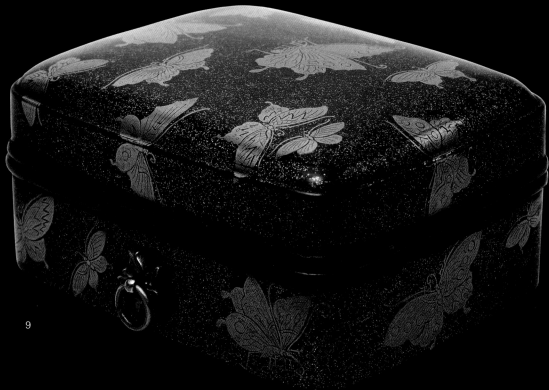

9

DRAGONFLY

Most Japanese have happy childhood memories of dragonflies. Children often catch the insect in a net by attaching a dragonfly decoy to the end of a stick which, when swung around, attracts real dragonflies.

Drawings of dragonflies are seen on ancient *dotaku*, bronze bell-shaped ceremonial objects. Warriors included dragonfly patterns on their armor as a symbol of victory. Dragonflies are commonly depicted in combination with autumn flowers and grasses.

3 4

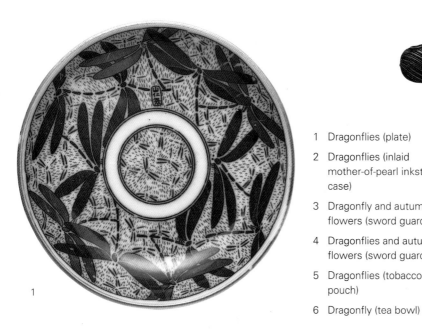

1

1 Dragonflies (plate)

2 Dragonflies (inlaid mother-of-pearl inkstone case)

3 Dragonfly and autumn flowers (sword guard)

4 Dragonflies and autumn flowers (sword guard)

5 Dragonflies (tobacco pouch)

6 Dragonfly (tea bowl)

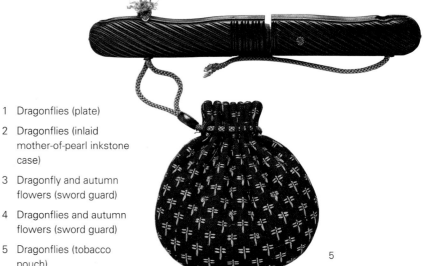

5

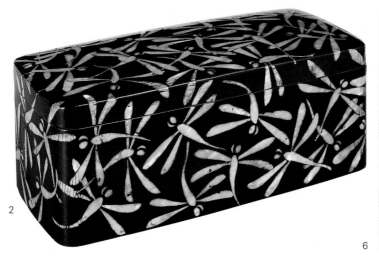

2

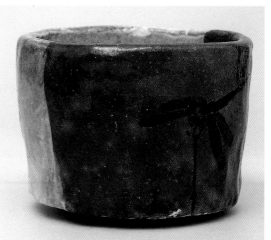

6

NATURAL PHENOMENA

Patterns based on natural phenomena—mountains, waves, whirlpools, the moon—are often the most immediately recognizable as being distinctively Japanese. This may be due to widespread familiarity with the woodblock prints of Edo-period artists such as Ando Hiroshige and countless other works of art that express the Japanese love for nature. The regular graphic repetition of an otherwise ordinary phenomenon often has a very beautiful effect—the overlapping-waves pattern being one such example.

For some natural phenomena, several variations on the pattern exist. There are, for instance, a number of clearly distinguishable cloud patterns as well as a separate mist pattern, and a variety of unique water and wave patterns.

FLOWING WATER

Flowing water is ever changing in form, sometimes swirling and eddying, sometimes appearing as choppy waves. Patterns in these shapes as well as water patterns including fish, leaves, boats, and water wheels exist. Artists clearly had to take great pains to depict the flow of water.

The *tatsutagawa* pattern depicts red maple leaves floating on water. It is named after the Tatsuta River, in Nara Prefecture, famed for this spectacle. The Kanzemizu pattern is one with unique eddy figures, first used by the Kanze family of Noh actors.

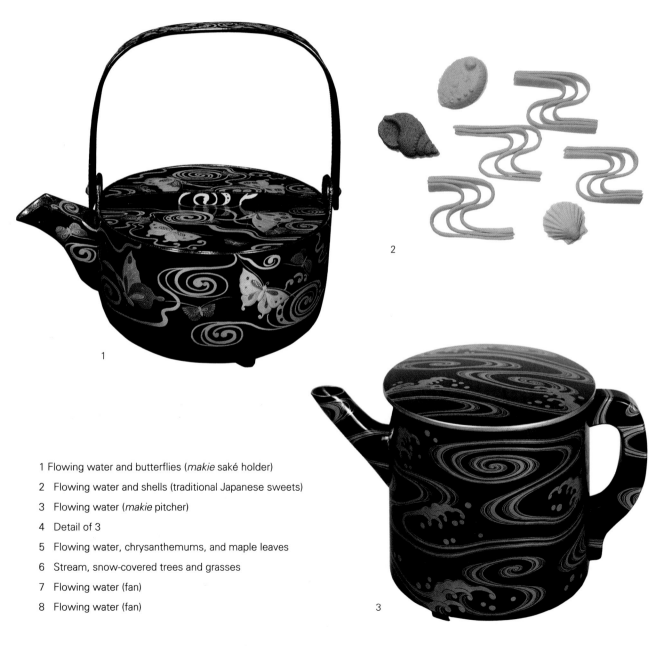

1 Flowing water and butterflies (*makie* saké holder)

2 Flowing water and shells (traditional Japanese sweets)

3 Flowing water (*makie* pitcher)

4 Detail of 3

5 Flowing water, chrysanthemums, and maple leaves

6 Stream, snow-covered trees and grasses

7 Flowing water (fan)

8 Flowing water (fan)

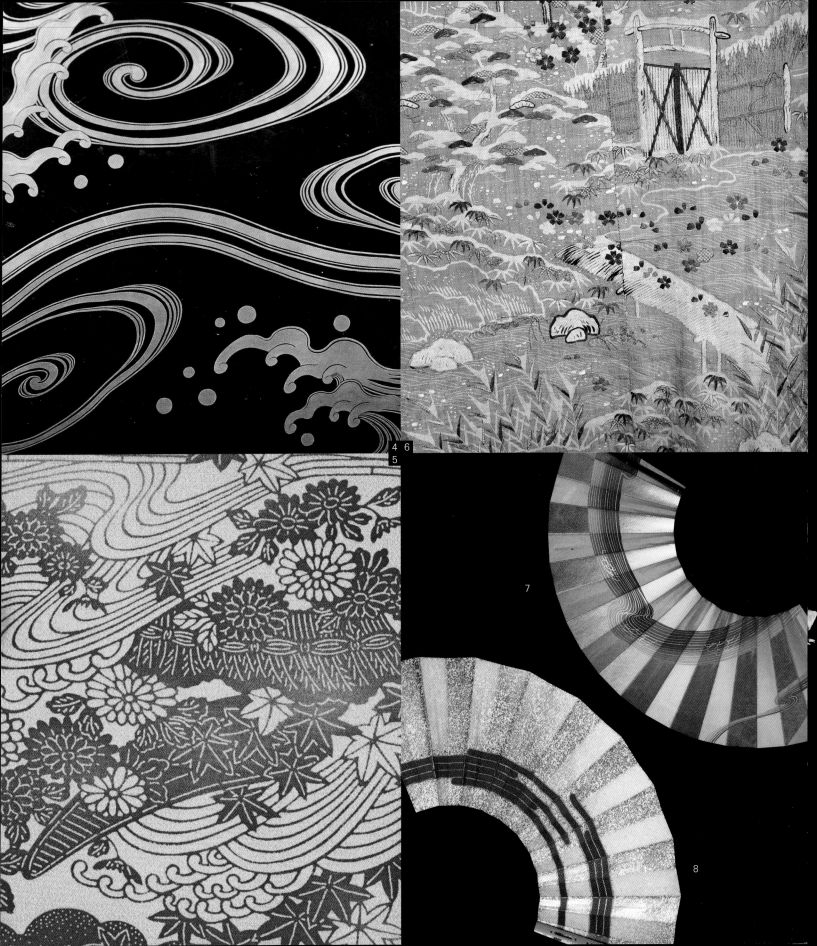

4 6
5

7

8

WAVE

A variety of wave patterns exist, all of which express dynamic motion. A common pattern that was popular during the Edo period portrays overlapping waves. Patterns showing combinations of waves and the moon, plovers, or water wheels are also frequent.

In ancient Japanese religion, waves—both those crashing against the shore and those returning to the sea—were considered the work of the Dragon King, who resided in the depths of the ocean. Rough waves thus expressed the Dragon King's anger, and a calm sea indicated that his ire had subsided. The Dragon King would make waterspouts as his vehicle for ascending into heaven.

1

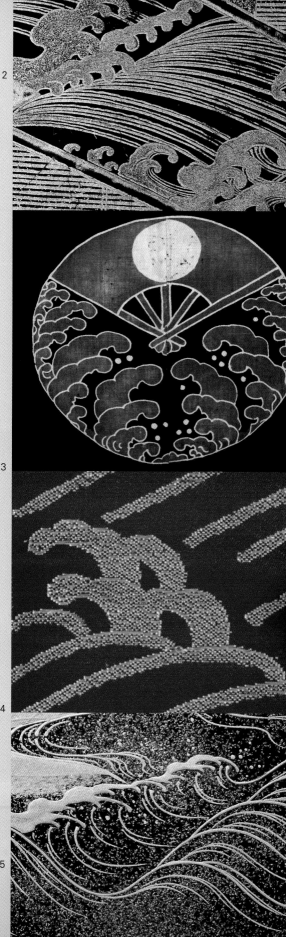

2

3

4

5

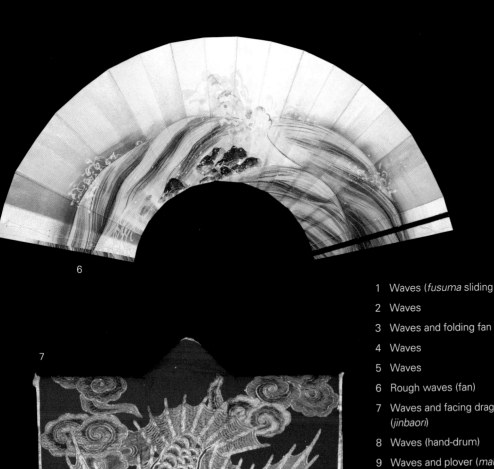

6

7

1 Waves (*fusuma* sliding doors)

2 Waves

3 Waves and folding fan

4 Waves

5 Waves

6 Rough waves (fan)

7 Waves and facing dragons (*jinbaori*)

8 Waves (hand-drum)

9 Waves and plover (*makie* tiered food box, 18th c.)

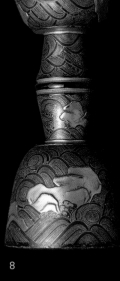

8

9

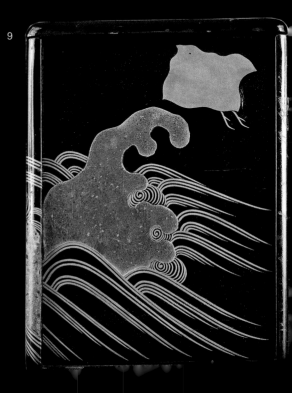

OVERLAPPING WAVES

A completely stylized example of a wave pattern, the overlapping-waves pattern was developed in the middle of the Edo period (1600–1867). Coins from Akita, in northern Japan, had this pattern on their reverse side. Tsugaru lacquerware, from the Tsugaru region of present-day Aomori, also in the north, featured the painted pattern as well.

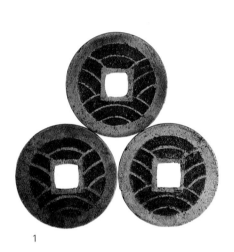

1

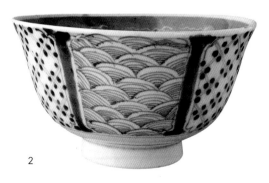

3

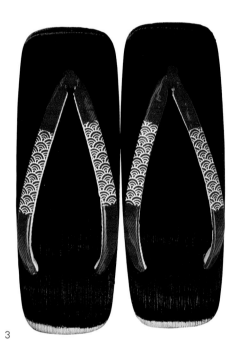

2

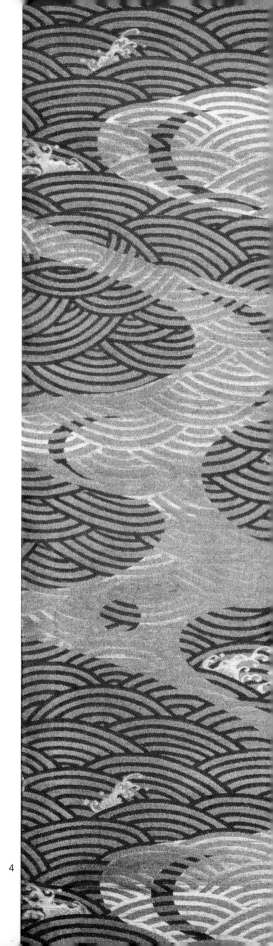

1 Overlapping waves (coins)

2 Overlapping waves and rhombuses (bowl)

3 Overlapping waves (*geta* clogs)

4 Overlapping waves (detail of *obi* sash)

5 Overlapping waves and plum blossoms

6 Overlapping waves (smoking equipment tray)

7 Overlapping waves

8 Overlapping waves

9 Overlapping waves (chopstick rests) 4

5 8

6

7 9

SNOW

In patterns snow appears in many forms and in combinations with other items from nature. Early renditions of snowflakes, such as snow circles, were rather fanciful, since their true structure could not be ascertained. When the Edo-period feudal lord Doi Toshitsura published drawings of snowflakes he had observed under a microscope, he caused quite a stir among the artists of his day, who fought to see the pictures.

Snow may be depicted falling or piling up, often with bamboo grass, pines, willows, cherry blossoms, and eulalias.

2

1 Snowflakes (smoking equipment tray)

2 Snow circles (lidded rice bowl)

3 Snowflakes (sword guard by Hirata Shunkan, 1828)

4 Snowflakes (comb, 17th–19th c.)

5 Snow-laden bamboo leaves (No robe)

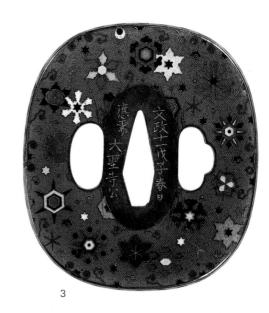
3

1

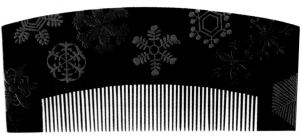
4

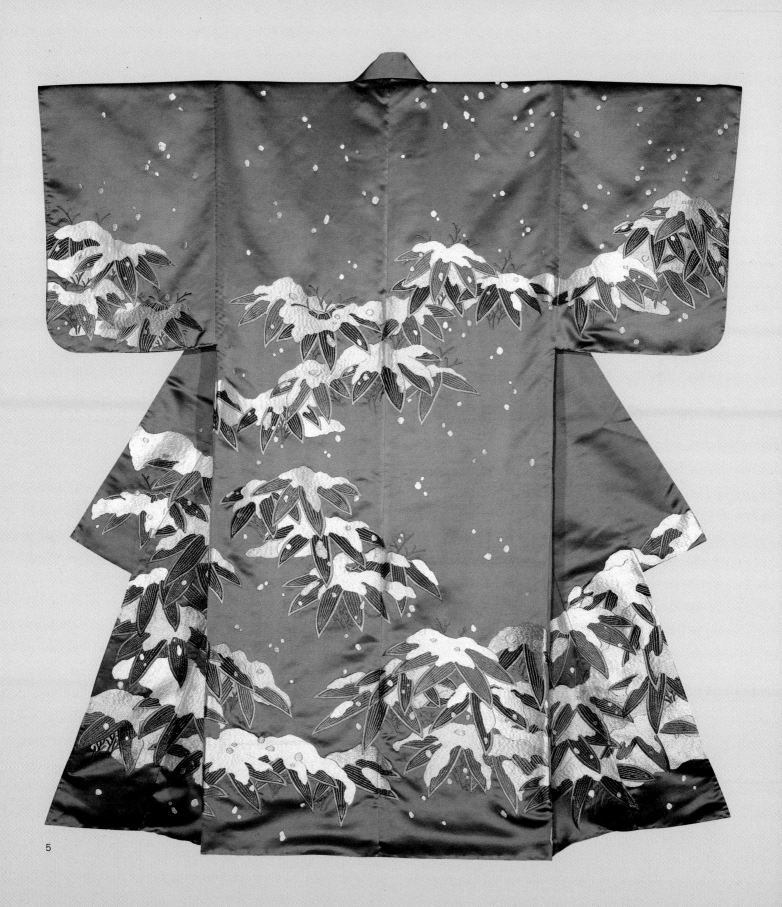

5

CLOUD

The use of clouds in patterns is unique to the East. They make for an especially interesting subject because of their countless varieties and transformations: fleecy or heavy with rain, low-hanging and stationary, or flowing lightly by. In artwork, heavenly figures and dragons are sometimes seen among the clouds.

3

1 Auspicious clouds (detail of kabuki robe)

2 Clouds and crane

3 Clouds and hawk (detail of kabuki robe)

4 Round cloud (detail of kabuki robe)

5 Clouds with *tatewaku*

6 Clouds (detail of kabuki robe)

1 4
2 5

6

MOON

The moon traditionally has had both practical and cultural meanings. The former includes the calendar and the relationship between the moon and the tides, while the latter comprises various legends. In Japan, for example, the image of a princess or a rabbit is traditionally thought to be visible in the face of the moon. These ideas may be depicted in patterns, with the moon shown in its varying stages.

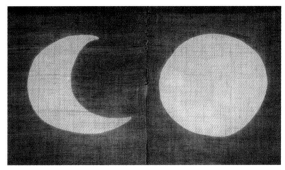

2

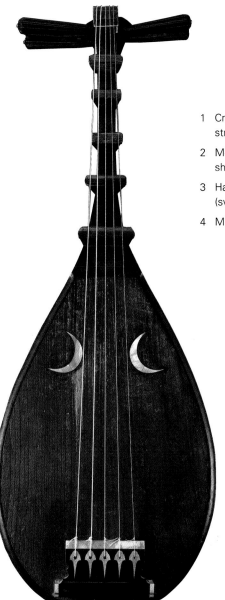

1 Crescent moon (*biwa* five-stringed lute)

2 Moon and sun (detail of *noren* shop curtain)

3 Hazy moon and cherry branch (sword guard, 19th c.)

4 Moon and grasses

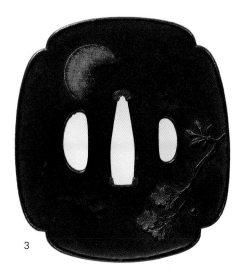

3

1

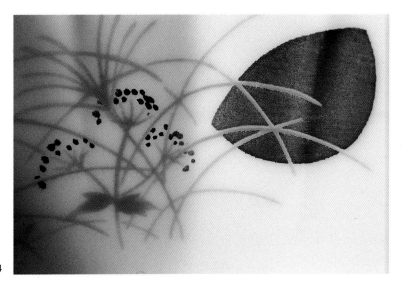

4

MOUNTAIN

Mountain patterns that depict mountains in their natural appearance or that simply use a mountain's shape range from simple geometric arrangements to beautiful scenes of peaks shrouded in clouds or mist. Since gods are said to dwell in them, mountains are often considered sacred.

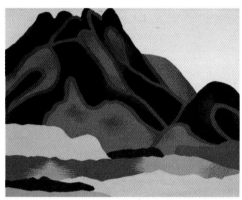

1

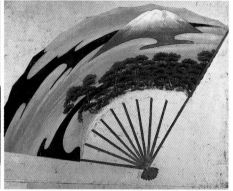

2

1 Mountain and clouds (detail of *obi* sash)

2 Mount Fuji and pine trees

3 Mountains (fan)

4 Mount Fuji and pine tree (plate)

5 Landscape (saké bottle)

6 Mount Fuji and pine trees (plate)

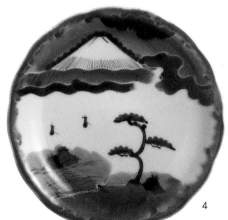

4

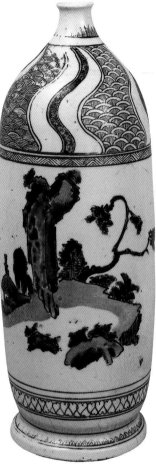

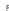

5

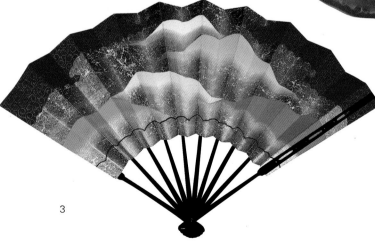

3

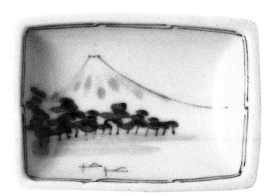

6

Unlike animals, which can be shown with dynamic expression, buildings, tools, and the like are relatively stationary. There is, however, great potential for variety in patterns portraying implements and structures. Implement patterns may be subdivided into religious objects (bells, the Buddhist jewel, *hoju*, Buddhist wheels), everyday items (bamboo hats, various tools), weapons (swords, arrows), toys (paper dolls, battledores), and musical instruments (koto, flutes, drums). Structures used in patterns include rafts, anchors, fences, and houses.

Favorite patterns seem to be objects indicating good fortune and unusual items— things such as treasure boats and *hoju*, on the one hand, and on the other, drawer handles and anchors.

MUSICAL INSTRUMENT

A wide variety of traditional musical instruments may be used in patterns: hand-drums, the *biwa* (a kind of lute), the koto, the *sho* (a reed mouth-organ), bells, flutes, and the *kugo* (a zitherlike instrument from the ancient Pakche kingdom of Korea). Patterns may depict the instruments alone or people playing them and dancing to their music. The motif of angels playing flutes as they descend from heaven came to Japan from the Asian mainland along with Buddhism.

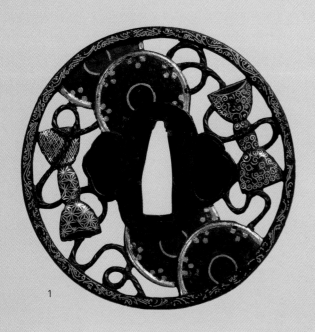

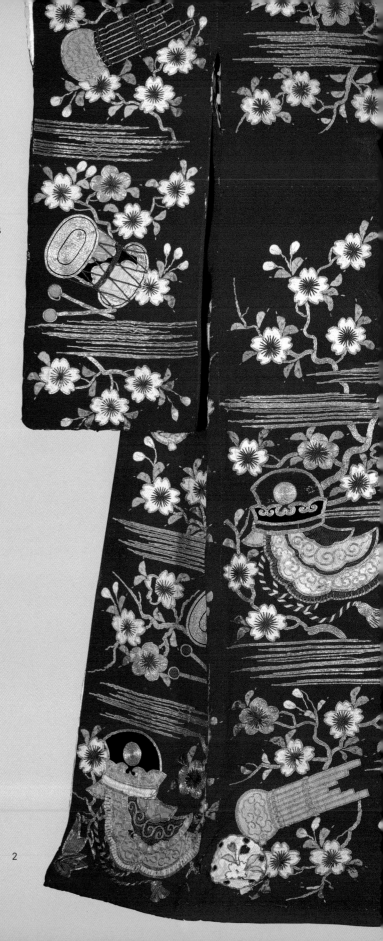

1 Drums (sword guard, 17th c.)

2 *Sho* reed instruments, hand-drums, and cherry blossoms (long-sleeved kabuki robe)

3 Koto (thirteen-stringed zither) and *kicho* curtain (detail of wrapping cloth)

4 Doll with hand-drum and flowers

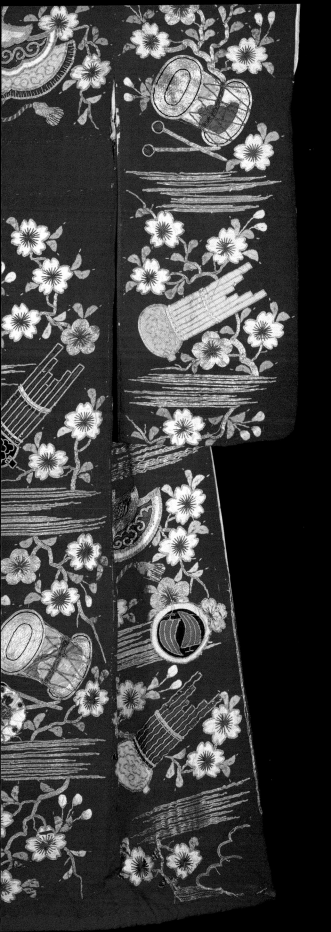

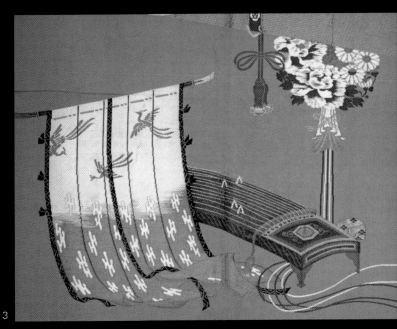

3

4

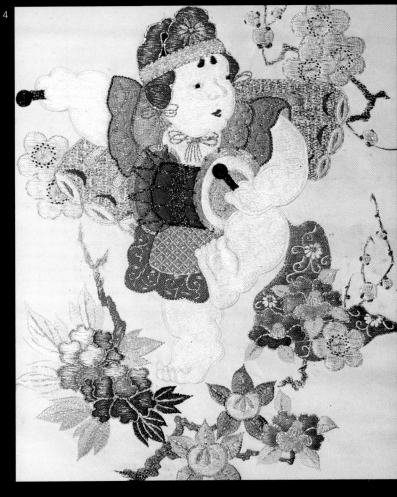

FOLDING FAN

The folding-fan pattern—and the folding fan itself—has been popular for over a thousand years, in part because the action of opening it is an auspicious omen for the "unfolding" of the future. In patterns, the fans may appear opened, closed, overlapping, or scattered.

The ribs of a folding fan may be made of bamboo or Japanese cypress. It is to the ribs that the painted paper is pasted. The paintings are often very beautiful.

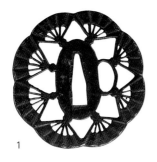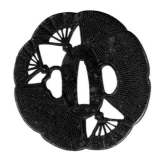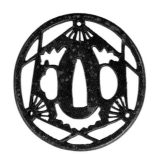

1

1 Folding fans (sword guards, 17th–19th c.)

2 Folding fans and cherry blossoms (comb and hairpin)

3 Folding fans

4 Folding fan with pine needles, bamboo, and plum blossoms

5 Scattered folding fans and birds (paper stencil)

6 Folding fan

7 Folding fan (splashed pattern)

8 Scattered folding fans

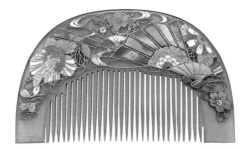

2

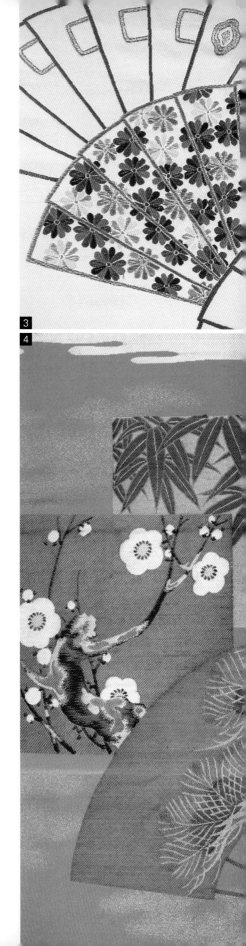

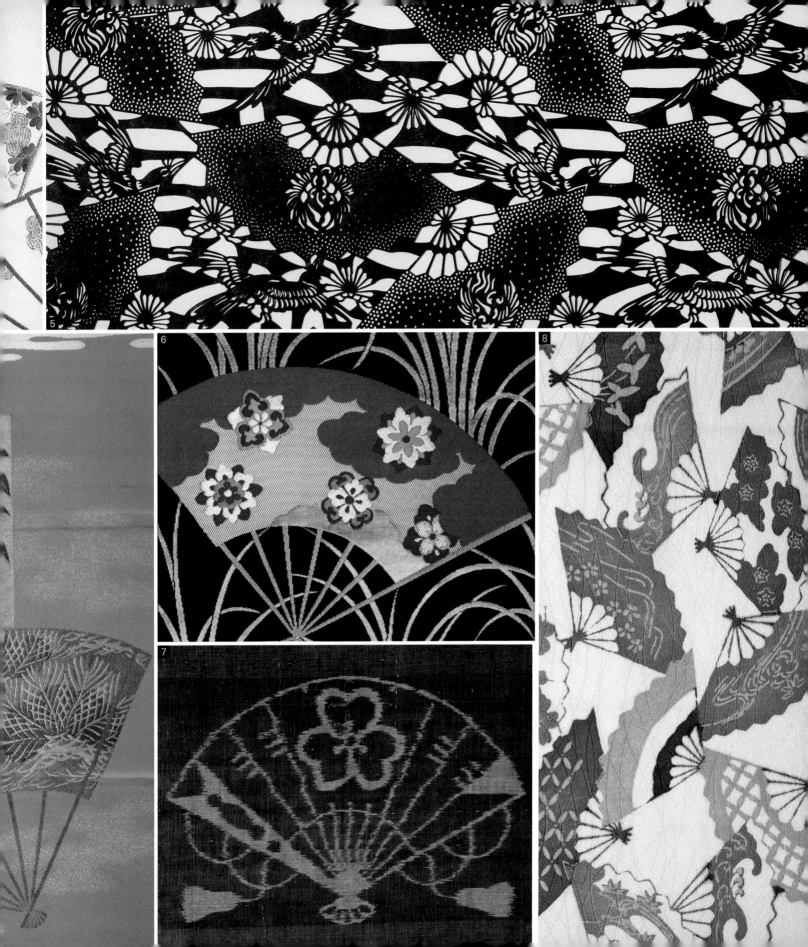

WHEEL

The earliest Japanese wheel patterns appeared during the Heian period, based on the wheels of the cow-drawn carts of the nobility. Other wheel or wheel-related patterns include the half-wheel pattern, depicting wheels partially submerged in flowing water, pin-wheels, and such uniquely Japanese motifs as flower-decorated wheels.

2

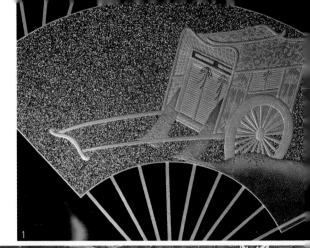

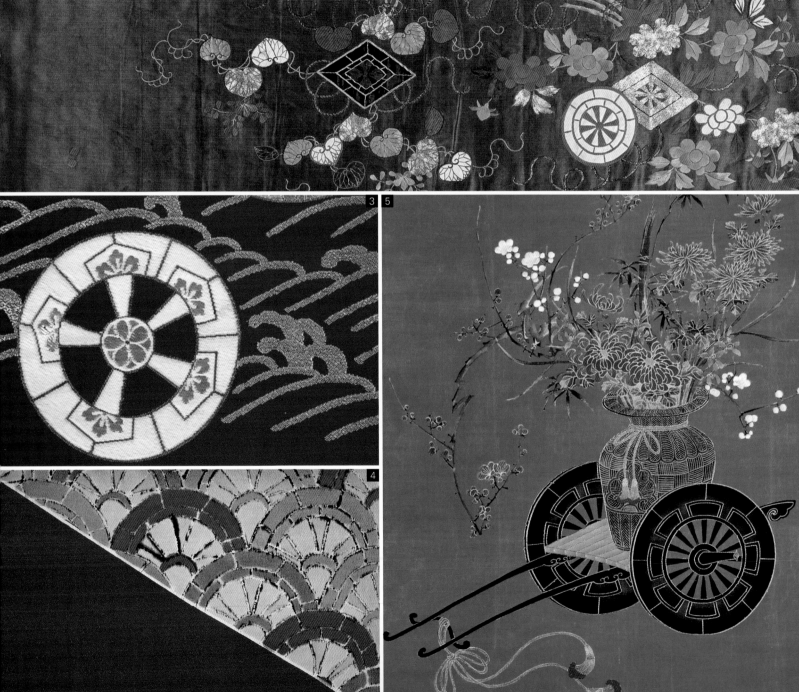

1 Carriage (*makie*)

2 Genji wheel and rhombus wheels among flowers (detail of *obi* sash)

3 Genji wheel and waves

4 Wheels

5 Flower-decorated carriage

6 Half-wheel (sword guard)

7 Genji half-wheels (*kitsuke* kabuki robe)

ARROW FEATHER

Patterns using arrow feathers may show them lined up, radiating,
or intersecting. Warrior families were fond of using arrow feathers
in their crests.

1

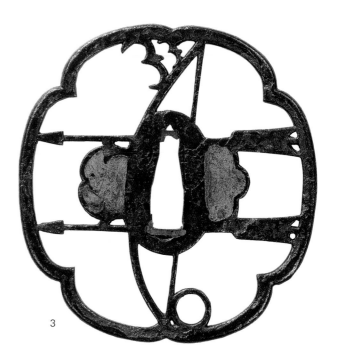

3

1 Arrow feathers (comb)

2 Hawk-feather wheel (plate)

3 Bow and arrows (sword guard, 15th–16th c.)

4 Arrows

5 Arrow and target (*haori* and *kitsuke* kabuki robe)

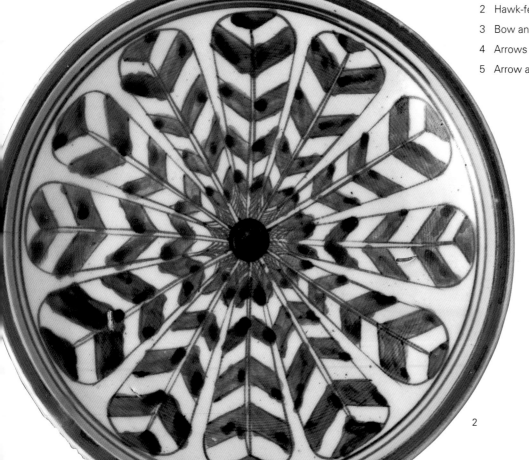

2

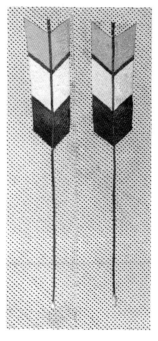

4

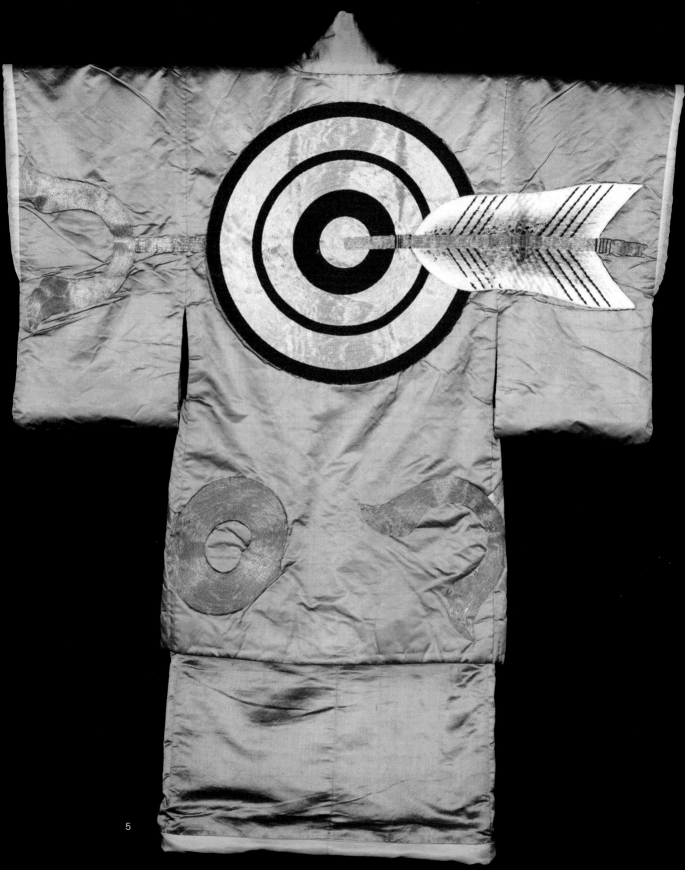

5

BOAT

Boats were frequently drawn on Edo-period *kosode* short-sleeved kimono and other items of clothing, both because of their scenic effect and to honor a means of transport that brought people the necessities of life. Different kinds of boats were seen: sailboats (or just sails), rush-roofed boats, pleasure boats, and, eventually, foreign ships. In combination with flowing water, boat patterns were especially pretty.

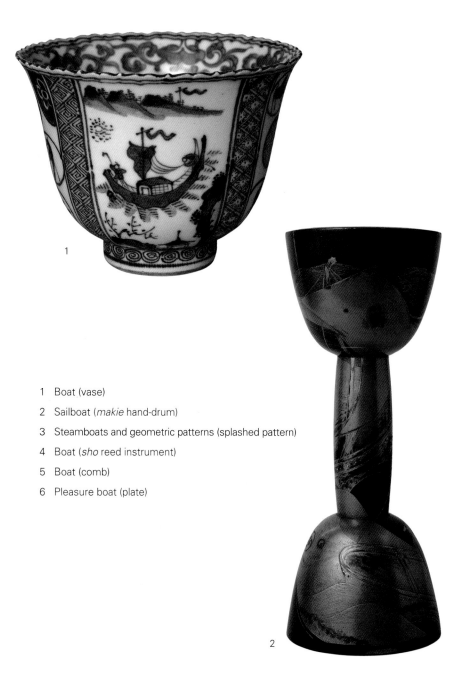

1 Boat (vase)

2 Sailboat (*makie* hand-drum)

3 Steamboats and geometric patterns (splashed pattern)

4 Boat (*sho* reed instrument)

5 Boat (comb)

6 Pleasure boat (plate)

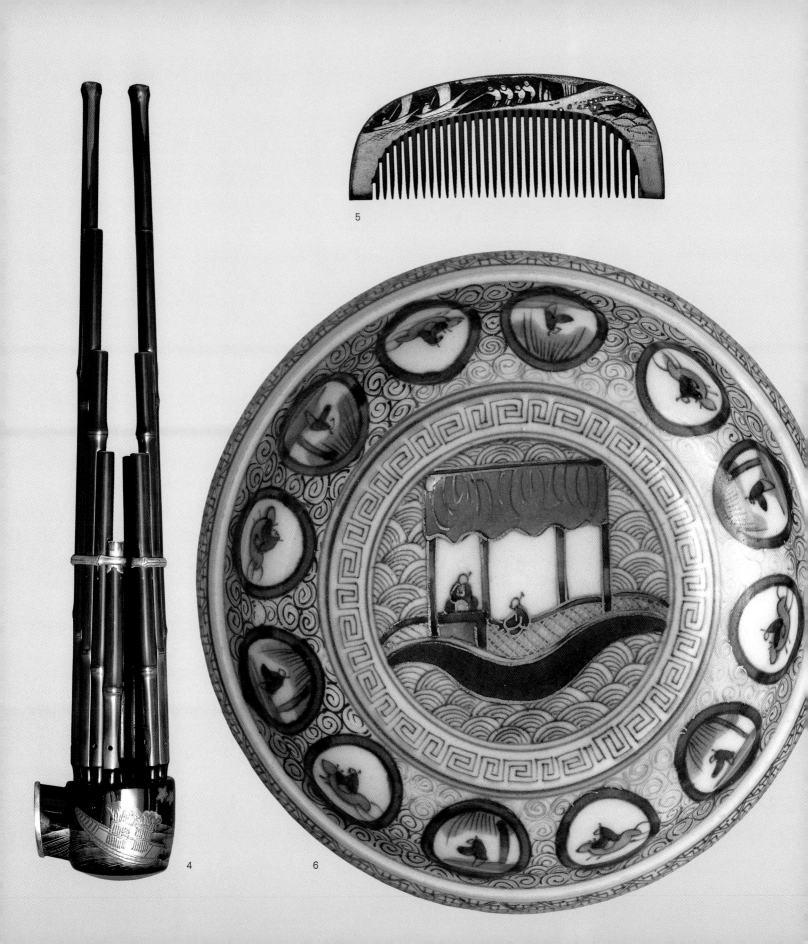

4 5 6

1

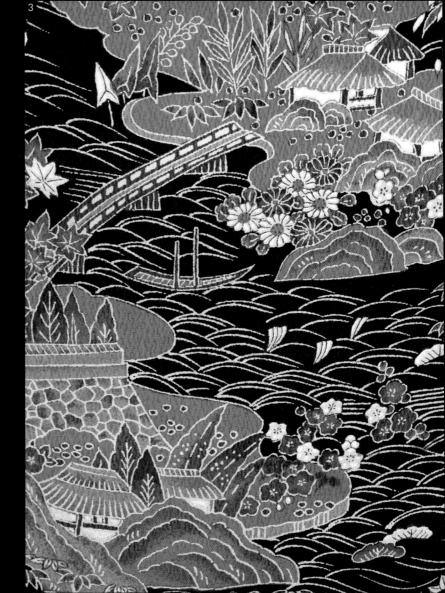

3

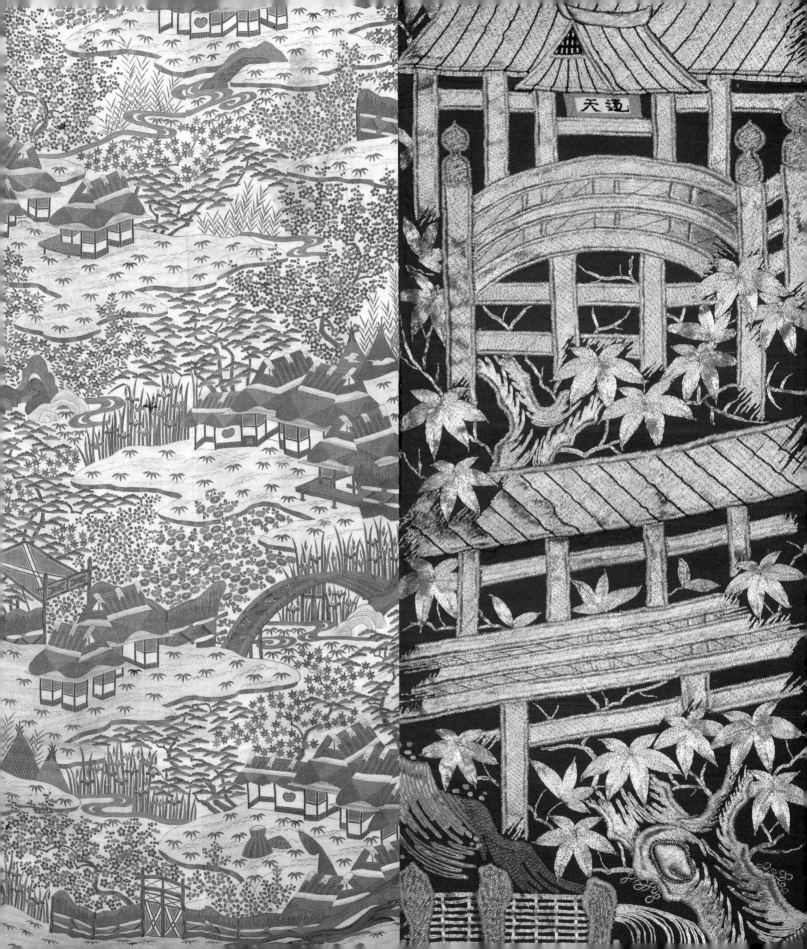

TREASURES (*Hoju*)

The treasures pattern depicts various objects of value. Traditional objects of this kind included jewels, keys, small mallets, money bags, magical cloaks and bamboo hats that ensured the wearer's invisibility, cloves, and interlaced circles. Other diverse items represented from time to time were umbrellas, bottles, goldfish, lotus blossoms, swords, conch shells, coins, and rhinoceros horns. The variety of items indicates the multiplicity of their origins, from India and points east along the Silk Road. The teeming-treasures pattern is a variation that seemingly surrounds the viewer with those objects.

A *hoju* (see page 166) is a spherical jewel slightly pointed at the top. In Buddhism, a *hoju* is supposed to give one one's heart's desire; thus in statues, the Buddha is sometimes seen holding one. *Hoju* are also a symbol of Inari shrines in Japan. In patterns and other artwork, *hoju* are often shown surrounded by flames.

1

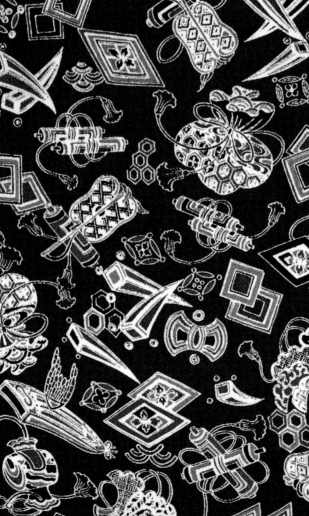

1 Lion and overlapping circles with flowers (plate)

2 Good-luck mallet

3 Good-luck mallet (splashed pattern)

4 Collection of treasures

5 Collection of treasures

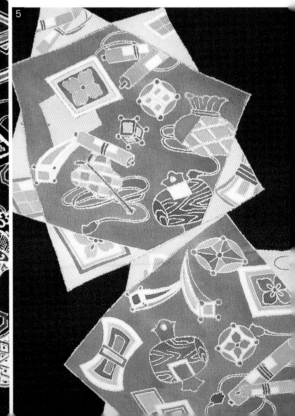

108

GEOMETRIC PATTERNS

In geometric patterns, points, lines, and shapes are combined with varying degrees of complexity. Historically, the development of geometric figures progressed in three main stages.

The first stage comprised the centuries before influence from the Asian mainland was felt—that is, the Jomon, Yayoi, and Tumulus periods. Simpler motifs included points, parallel lines, mountain shapes, comb's teeth, and swirls. More intricate renderings involved arcs, flowing water, fan shapes, waves, leaf shapes, rhombuses, and tortoise shell patterns.

Increasingly complicated ideas came into being in the next stage—comprising the Asuka, Nara, and Heian periods—when Chinese motifs mixed with native Japanese styles. Patterns developed at this time were wickerwork, *tatewaku*, lightning, well cover, checks, overlapping circles, and hemp leaf, among others.

The third stage, comprising the Kamakura and later periods, saw the burgeoning of zigzags, pin-wheel, drawer handle, and various other unusual patterns. These tended to reflect influences from the Asian mainland, and Buddhism in particular. During the Edo period the patterns often became Japanized. The arrival of Western culture in relatively recent times has also had an influence on geometric patterns.

STRIPES

Stripes may be either vertical or horizontal, and a large number of variations exists, some examples being *mansuji* (a two-colored vertical-striped pattern in which the two colors of thread alternate in pairs of two threads each), *sensuji* (similar to *mansuji* but with an alternation of two), wide-striped, *daimyo*-striped (a fine vertical pattern), waterfall-striped (a vertical pattern in which there is a slow gradation from thick to very thin stripes), *komochi*-striped (a pattern of alternating wide and fine stripes), triple-striped, *mekura*-striped (stripes made with dark blue thread), and random-striped patterns. Stripes were used widely among the nobility of the Nara period.

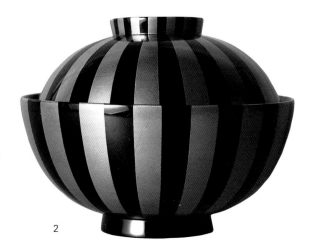

2

1

3

1 Stripes (tobacco pouch)

2 Stripes (lidded lacquer bowl)

3 Stripes (lidded rice bowl)

4 Yoshiwara stripes

5 Saint Thome stripes (pattern originally from Saint Thome, India)

6 Random stripes

7 Stripes

8 Stripes

9 Stripes

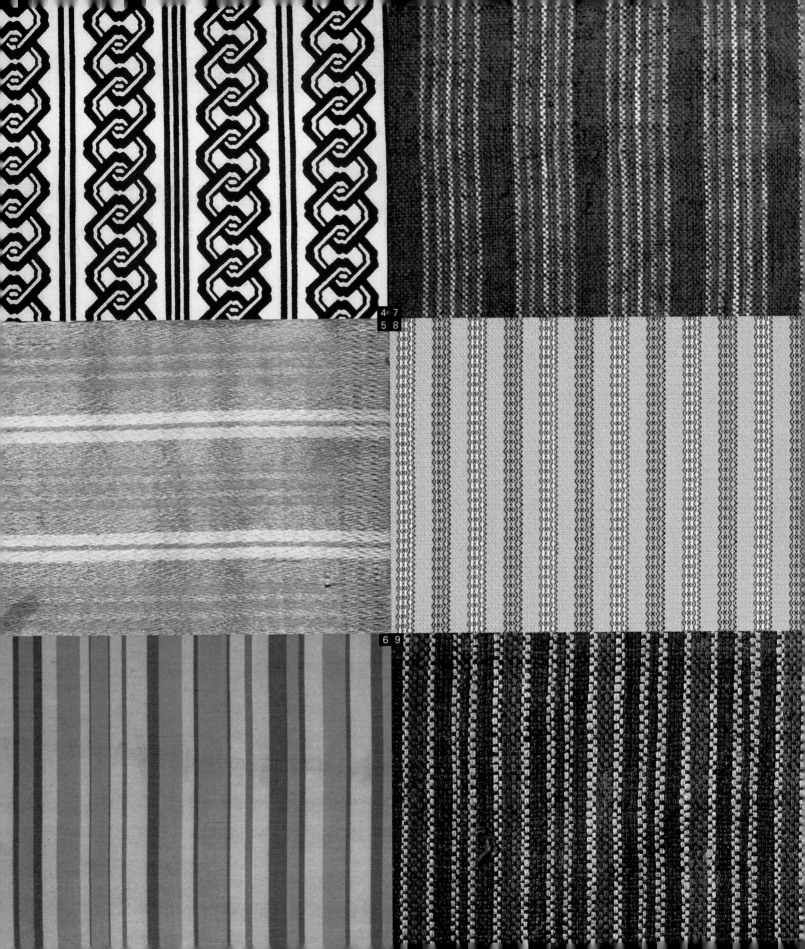

4 7
5 8

6 9

PLAID

There are numerous possibilities for plaid patterns, the result of differences in the number, spacing, and width of the horizontal and vertical stripes. Color combinations increase the variety still more. A strong impression is created when figures are drawn within the open spaces of the plaid. Many plaid patterns appear on the doors of old houses, as well as on fabrics.

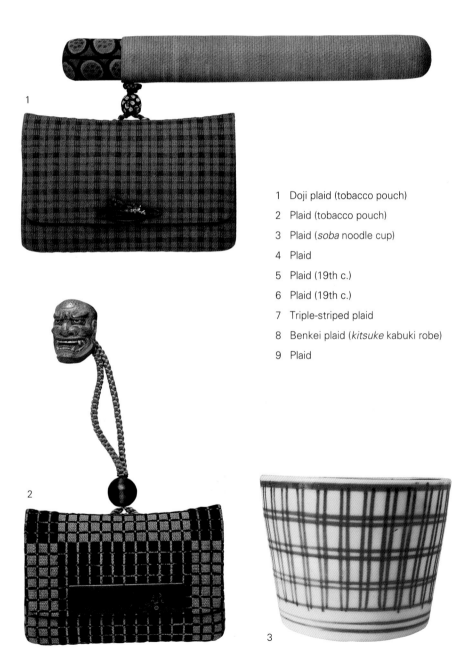

1 Doji plaid (tobacco pouch)

2 Plaid (tobacco pouch)

3 Plaid (*soba* noodle cup)

4 Plaid

5 Plaid (19th c.)

6 Plaid (19th c.)

7 Triple-striped plaid

8 Benkei plaid (*kitsuke* kabuki robe)

9 Plaid

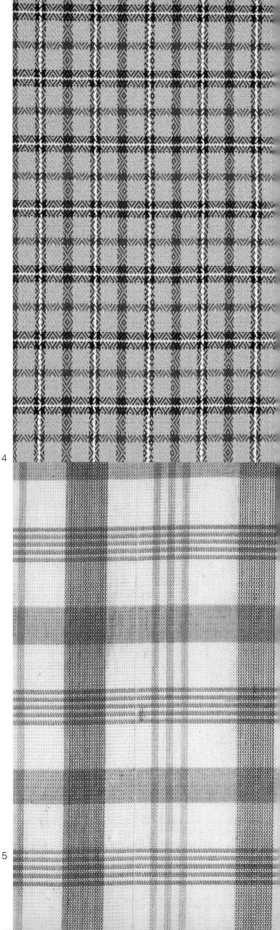

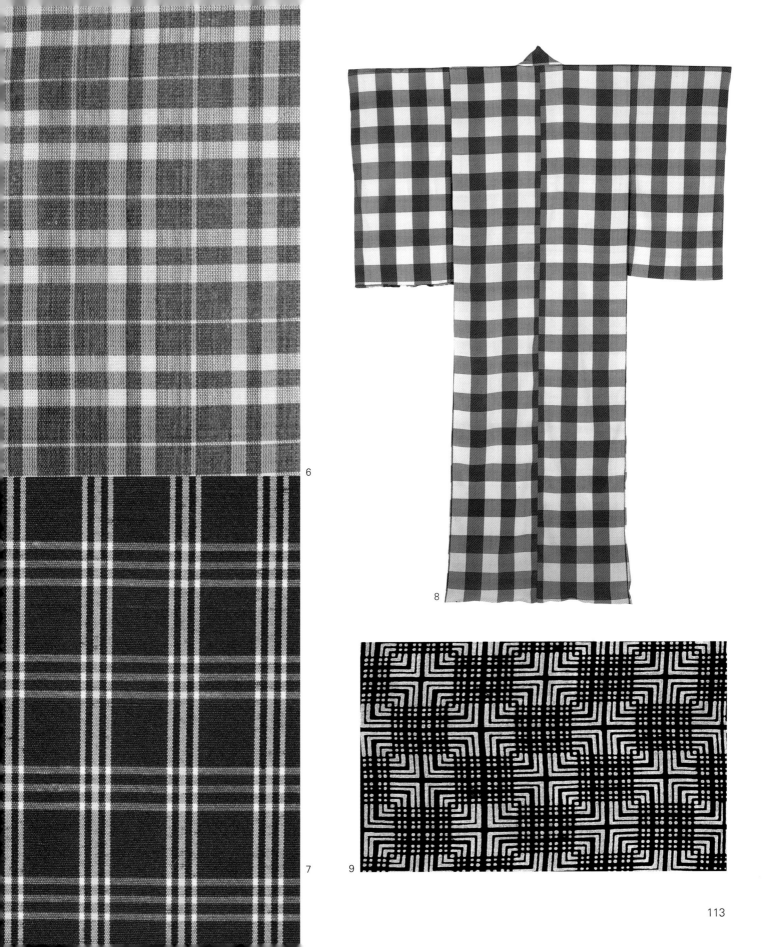

6

7

8

9

CHECKS

Check are called *ichimatsu* in Japanese, a term named after Sanogawa Ichimatsu, an Edo-period Kabuki actor who wore checked costumes. The pattern is also called *ishidatami*, or "paving stones." Because the pattern is used for the paving stones on the grounds of Shinto shrines, the families of shrine priests use various checks as their family crests.

This pattern, which makes a strong impression in black and white, was once very popular.

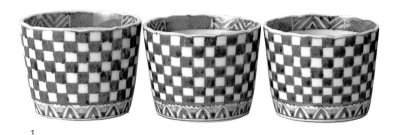

1

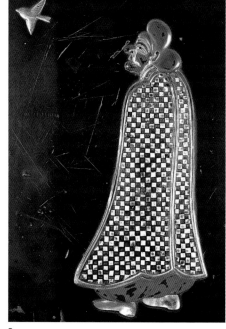

3

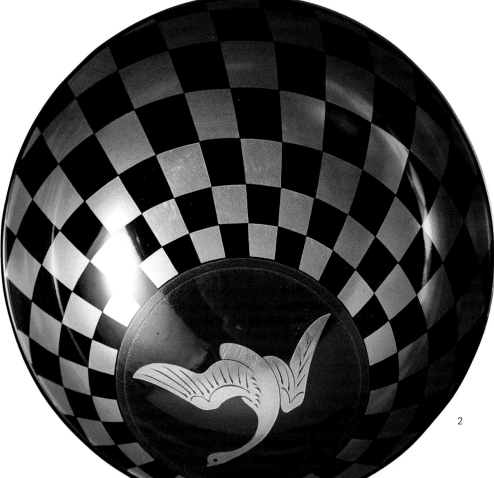

2

1 Checks (*soba* noodle bowls)

2 Checks and crane (*makie* bowl)

3 Checked gown worn by early European visitor (inlaid mother-of-pearl)

4 Checks

5 Checks and die

6 Checks

7 Checks (smoking equipment tray)

8 Checks (*kosode* short-sleeved kimono)

4

5

6

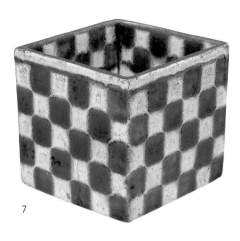

7

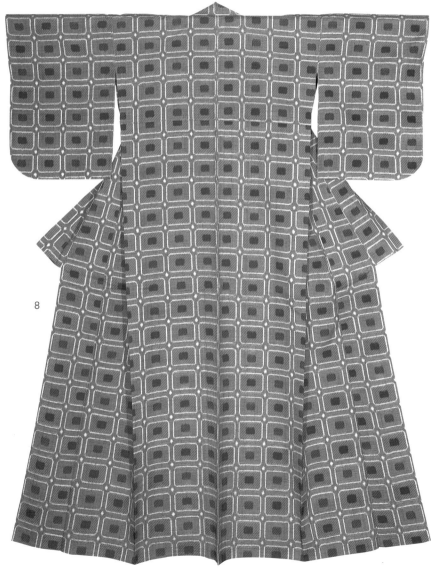

8

OVERLAPPING CIRCLES

The overlapping circles pattern appeared as early as the eighth century, in the Shosoin, a building that is part of Todai-ji temple, in Nara.

The pattern is called *shippo* in Japanese, since it appears so often on cloisonné, or *shippo-yaki*. *Shippo* also means "seven treasures," which in ancient Asia referred to gold, silver, lapis lazuli, agate, pearl, coral, and crystal.

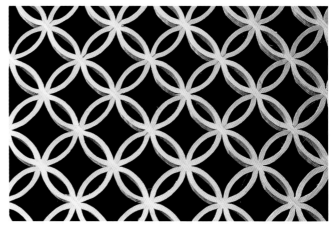

3

1

1 Overlapping circles (sandals)

2 Overlapping circles (bowl)

3 Overlapping circles

4 Overlapping circles (tray)

5 Overlapping circles

6 Overlapping circles

7 Overlapping circles

8 Overlapping circles (bowl)

9 Overlapping circles (*hibachi* hand warmer)

10 Overlapping circles (lidded tea bowl and saucer)

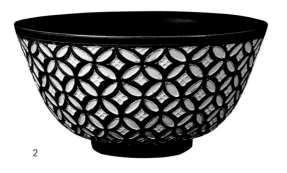

2

4

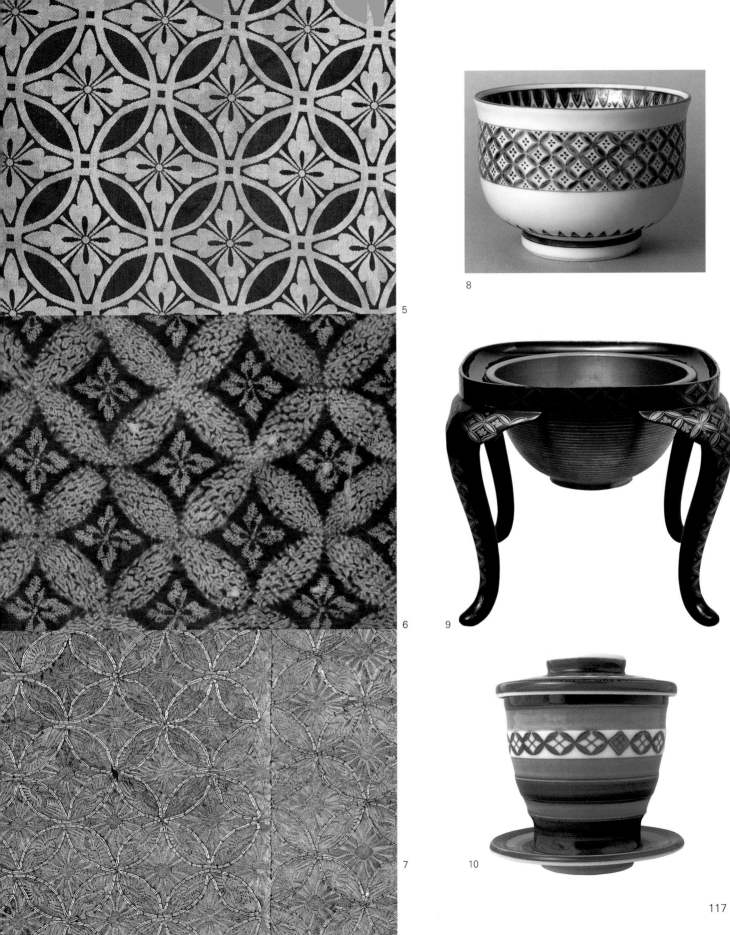

5

6

7

8

9

10

TATEWAKU

The *tatewaku* pattern is one of "stripes" with alternating symmetrical distensions and depressions. The pattern is an old one, seen on pieces of cloth in the Shosoin. Flowers, clouds, and other figures may be drawn in the distended portions, resulting in patterns with such names as cloud *tatewaku*, wisteria *tatewaku*, bamboo-grass *tatewaku*, cherry-blossom *tatewaku*, wave *tatewaku*, and arabesque *tatewaku*.

1 *Tatewaku* with rounded clouds (detail of kabuki robe)

2 *Tatewaku* with flowers

3 *Tatewaku* with rounded waves (detail of kabuki robe)

4 *Tatewaku* with rounded clouds (detail of kabuki robe)

5 *Tatewaku*

6 *Tatewaku* with flowers (*inro* medicine container; *tatewaku* pattern is seen at the bottom)

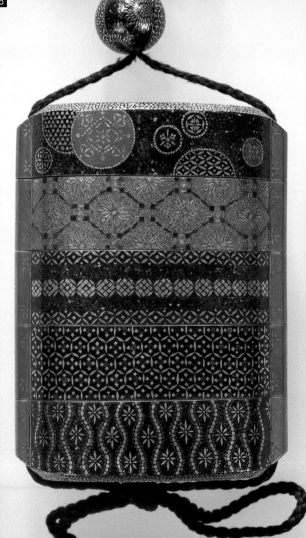

RHOMBUS

The word in Japanese for the rhombus pattern, *hishi*, actually refers to the water chestnut plant, as the pattern is based on the forms of this plant's diamond-shaped leaves and fruit. The pattern is very old, having been found on cloth fragments from the Shosoin. Variations include *takeda*, or the divided-rhombus pattern, in which the rhombus is divided into four parts; flower-rhombuses, *karabana* inside rhombuses; and pine-bark rhombuses, in which two small rhombuses are overlapped and inserted into all four angles of a larger rhombus, giving a jagged effect.

4

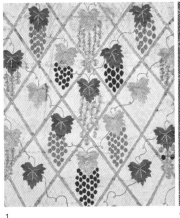

1

2

1 Rhombuses with grapes (detail of kabuki robe)

2 Deer in rhombuses

3 Rhombus-shaped plate

4 Divided rhombus (detail of *noren* shop curtain)

5 Divided rhombus (lacquer bowl)

6 Rhombus (head of pipe)

3

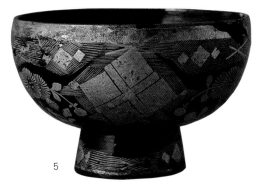

5

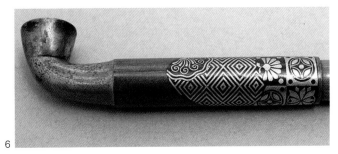

6

TRIANGLE

Uroko, the Japanese word for this pattern, literally means "fish scale," but the pattern is actually made up of closely packed triangles, perhaps a stylization of dragon or sea serpent scales.

There is a story about the origin of the three-triangle Hojo family crest. Hojo Tokimasa, a high official in the Kamakura shogunate, prayed that one day he would be able to subdue the whole of Japan. A sea serpent eventually appeared on the surface of the sea, turned into a beautiful woman, and told Tokimasa that his request would be granted. When the woman departed, she left three scales behind. The crest of the temple at which Tokimasa prayed—Benten, in Enoshima (in present-day Kanagawa Prefecture)—is formed by two facing triangles touching only at one of their vertices.

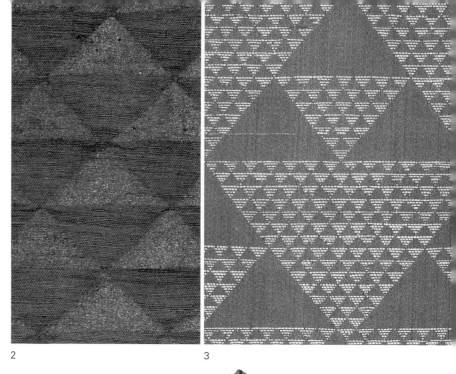

2

3

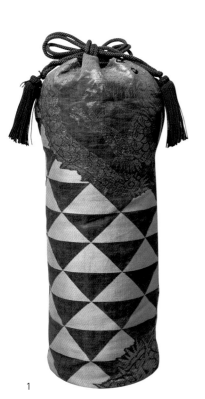

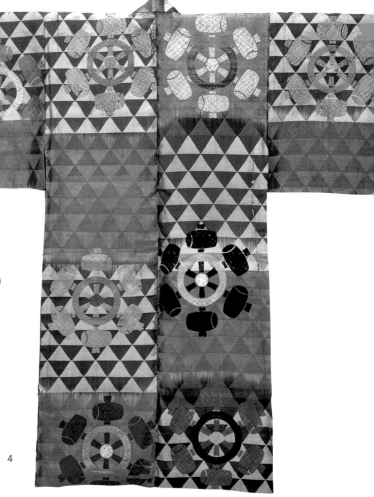

1 Triangles and dragons (hand-drum bag)

2 Triangles

3 Triangles

4 Triangles and mallets (*atsuita* No robe, 17th–19th c.)

1

4

TORTOISE SHELL

Without exception, tortoise shell patterns employ the nearly hexagonal shape of the tortoise shell itself. The patterns are usually made up of perfectly symmetrical hexagons, sometimes with small hexagons inside them, in which case the design is referred to as a double tortoise shell pattern. Combinations with flowers, rhombuses, cranes, and other figures exist. A special design is the Bishamon tortoise shell pattern, which includes, in addition to tortoise shell figures, representations of the armor of Bishamonten, the god of good fortune.

3

1 Tortoise shell pattern with *tatewaku*

2 Tortoise shell pattern with flower-rhombuses

3 Tortoise shell pattern and plum blossoms (saké cup basin)

4 Tortoise shell pattern, overlapping circles, and joined broken crosses (saké bottle)

1

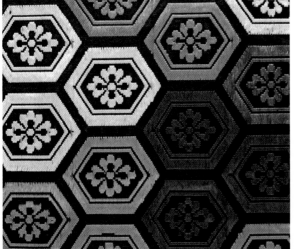
2

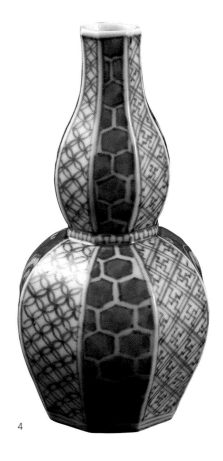
4

HEMP LEAF

The hemp-leaf (*asa*) pattern is made up of regular hexagons that resemble the leaves of the hemp plant. A connected sequence of these shapes makes up a joined-hemp-leaves pattern. (In early times, because hemp was an important source of cloth, hemp leaves themselves formed the basis of a variety of hemp patterns.)

The god of hemp is revered at Oasahiko Shrine in Tokushima. Known as Oasahiko-no-Mikoto, this god is said to have cultivated hemp and made it into clothing, thus creating the basis for what would become a vital industry. Hemp is still used for women's *obi* sashes and clothes for newborn babies.

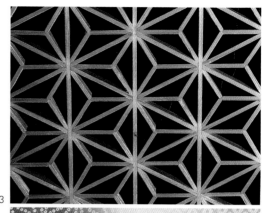

3

1 Hemp leaf and dappled patterns
2 Hemp leaf pattern (smoking equipment tray)
3 Hemp leaf pattern
4 Detail of 1
5 Toy figure and hemp leaf pattern

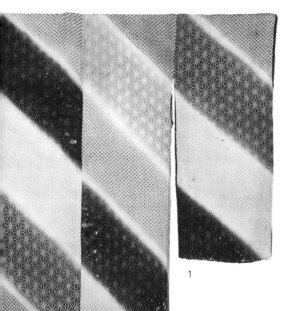

1

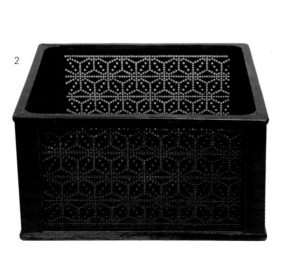

2

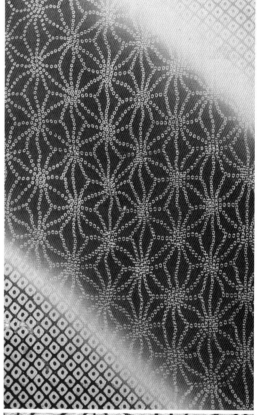

4

5

OTHER MISCELLANEOUS PATTERNS

This category comprises patterns that do not easily fit into any of the other groupings. Some so-called patterns are actually specific styles (the Japanese term for "category" translates as "style patterns"), such as the splashed pattern. Other patterns are disparate in appearance but possess a common theme. An example of the latter is the good-fortune pattern, which covers various combinations of animals and plants considered auspicious —the "three friends of winter" (pine-bamboo-plum), crane-and-turtle, and peony-and-lion patterns, to name a few. Similarly, the Genji figures —clouds, carts, and other items seen in the traditional illustrations to *The Tale of Genji* —are considered providential, and have such constant elements that they can be called a pattern.

AUSPICIOUS PATTERNS

The auspicious pattern classification is a general grouping of many items considered to bring happiness, including the so-called "three friends of winter" (pine-bamboo-plum), dragon-and-tiger, and orchid-chrysanthemum-peony patterns. Also included are patterns based on certain Chinese characters, such as those for "joy," "longevity," and "mountain."

1 Pine-bamboo-plum (plate)

2 Pine-bamboo-plum (plate)

3 Pine-and-bamboo and cranes-and-turtles (fan, 18th c.)

4 Pine-bamboo-plum and cranes-and-turtles (comb and hairpin)

5 Dragons and auspicious clouds

6 Treasure ship, fat sparrows, bamboo, cranes-and-turtles, waves-and-rabbits (*tsutsugaki*-dyed cloth)

7 Crane-and-turtle

8 Cranes-and-pine tree

9 Collection of treasures, cranes, and pine-and-bamboo

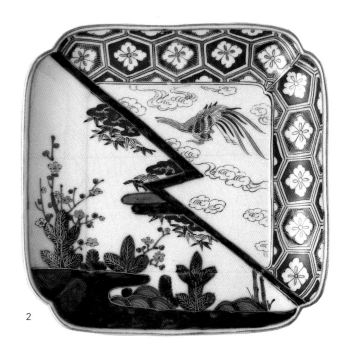

2

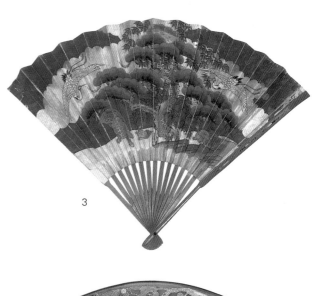

3

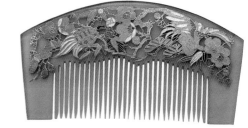

4

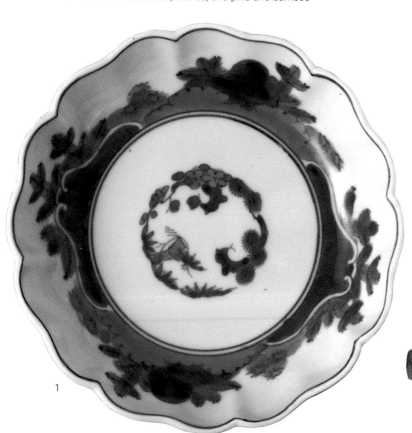

1

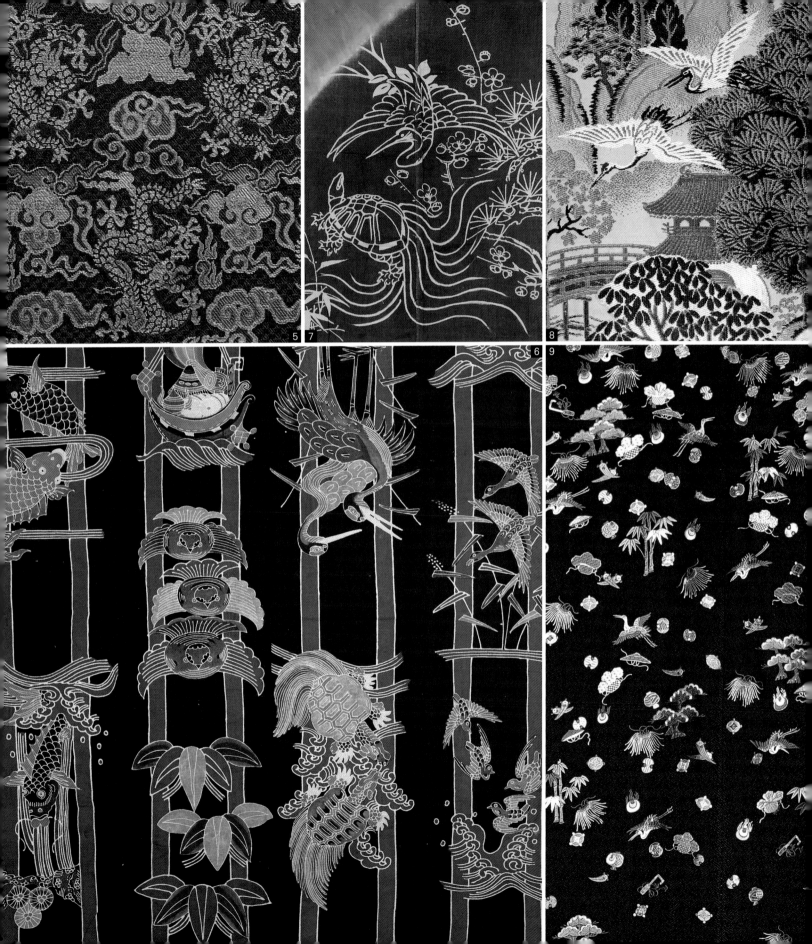

HUMAN FORM

The inclusion of human beings in a pattern often produces a dynamic, eye-catching effect. Humans may figure in a story or may just be part of the scenery. On pieces of cloth at the Shosoin, in Nara, naked human figures, riders on horseback, hunters, and flying wizards are portrayed. Chinese people are depicted on Old Imari ware.

1 Woman (vase)

2 Man and children under maple leaves (lidded jar)

3 Woman and two men (battledore)

4 Children and dog (jug)

5 European (vase)

6 Woman (vase)

7 Three men under cherry blossoms (bowl)

8 European (bowl)

9 Flower viewing (*makie*)

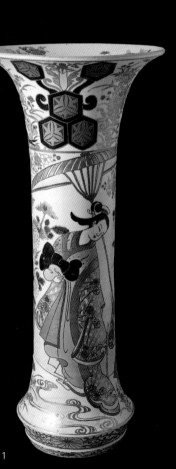

1

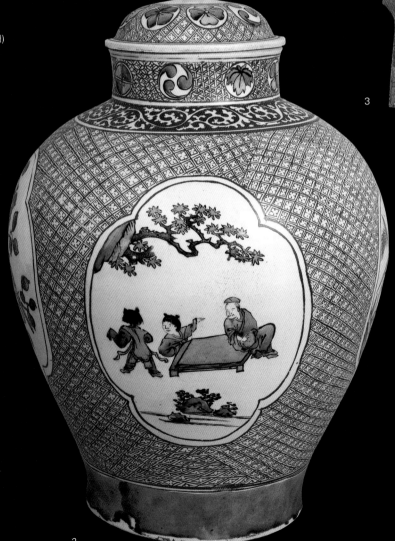

2

3

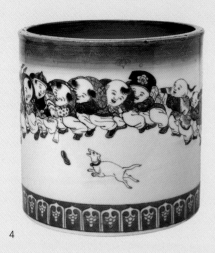

4

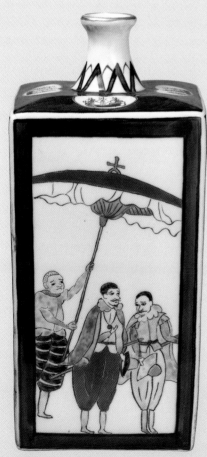

5

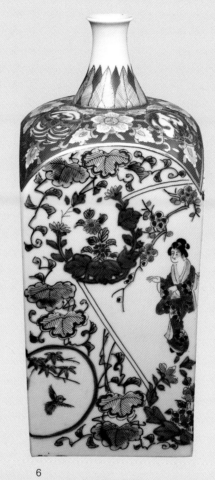

6

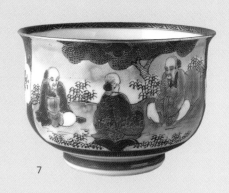

7

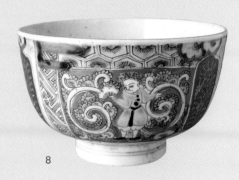

8

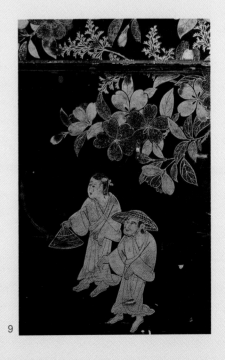

9

FINE PATTERNS

The term "fine pattern" (*komon*) does not refer to a specific pattern or shape, but to detailed patterns of various sorts that are made by a textile-printing method. Thus, many of the designs that are patterns in their own right—for example, overlapping-ellipses, hail, rhombus, net, woven-bamboo, chrysanthemum, bamboo-grass, cane, willow, plover, and tortoise shell patterns—may be made into fine patterns as well.

Fine patterns were popular during the Edo period and are therefore often called Edo *komon*. They were used in the early part of the period on *kamishimo* ceremonial garments but later came into more widespread use, especially as an undergarment when a plain robe without a family crest was worn over it.

1	Cherry blossoms	5	Chrysanthemums
2	Chrysanthemums on water	6	Triangles
3	Mortar grain	7	Fine pattern
4	Motif of red and white plum blossoms		

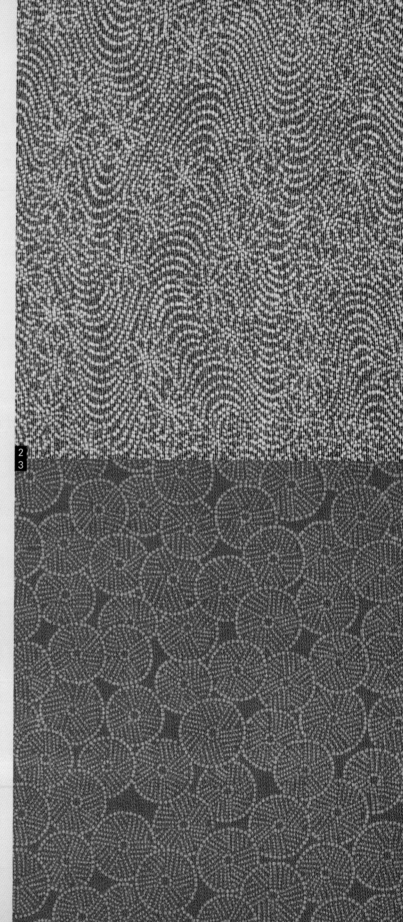

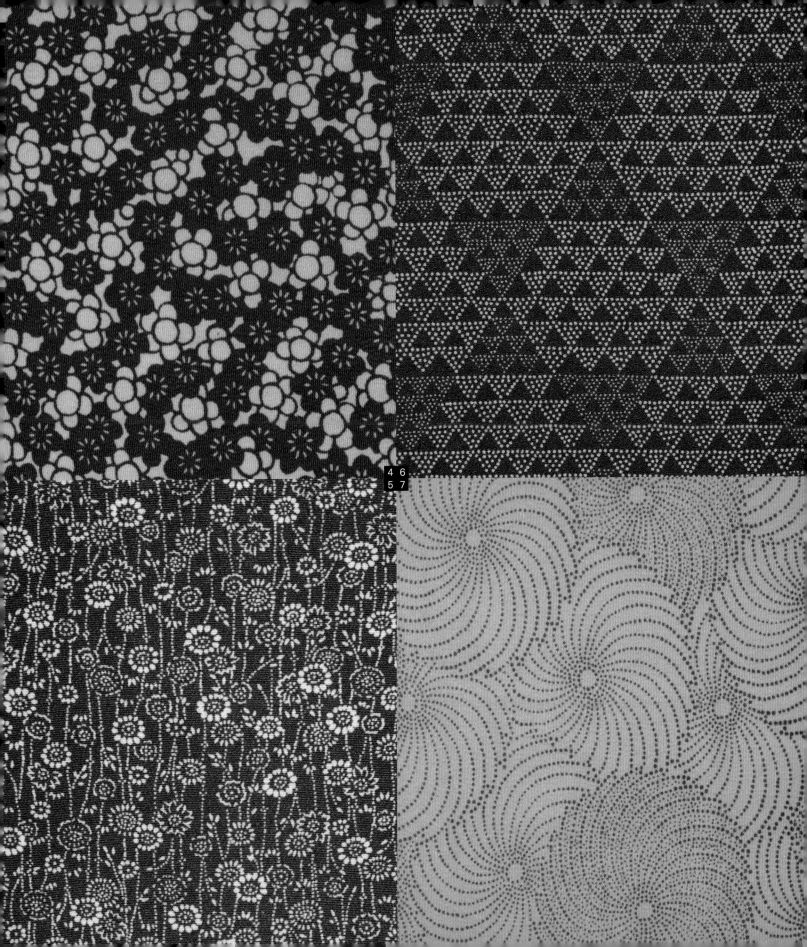

KABUKI

Kabuki patterns are those related in one way or another to Kabuki theater. Some of these patterns were developed and used by only one member of a hereditary Kabuki "family" of actors, such as the Ichikawa Danjuro family. In other cases, an entire troupe of actors such as the Omodaka-ya or Yamato-ya, would outfit themselves in these patterns. Many Kabuki patterns are visual-riddle patterns.

1 Scattered crests

2 Kikugoro plaid (Syllable *ki* [き] + nine [*ku*] stripes + five [*go*] stripes + the character *ro* [呂])

3 Ichikawa Sadanji (family) pattern

4 Narikoma-ya pattern

5 Ichimura plaid (one [*ichi*] stripe + six [*mu*] stripes + the syllable *ra* [ら])

6 Yamato-ya pattern (contains three stylized 大 [the first character in the word "Yamato"])

7 Ichikawa Danjuro pattern

8 Harima-ya pattern

9 Nakamura plaid (character *naka* [中] + six [*mu*] stripes + the syllable *ra* [ら])

10 Omodaka-ya pattern (Omodaka means "arrowhead plant," which can be seen in the pattern)

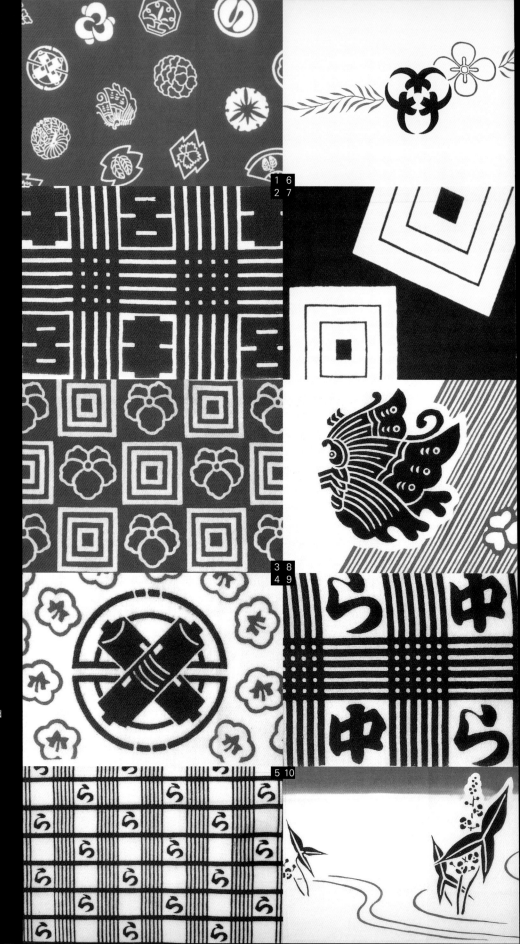

WHORL

The whorl (*tomoe*) pattern is very popular. Although the pattern is representative of eddies and water in general, the appearance of the pattern on Shinto shrine buildings and implements indicates that it signifies mainly the spirits of the gods. The pattern appears as the repetition of a single curved figure (as in the center of the large oval or as a combination of several whorls).

3

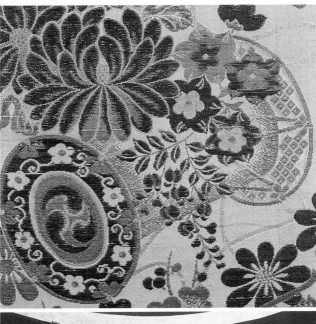

1

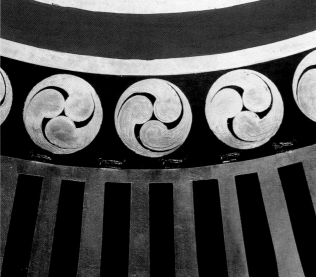

2

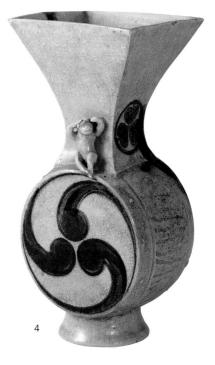

1 Whorl (pattern is seen on the drum)

2 Whorls

3 Whorl (*noren* shop curtain)

4 Whorls (vase, 17th c.)

5 Whorls (*makie* cosmetic box)

4

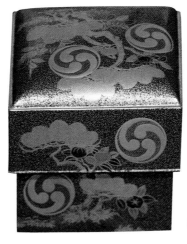

5

SPLASHED PATTERN

The splashed pattern is one of somewhat irregularly alternating dyed and undyed portions; the ground may be dyed, usually deep blue, with undyed "splashes" of white as the pattern or the ground may be white with a dyed pattern. The pattern may be woven in or printed. Naturally, a great variety of splashed patterns exists.

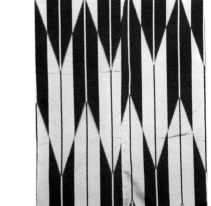

1 Hail and mosquitoes

2 Splashed pattern

3 Hail

4 Splashed pattern

5 Rice grains

6 Splashed pattern (*kosode* short-sleeved kimono)

7 Splashed pattern

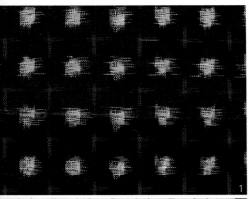

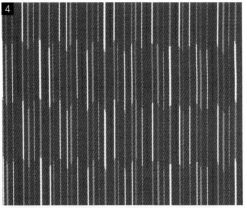

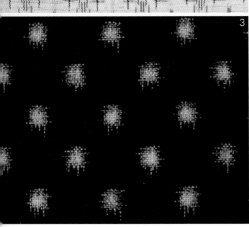

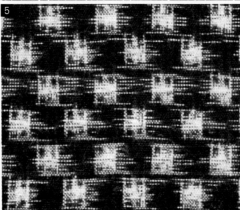

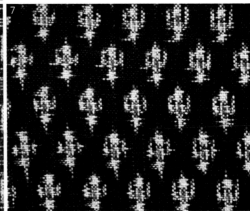

FAMILY CRESTS

A huge array of objects has been depicted in stylized form on family crests: animals and plants, natural phenomena, and such manmade objects as toys or even love letters. Family crests can be divided into eight broad categories:

PLANTS

- bamboo
- cherry blossoms
- ginkgos
- morning glories

ANIMALS

- lions ■ dragons
- bats ■ crabs
- lobsters ■ butterflies
- phoenixes

NATURAL PHENOMENA

- mountains ■ clouds
- sun ■ moon
- mist ■ flowing water

IMPLEMENTS

- Buddhist wheels
- fishing nets
- folding fans
- hand-drums ■ helmets

STRUCTURES

- *torii* shrine gates
- shrine gates
- five-stone stupas
- hermitages
- fences

TRADITIONAL PATTERNS

- tilted lightning
- Genji rings
- treasure loops

CHARACTERS AND MARKS

- Chinese characters
- Cross (Christian)
- Divination marks

PLANTS

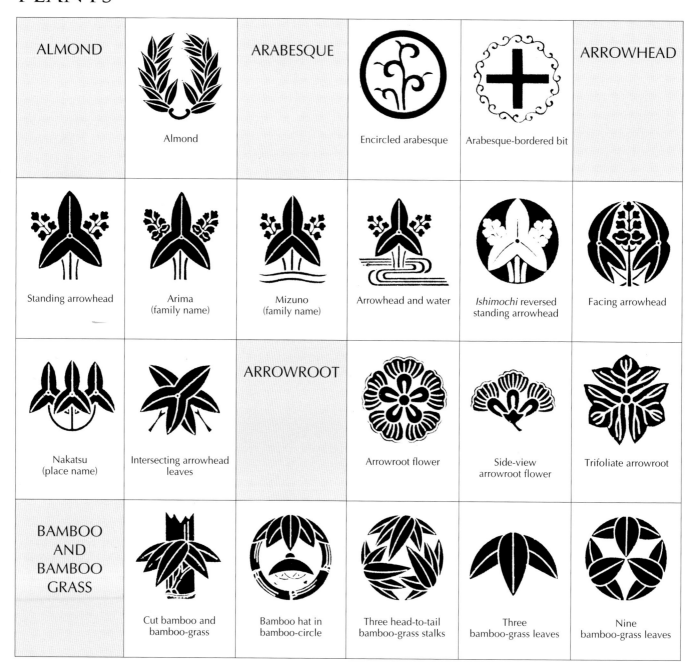

ALMOND	Almond	ARABESQUE	Encircled arabesque	Arabesque-bordered bit	ARROWHEAD
Standing arrowhead	Arima (family name)	Mizuno (family name)	Arrowhead and water	*Ishimochi* reversed standing arrowhead	Facing arrowhead
Nakatsu (place name)	Intersecting arrowhead leaves	ARROWROOT	Arrowroot flower	Side-view arrowroot flower	Trifoliate arrowroot
BAMBOO AND BAMBOO GRASS	Cut bamboo and bamboo-grass	Bamboo hat in bamboo-circle	Three head-to-tail bamboo-grass stalks	Three bamboo-grass leaves	Nine bamboo-grass leaves

			BOTTLE GOURD FLOWER		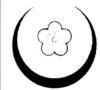
Encircled bamboo *(nezasa)*	Encircled bamboo *(shinozasa)*	Sendai (place name)		Bottle gourd flower	Small shadowed bottle gourd flower in moon-ring
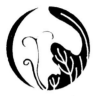	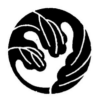	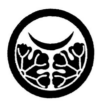		**BOTTLE GOURD**	
Bottle gourd flower and moon	Bottle gourd leaf-circle	Encircled bisected bottle gourd leaf and moon	Bottle gourd leaves and Genji wheel		Encircled bottle gourd
				BRACKEN	
Two bottle gourds	Encircled pile of bottle gourds	Three facing bottle gourds	Five bottle gourds		Facing bracken
				BRUSHWOOD	
Facing bundled braken	Bracken wheel	Bracken wheel	Three *ishimochi* reversed bracken fronds		Snow-covered bundled brushwood encircled
BURNET	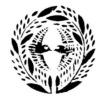	**BUSH CLOVER**	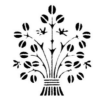	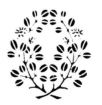	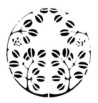
	Burnet and facing sparrows		Bundled bush clover	Facing bush clover	Facing bush clover

	CAMELLIA	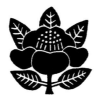	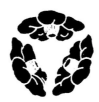	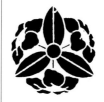	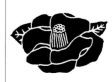
Bush clover-circle		Suitengu camellia	Three camellias	Three-camellia wheel	Camellia with leaves
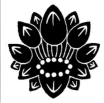	CHERRY BLOSSOM	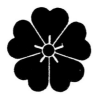	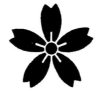	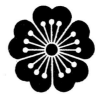	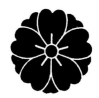
Double-blossomed camellia		Wild-cherry blossom	Fine wild-cherry blossom	Hosokawa (family name)	Double cherry blossom
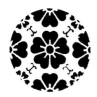		CHESTNUT			CHINESE BELLFLOWER
Fusenryo cherry blossom	Cherry blossom and water		Chestnut	Chestnut	
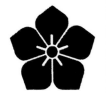	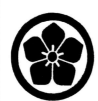	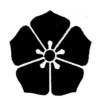	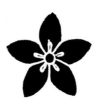	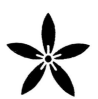	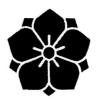
Chinese bellflower	Encircled Chinese bellflower	Toki (family name)	Ota (family name)	Fine Chinese bellflower	Double-blossomed Chinese bellflower
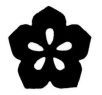	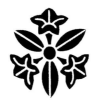	CHRYSANTHE-MUM	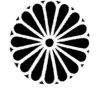		
Korin Chinese bellflower	Trifoliate Chinese bellflower		Imperial Crest	Sixteen-petaled chrysanthemum	Bottom-view sixteen-petaled chrysanthemum

Eight-petaled
chrysanthemum

Ten-petaled
chrysanthemum

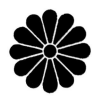

Twelve-petaled
chrysanthemum

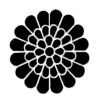

Double-blossomed
chrysanthemum

Korin chrysanthemum

Bisected
chrysanthemum

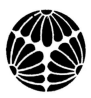

Trisected
chrysanthemum

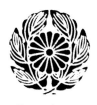

Chrysanthemum
between facing leaves

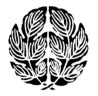

Facing chrysanthemum
leaves

Chrysanthemum and
water

CLEMATIS

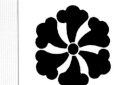

Clematis flower

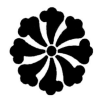

Eight-petaled clematis

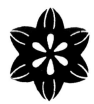

Clematis flower

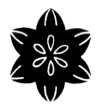

Clematis flower

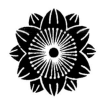

Double-blossomed
top-view clematis
flower

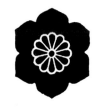

Chrysanthemum-shaped
clematis flower

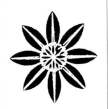

Eight-petaled clematis

CLOVE

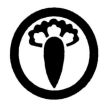

Encircled cloves

Encircled intersecting
cloves

Encircled
light-and-shadowed
intersecting cloves

Pair of cloves encircled

Eight cloves

Single
counterclockwise
clove whorl

COMMON
REED

Common reed

DAIKON
(GIANT RADISH)

Head-on daikon

Daikon-circle

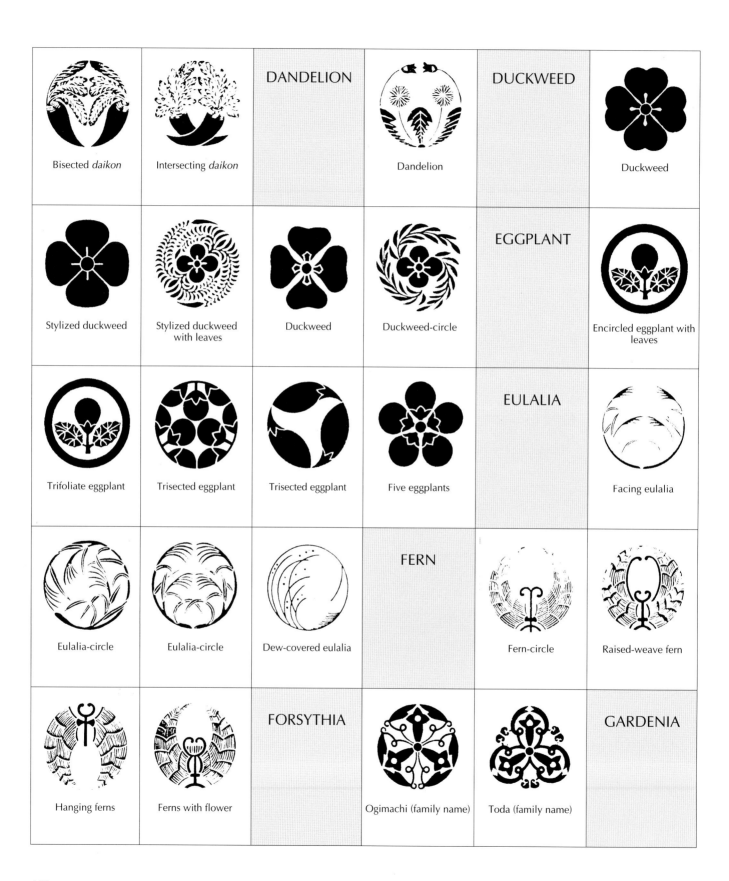

Bisected *daikon*	Intersecting *daikon*	DANDELION	Dandelion	DUCKWEED	Duckweed
Stylized duckweed	Stylized duckweed with leaves	Duckweed	Duckweed-circle	EGGPLANT	Encircled eggplant with leaves
Trifoliate eggplant	Trisected eggplant	Trisected eggplant	Five eggplants	EULALIA	Facing eulalia
Eulalia-circle	Eulalia-circle	Dew-covered eulalia	FERN	Fern-circle	Raised-weave fern
Hanging ferns	Ferns with flower	FORSYTHIA	Ogimachi (family name)	Toda (family name)	GARDENIA

			GENTIAN		
Gardenia	Trisected gardenias	Three side-view gardenias		Gentian-wheel	Kuga (family name)
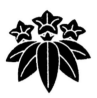	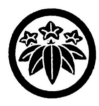	GINKGO	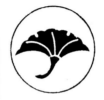	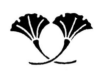	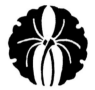
Bamboo grass-shaped gentian	Encircled bamboo grass-shaped gentian		Single ginkgo leaf encircled	Intersecting ginkgo leaves	Intersecting ginkgo leaves
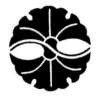	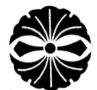	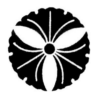		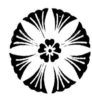	GOURDS AND MELONS
Facing ginkgo leaves	Two swords and ginkgo leaves	Three ginkgo leaves	Three ginkgo leaves shadowed	Asukai (family name)	
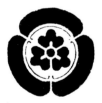	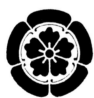	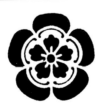	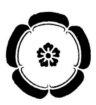	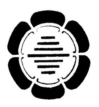	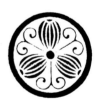
Three gourds and *karabana*	Five gourds and *karabana*	Oda (family name)	Oda (family name)	Sagara (family name)	Three melons and tendrils encircled
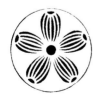	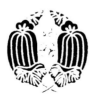	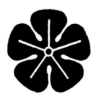	GRAPE	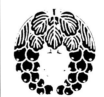	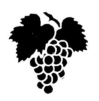
Five melons encircled	Facing gourds	Gourd flower		Hanging grapes	Single bunch of grapes

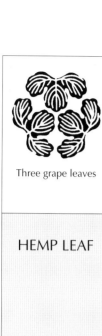 Three grape leaves	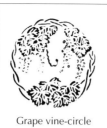 Grape vine-circle	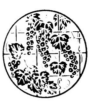 Grape branch-circle	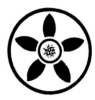 Grapes on trellis encircled	HAGIKUSO	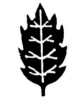 *Hagikuso*
HEMP LEAF	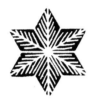 Hemp Leaf	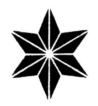 Fine hemp leaf	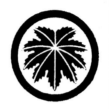 Encircled hemp leaf	HOLLY	Single holly leaf
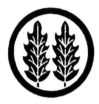 Pair of holly leaves encircled	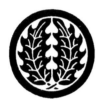 Facing holly leaves encircled	Intersecting holly leaves	Three holly leaves	Ichinohashi (family name)	HOLLYHOCK AND WILD GINGER
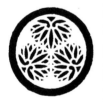 Three hollyhocks encircled	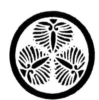 Aizu (place name)	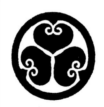 Three bottom-view hollyhocks encircled	Honda (family name)	Wild ginger	Kishu hollyhock
Tokugawa Ieyasu, Hidetada, Iemitsu	HYDRANGEA	Hydrangea	IVY	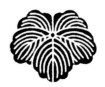 Ivy leaf	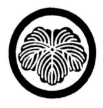 Encircled ivy leaf

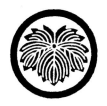	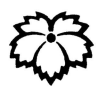			
Encircled pointed ivy leaf	Shadowed pointed ivy leaf	Shadowed Korin leaves	Pile of ivy leaves	Three ivy leaves stem-to-stem

JAPANESE CEDAR

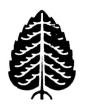	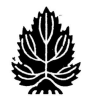	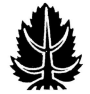	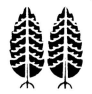	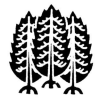
Single Japanese cedar	Honda (family name)	Single Korin Japanese cedar	Pair of Japanese cedars	Three overlapping Japanese cedars

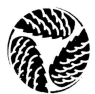

Trisected Japanese cedar

JAPANESE CYPRESS

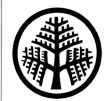

Japanese cypress

JAPANESE GINGER

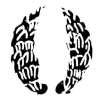	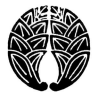	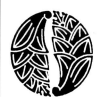
Japanese ginger	Facing cloves of Japanese ginger	Pair of head-to-tail cloves of Japanese ginger

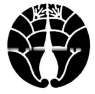	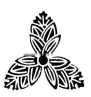			
Facing cloves of Japanese ginger	Three cloves of Japanese ginger	Japanese ginger as flower-wheel		

JAPANESE KNOTWEED

Japanese knotweed	Japanese knotweed

		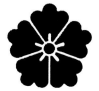	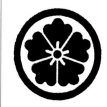	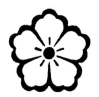
Trisected knotweed	**KARABANA**	*Karabana*	Encircled *karabana*	Shadowed *karabana*

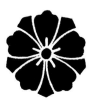

Swords and *karabana*

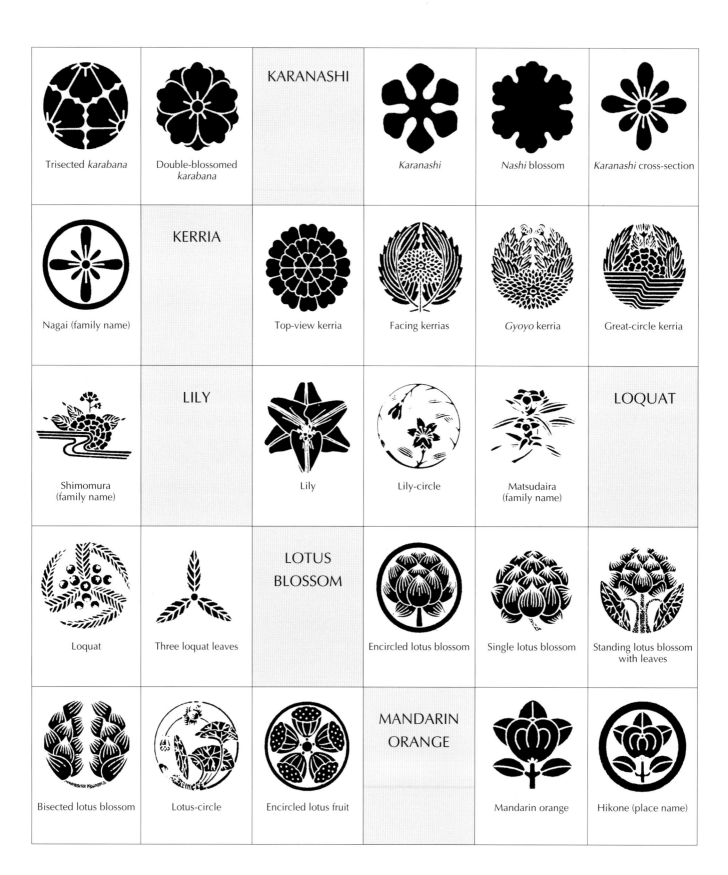

		KARANASHI			
Trisected *karabana*	Double-blossomed *karabana*		*Karanashi*	*Nashi* blossom	*Karanashi* cross-section
Nagai (family name)	KERRIA	Top-view kerria	Facing kerrias	*Gyoyo* kerria	Great-circle kerria
Shimomura (family name)	LILY	Lily	Lily-circle	Matsudaira (family name)	LOQUAT
Loquat	Three loquat leaves	LOTUS BLOSSOM	Encircled lotus blossom	Single lotus blossom	Standing lotus blossom with leaves
Bisected lotus blossom	Lotus-circle	Encircled lotus fruit	MANDARIN ORANGE	Mandarin orange	Hikone (place name)

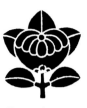	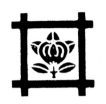	MAPLE LEAF		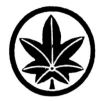	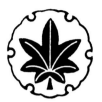
Chrysanthemum-shaped mandarin orange	A crest of the Nichiren sect of Buddhism		Single maple leaf	Encircled maple leaf	Maple leaf in snow-circle
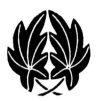	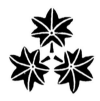	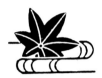	MILLET	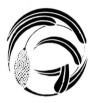	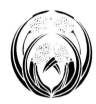
Facing maple leaves	Three maple leaves stem-to-stem	Tatsuta (place name)		Single millet-stalk-circled	Facing millet stalks
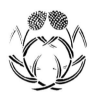			MISTLETOE		
Facing millet stalks	Encircled variation on facing millet stalks	Millet-stalk-circle		Mistletoe	Kumagai (family name)
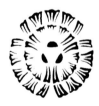	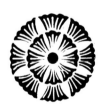	MIZUAOI	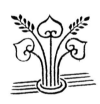	MORNING GLORY	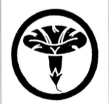
Trisected mistletoe flower	Eight mistletoe flowers		Mizuaoi		Encircled morning glory
		MULBERRY			Facing mulberry leaves
Five morning glories	Morning glory encircled in stem		Standing mulberry leaf	Matsuura (family name)	Facing mulberry leaves

Intersecting mulberry leaves	Three standing mulberry leaves	Suwa (family name)	NAGI	Single *nagi* leaf	Two *nagi* leaves
Encircled facing *nagi*	Two *nagi* leaves encircled	*Nagi* leaves intersecting	NANDIN	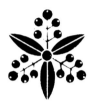Trifoliate nandin	Encircled three-leaved nandin
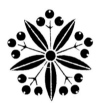Nandin-wheel	Facing nandins	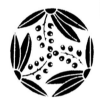Three nandins	NARCISSUS	Facing narcissus	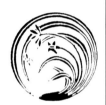Narcissus
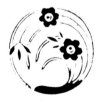Narcissus-circle	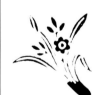Uprooted narcissus	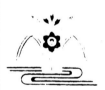Narcissus and water	OAK	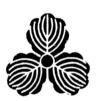Three oak leaves	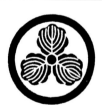Three oak leaves encircled
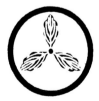Tosa (place name)	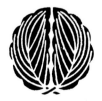Facing oak leaves	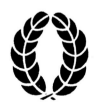Nakagawa (family name)	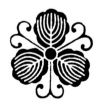Tendrils and oak leaves	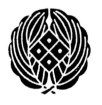Facing oak leaves with four spotted squares	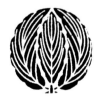Three facing oak leaves

Intersecting oak leaves

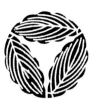

Three head-to-tail oak leaves

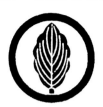

Single oak leaf encircled

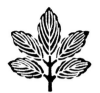

Kushimoto (family name)

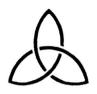

Joined oak leaves

ORCHID

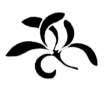

Orchid

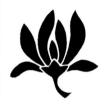

Fallen orchid

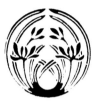

Facing orchids

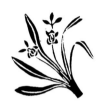

Orchid stem

PALM

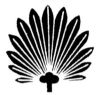

Palm frond

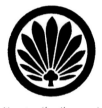

Yonetsu (family name)

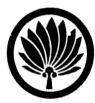

Choko (family name)

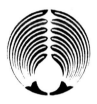

Facing palm fronds

PAULOWNIA

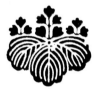

Five-three paulownia

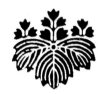

Variation on five-three paulownia

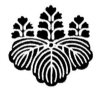

Five-seven paulownia

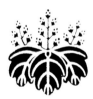

Toyotomi Hideyoshi's crest

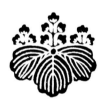

Sengoku (family name)

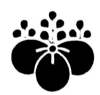

Korin paulownia

Rikyu paulownia

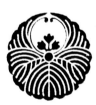

Raised-weave paulownia

Paulownia with hanging flowers

PEACH

Single peach

Encircled peach

Encircled peach with leaves

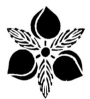

Three peaches and leaves

PEONY

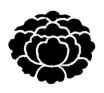

Fallen peony

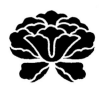

Satsuma (place name)

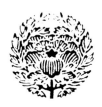

Konoe (family name)

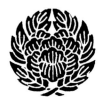

Kamo (family name)

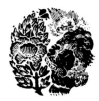

Akita (family name)

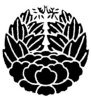

Gyoyo-shaped peony

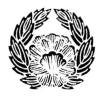

Peony and leaves

PEPPER

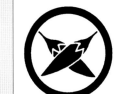

Encircled intersecting cayenne peppers

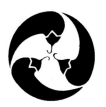

Cayenne pepper whorl

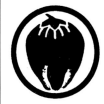

Encircled green pepper

PERSIMMON

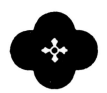

Persimmon flower

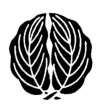

Facing persimmon leaves

PINE

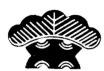

Single pine

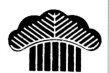

Comb-shaped pine

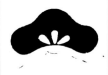

Korin pine

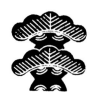

Two-tiered pines

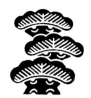

Three-tiered pines

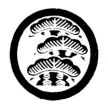

Encircled three-tiered pines

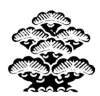

Takasago pine

Facing young pines

Triple-pine-cone whorl

Encircled intersecting pine needles

Three head-to-tail pine needles

PINK

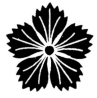

Pink

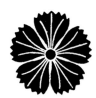

China pink

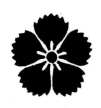			**PLANTAIN (*BANANA*)**	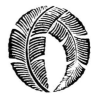	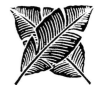
Yamaguchi (family name)	Akizuki (family name)	Piled pinks		Bent plantain leaf	Intersecting plantain leaves
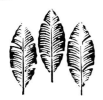	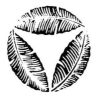	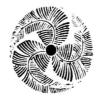	**PLANTAIN (*PLANTAGO*)**		
Three plantain leaves	Three head-to-tail plantain leaves	Three-plantain-leaf whorl		Plantain	Tamura (family name)
	PLUM BLOSSOM	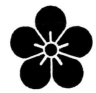	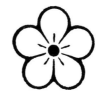	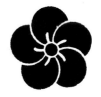	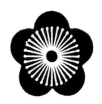
Ichinoseki (place name)		Plum blossom	Shadowed plum blossom	Twisted plum blossom	Top-view plum blossom
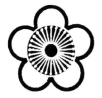	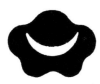	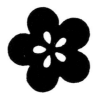	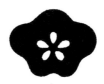	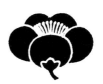	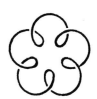
Shadowed top-view plum blossom	Korin plum blossom	Korin top-view plum blossom	Rikyu plum blossom	Side-view plum blossom	Joined-petaled plum blossom
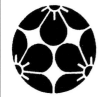	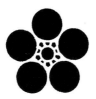			**POMEGRANATE**	
Trisected plum blossom	*Umebach*	Star in *umebachi*	Bottom-view double plum blossom-crest		Pomegranate

		RABBIT-EAR IRIS		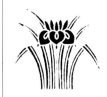	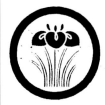
Facing pomegranates	Facing pomegranate flowers		Rabbit-ear iris	Standing rabbit-ear iris	Imajo (family name)
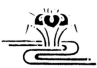	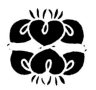		**REED**		
Rabbit-ear iris and water	Two rabbit-ear iris flowers	Nakayama (family name)		Single reed leaf	Intersecting reed leaves
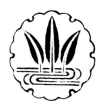	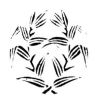	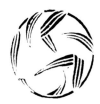	**RICE PLANT**	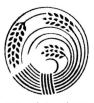	
Reeds and water in snow-circle	Facing reeds	Reed-circle		Wound rice plants	Rice plants wound clockwise
			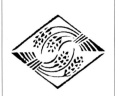	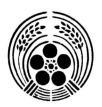	**ROYAL FERN**
Rice plant-circle	Facing bound rice plants	Facing joined rice plants	Facing rice plants in rhombus	*Umebachi* in facing rice plants	
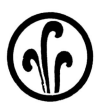	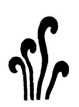		**SAKAKI**		
Three royal ferns encircled	Four royal ferns	Koide (family name)		*Sakaki* and zigzag paper	*Sakaki* and zigzag paper encircled

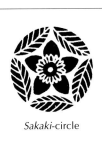		SHEPHERD'S PURSE			
Sakaki-circle	*Sakaki* encircled		Shepherd's purse	Six-pod shepherd's in snow-wheel	Eight-pod shepherd's purse
SPATTERDOCK	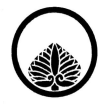	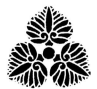	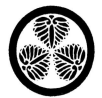	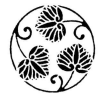	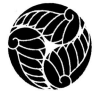
	Single spatterdock leaf encircled	Three spatterdock leaves	Three tip-to-tip spatterdock leaves encircled	Three heat-to-tail spatterdock leaves and tendrils	Trisected spatterdock leaves
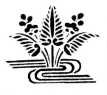	TEA PLANT	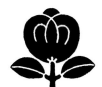	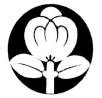		
Spatterdock and water		Tea plant	*Ishimochi* reversed tea plant	Tea plant in snow-wheel	Intersecting tea plant
		TURNIP	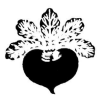	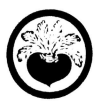	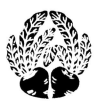
Piled tea plants	Tea-plant branch		Single turnip	Encircled six-leaved turnip	Facing turnips
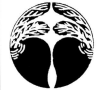	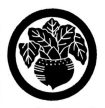	VIOLET	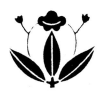	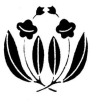	
Bisected turnip	Nao (family name)		Masuyama (family name)	Single violet	Facing violets

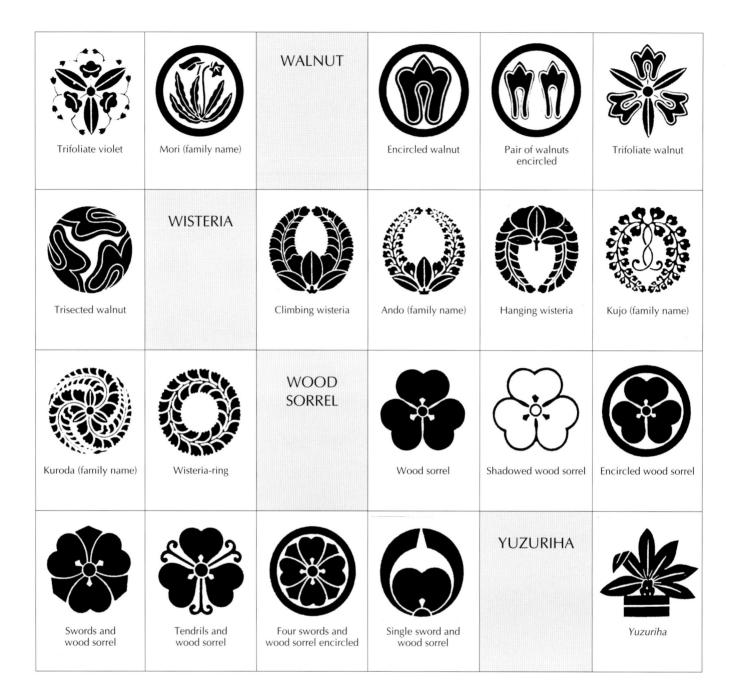

Trifoliate violet	Mori (family name)	WALNUT	Encircled walnut	Pair of walnuts encircled	Trifoliate walnut
Trisected walnut	WISTERIA	Climbing wisteria	Ando (family name)	Hanging wisteria	Kujo (family name)
Kuroda (family name)	Wisteria-ring	WOOD SORREL	Wood sorrel	Shadowed wood sorrel	Encircled wood sorrel
Swords and wood sorrel	Tendrils and wood sorrel	Four swords and wood sorrel encircled	Single sword and wood sorrel	YUZURIHA	*Yuzuriha*

ANIMALS

ANTLER	Facing antlers	Fine antlers	Paulownia between facing antlers	Intersecting facing antlers	Intersecting antlers
AZURE-WINGED MAGPIE	Azure-winged magpies	Azure-winged magpies	BAT	Bat	Bat
BAY SCALLOP	Single bay scallop	Single bay scallop	Encircled bay scallop	Shadowed bay scallop in tortoise shell	Three bay scallops
BUTTERFLY	Spread-winged butterfly	Encircled spread-winged butterfly	Bizen (place name)	Hojo (family name)	Genji butterfly

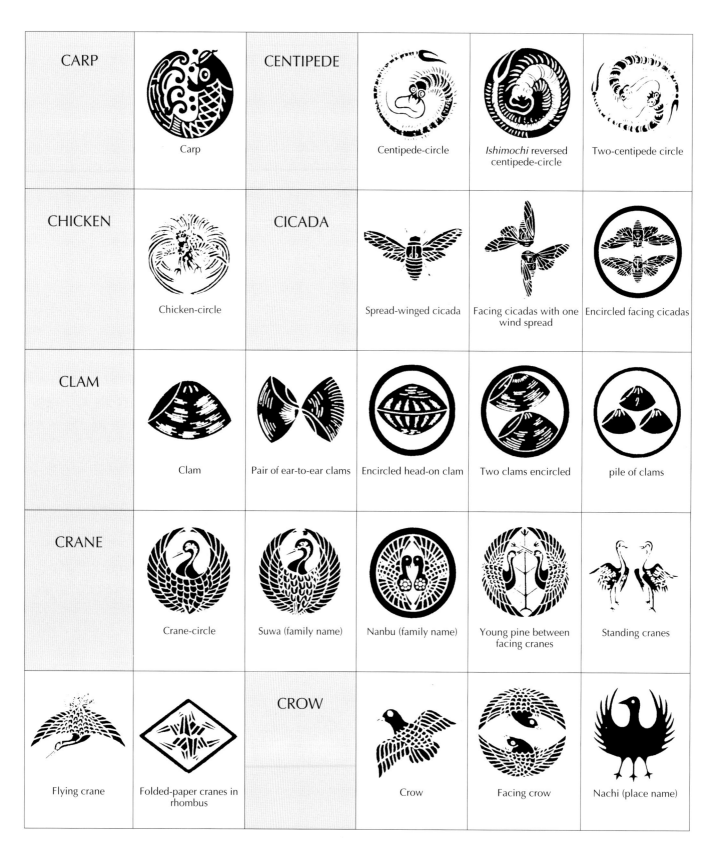

CARP	Carp	**CENTIPEDE**	Centipede-circle	*Ishimochi* reversed centipede-circle	Two-centipede circle
CHICKEN	Chicken-circle	**CICADA**	Spread-winged cicada	Facing cicadas with one wind spread	Encircled facing cicadas
CLAM	Clam	Pair of ear-to-ear clams	Encircled head-on clam	Two clams encircled	pile of clams
CRANE	Crane-circle	Suwa (family name)	Nanbu (family name)	Young pine between facing cranes	Standing cranes
Flying crane	Folded-paper cranes in rhombus	**CROW**	Crow	Facing crow	Nachi (place name)

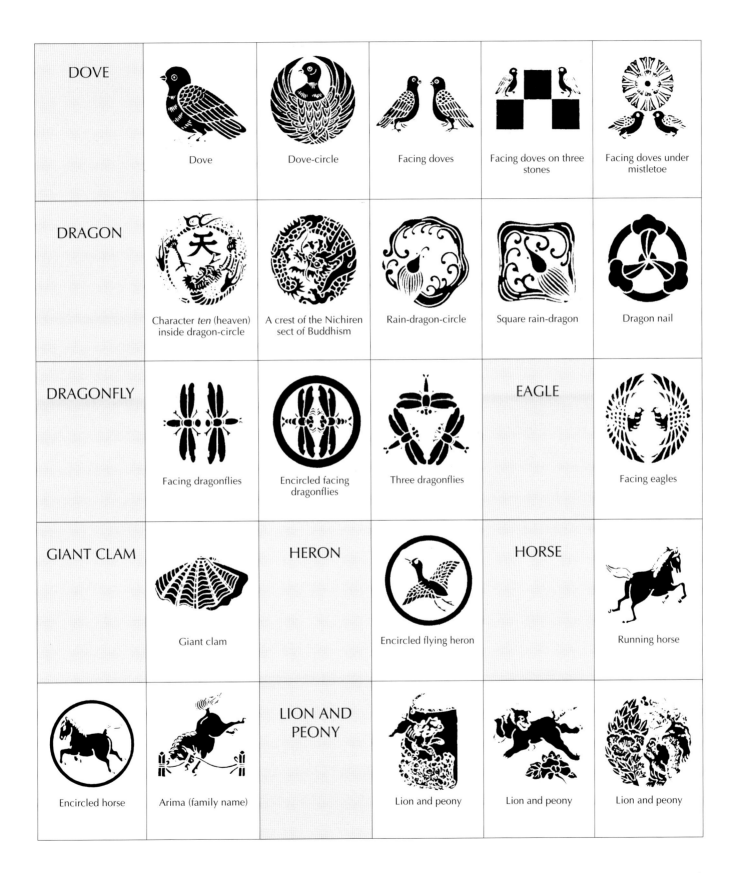

DOVE	Dove	Dove-circle	Facing doves	Facing doves on three stones
DRAGON	Character *ten* (heaven) inside dragon-circle	A crest of the Nichiren sect of Buddhism	Rain-dragon-circle	Square rain-dragon
DRAGONFLY	Facing dragonflies	Encircled facing dragonflies	Three dragonflies	**EAGLE**
GIANT CLAM	Giant clam	**HERON**	Encircled flying heron	**HORSE**
Encircled horse	Arima (family name)	**LION AND PEONY**	Lion and peony	Lion and peony

Facing doves under mistletoe

Dragon nail

Facing eagles

Running horse

Lion and peony

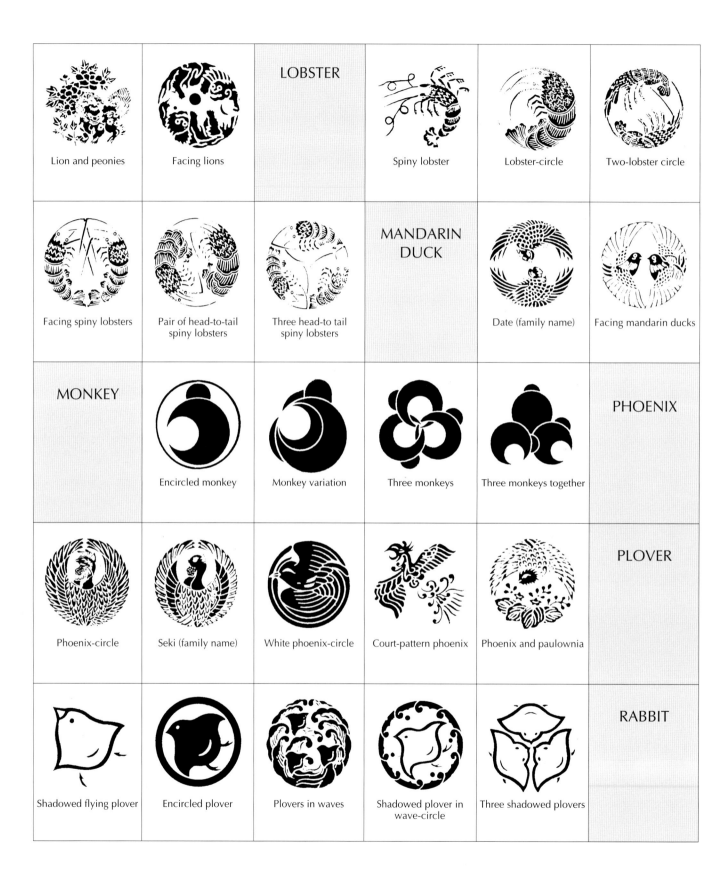

		LOBSTER			
Lion and peonies	Facing lions		Spiny lobster	Lobster-circle	Two-lobster circle
Facing spiny lobsters	Pair of head-to-tail spiny lobsters	Three head-to tail spiny lobsters	MANDARIN DUCK	Date (family name)	Facing mandarin ducks
MONKEY	Encircled monkey	Monkey variation	Three monkeys	Three monkeys together	PHOENIX
Phoenix-circle	Seki (family name)	White phoenix-circle	Court-pattern phoenix	Phoenix and paulownia	PLOVER
Shadowed flying plover	Encircled plover	Plovers in waves	Shadowed plover in wave-circle	Three shadowed plovers	RABBIT

	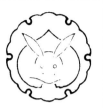	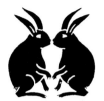		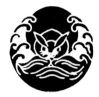	SEASHELL
Rabbit	Shadowed rabbit in snow-wheel	Facing rabbits	Three rear-view rabbits	Waves, moon, and rabbit	
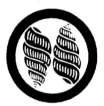	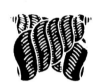	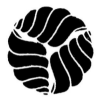	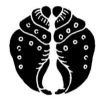	SHACHIHOKO (ROOF ORNAMENT)	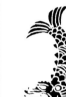
Two seashells encircled	Intersecting seashells	Three seashells	Facing conches		*Shachihoko*
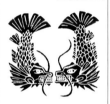	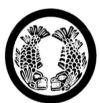	SPARROW	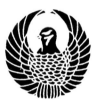		
Facing *shachihoko*	Encircled facing *shachihoko*		Sparrow-circle	Baby sparrow in snow-wheel	Fat sparrow
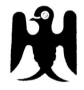	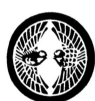	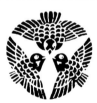	SWALLOW	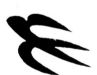	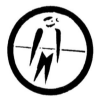
Sparrow variation	Encircled facing sparrows	Bonojo (family name)		Flying swallow	Encircled resting swallow
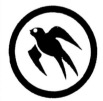	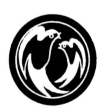	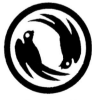	SWAN	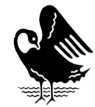	
Encircled flying swallow	Encircled mother and baby swallows	Encircled pair of head-to-tail swallows		Swan	

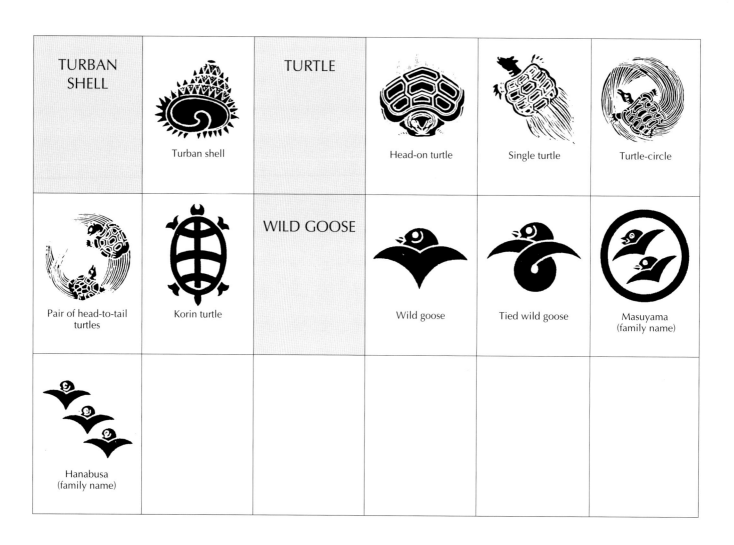

TURBAN SHELL	Turban shell	TURTLE	Head-on turtle	Single turtle	Turtle-circle
Pair of head-to-tail turtles	Korin turtle	WILD GOOSE	Wild goose	Tied wild goose	Masuyama (family name)
Hanabusa (family name)					

NATURAL PHENOMENA

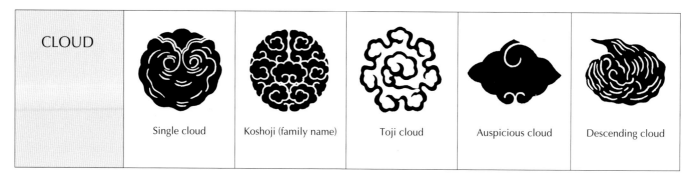

CLOUD	Single cloud	Koshoji (family name)	Toji cloud	Auspicious cloud	Descending cloud

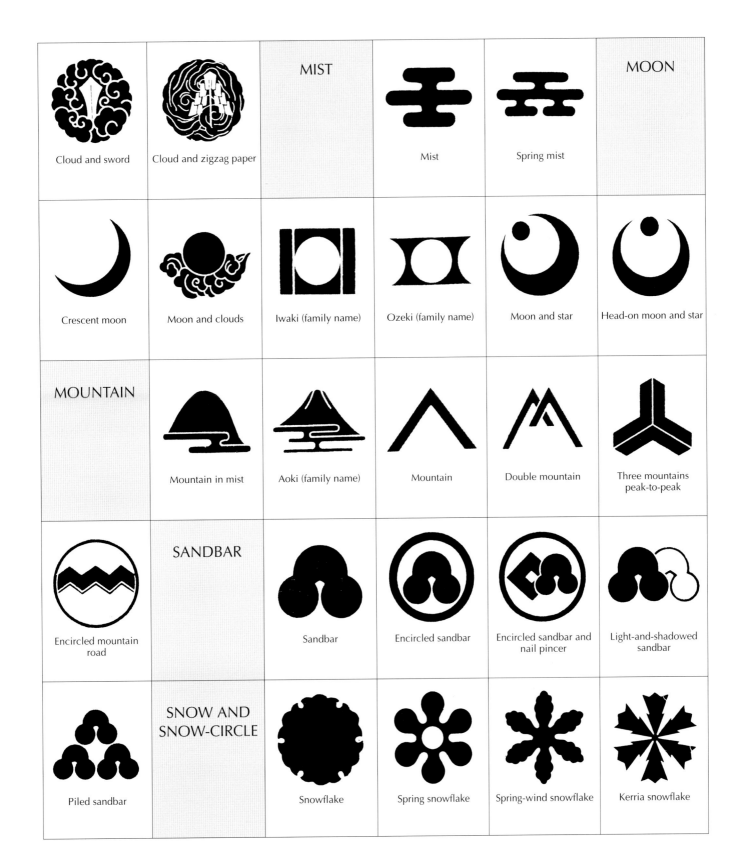

		MIST			MOON
Cloud and sword	Cloud and zigzag paper		Mist	Spring mist	
Crescent moon	Moon and clouds	Iwaki (family name)	Ozeki (family name)	Moon and star	Head-on moon and star
MOUNTAIN	Mountain in mist	Aoki (family name)	Mountain	Double mountain	Three mountains peak-to-peak
Encircled mountain road	SANDBAR	Sandbar	Encircled sandbar	Encircled sandbar and nail pincer	Light-and-shadowed sandbar
Piled sandbar	SNOW AND SNOW-CIRCLE	Snowflake	Spring snowflake	Spring-wind snowflake	Kerria snowflake

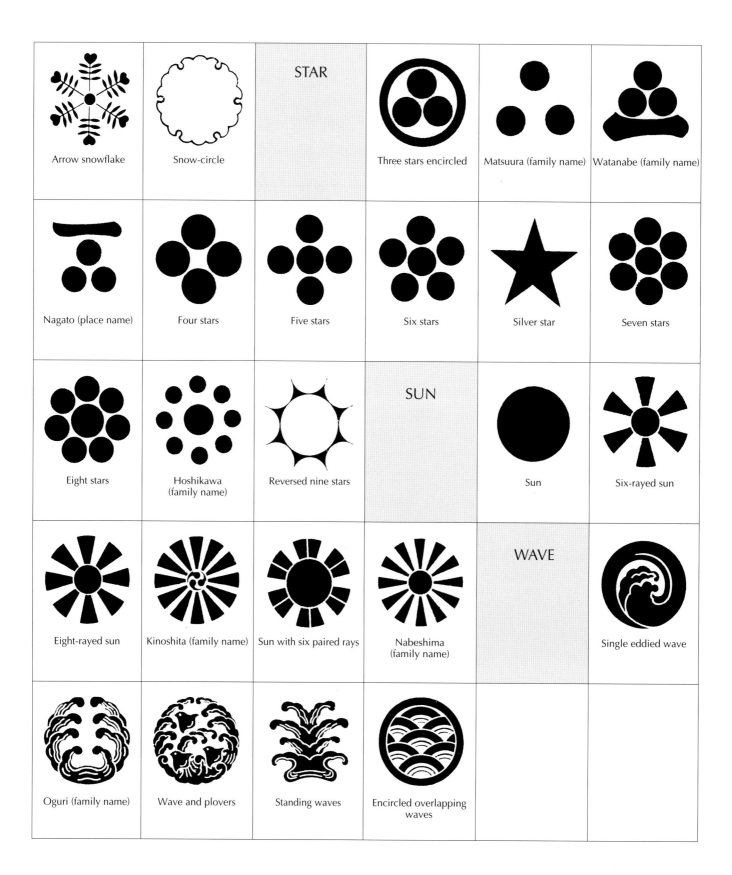

Arrow snowflake	Snow-circle	**STAR**	Three stars encircled	Matsuura (family name)	Watanabe (family name)
Nagato (place name)	Four stars	Five stars	Six stars	Silver star	Seven stars
Eight stars	Hoshikawa (family name)	Reversed nine stars	**SUN**	Sun	Six-rayed sun
Eight-rayed sun	Kinoshita (family name)	Sun with six paired rays	Nabeshima (family name)	**WAVE**	Single eddied wave
Oguri (family name)	Wave and plovers	Standing waves	Encircled overlapping waves		

IMPLEMENTS

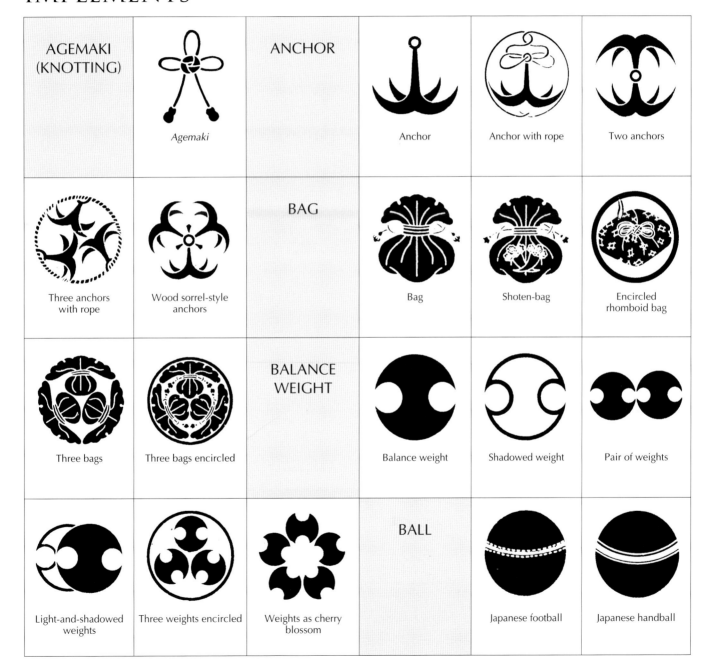

AGEMAKI (KNOTTING)		ANCHOR			
	Agemaki		Anchor	Anchor with rope	Two anchors
Three anchors with rope	Wood sorrel-style anchors	BAG	Bag	Shoten-bag	Encircled rhomboid bag
Three bags	Three bags encircled	BALANCE WEIGHT	Balance weight	Shadowed weight	Pair of weights
Light-and-shadowed weights	Three weights encircled	Weights as cherry blossom	BALL	Japanese football	Japanese handball

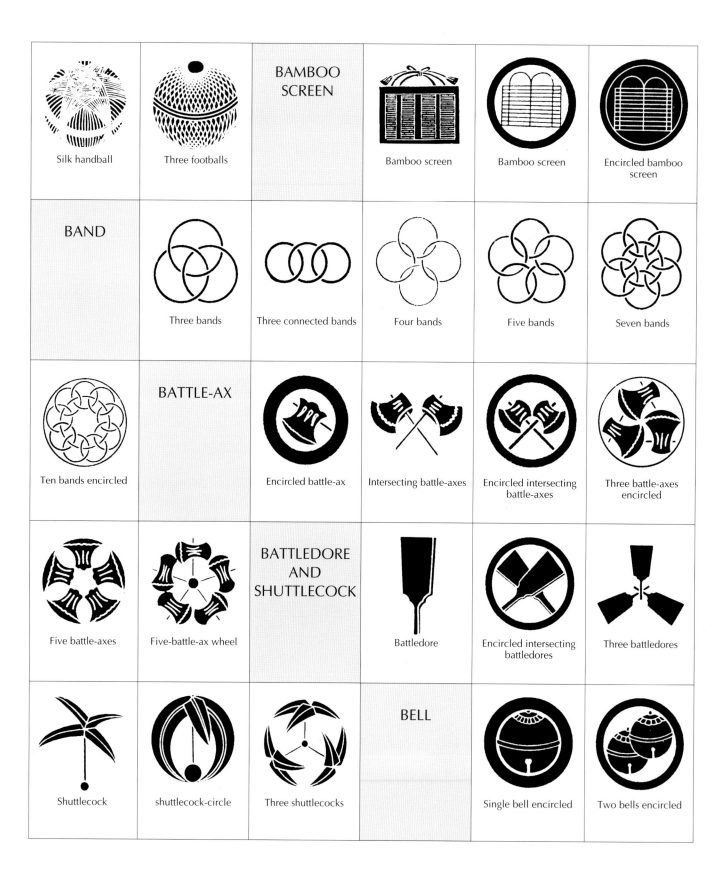

| | | BAMBOO SCREEN | | | |
| Silk handball | Three footballs | | Bamboo screen | Bamboo screen | Encircled bamboo screen |

| BAND | | | | | |
| | Three bands | Three connected bands | Four bands | Five bands | Seven bands |

| Ten bands encircled | BATTLE-AX | | Encircled battle-ax | Intersecting battle-axes | Encircled intersecting battle-axes | Three battle-axes encircled |

| Five battle-axes | Five-battle-ax wheel | BATTLEDORE AND SHUTTLECOCK | Battledore | Encircled intersecting battledores | Three battledores |

| Shuttlecock | shuttlecock-circle | Three shuttlecocks | BELL | Single bell encircled | Two bells encircled |

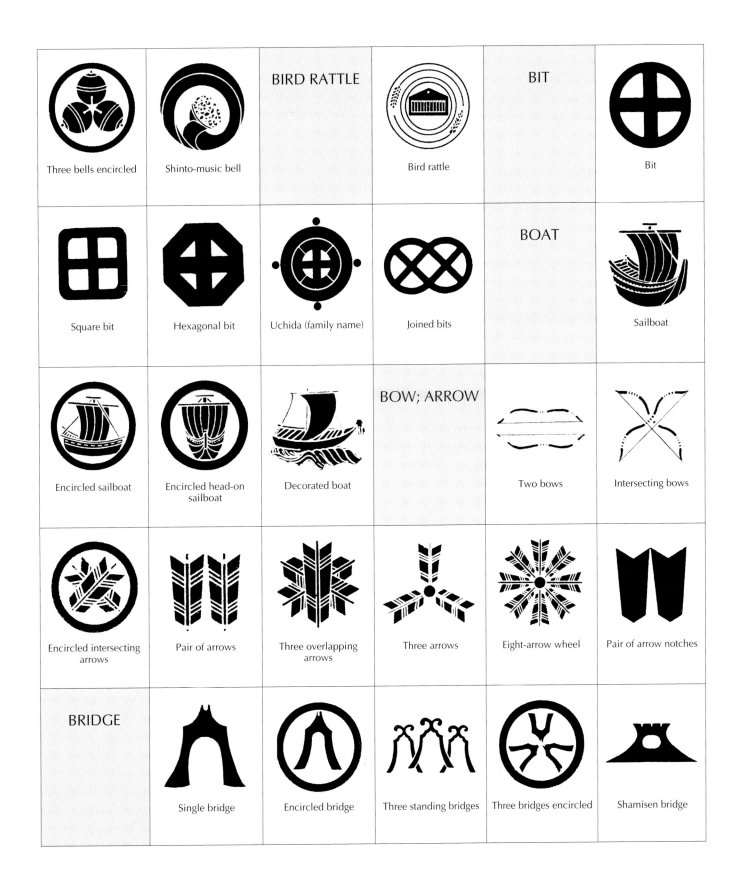

Three bells encircled	Shinto-music bell	BIRD RATTLE Bird rattle		BIT	Bit
Square bit	Hexagonal bit	Uchida (family name)	Joined bits	BOAT	Sailboat
Encircled sailboat	Encircled head-on sailboat	Decorated boat	BOW; ARROW	Two bows	Intersecting bows
Encircled intersecting arrows	Pair of arrows	Three overlapping arrows	Three arrows	Eight-arrow wheel	Pair of arrow notches
BRIDGE	Single bridge	Encircled bridge	Three standing bridges	Three bridges encircled	Shamisen bridge

BUDDHIST WHEEL					
	Buddhist wheel	Dainichi Buddhist wheel	A crest of the Shingon sect of Buddhism	Ascetic's wheel	Narita (temple name)

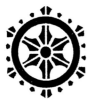	BUNDLE OF SILK	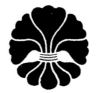	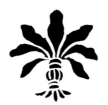	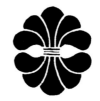	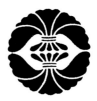
Six-spoked Buddhist wheel		Bundle of silk	Single bundle of silk	Variation on bundle of silk	Two bundles of silk

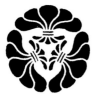	CANDLE			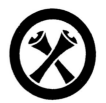	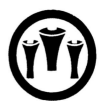
Three bundles of silk		Single candle encircled	Two candles encircled	Encircled intersecting candles	Three encircled candles

CARPENTER'S SQUARE			CHARM		
	Carpenter's square	Encircled carpenter's square		Gion charm	Yanagawa (family name)

			CLAPPERS		
Tachibana (family name)	Inshu (place name)	Tube-shaped charm		Clappers	Clappers

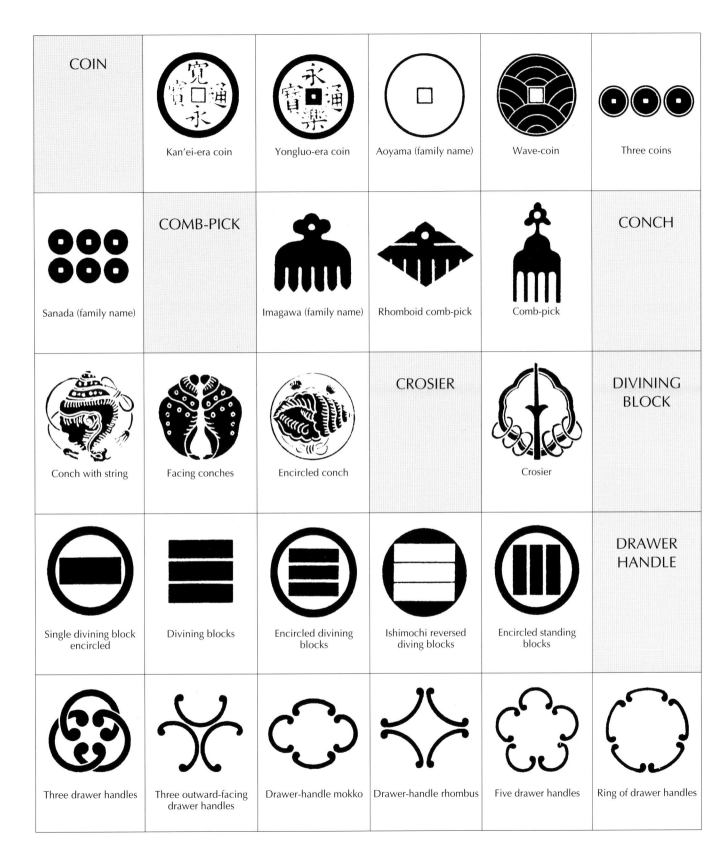

COIN	Kan'ei-era coin	Yongluo-era coin	Aoyama (family name)	Wave-coin	Three coins
Sanada (family name)	COMB-PICK	Imagawa (family name)	Rhomboid comb-pick	Comb-pick	CONCH
Conch with string	Facing conches	Encircled conch	CROSIER	Crosier	DIVINING BLOCK
Single divining block encircled	Divining blocks	Encircled diving blocks	Ishimochi reversed diving blocks	Encircled standing blocks	DRAWER HANDLE
Three drawer handles	Three outward-facing drawer handles	Drawer-handle mokko	Drawer-handle rhombus	Five drawer handles	Ring of drawer handles

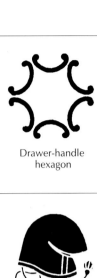	DUMPLINGS	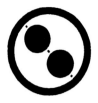		EBOSHI (CAP)	
Drawer-handle hexagon		Two dumplings on a stick encircled	Inaba (place name)		Court noble *eboshi*

			FEATHER DUSTER	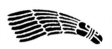	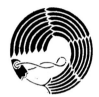
General's *eboshi*	Warrior's headgear	Standing headgear		Feather duster	Feather duster-circle

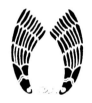	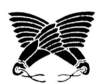		FIRE BELL		
Pair of feather dusters	Intersecting feather dusters	Three head-to-tail feather dusters		Fire bell	Old-style fire bell

FISHING NET		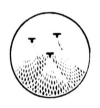	FLAG	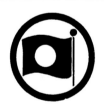	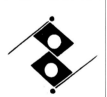
	Two fishing nets encircled	Two fishing nets and water encircled		Single flag encircled	Two national flags

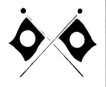	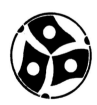	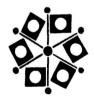	FOLDING FAN	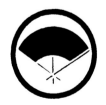	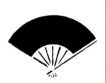
Intersecting national flags	Three flags circled	Six-flag wheel		Encircled three-ribbed fan	Seven-ribbed fan

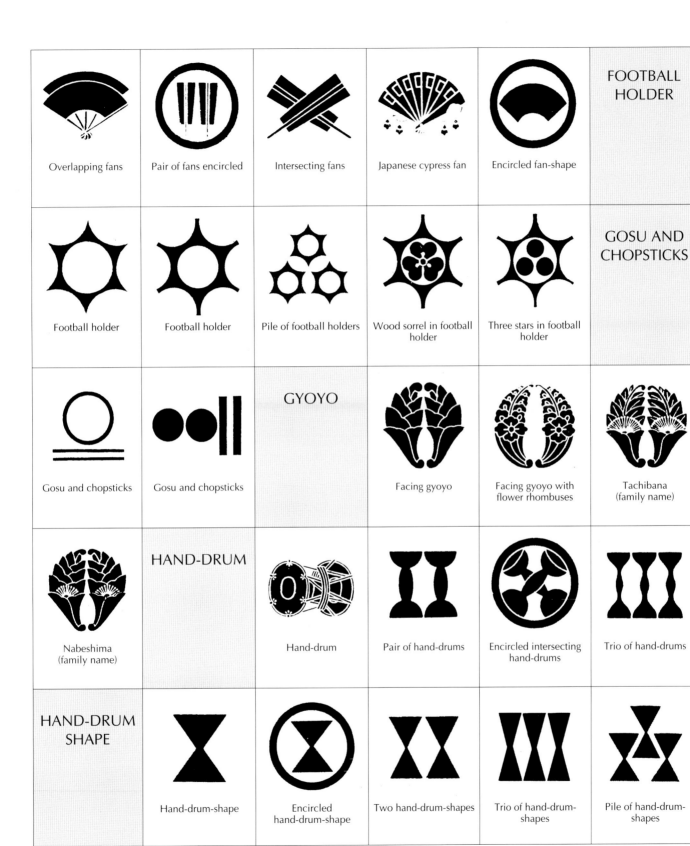

Overlapping fans	Pair of fans encircled	Intersecting fans	Japanese cypress fan	Encircled fan-shape

Football holder	Football holder	Pile of football holders	Wood sorrel in football holder	Three stars in football holder

GOSU AND CHOPSTICKS

Gosu and chopsticks	Gosu and chopsticks	GYOYO	Facing gyoyo	Facing gyoyo with flower rhombuses

Tachibana (family name)

Nabeshima (family name)	HAND-DRUM	Hand-drum	Pair of hand-drums	Encircled intersecting hand-drums

Trio of hand-drums

HAND-DRUM SHAPE	Hand-drum-shape	Encircled hand-drum-shape	Two hand-drum-shapes	Trio of hand-drum-shapes

Pile of hand-drum-shapes

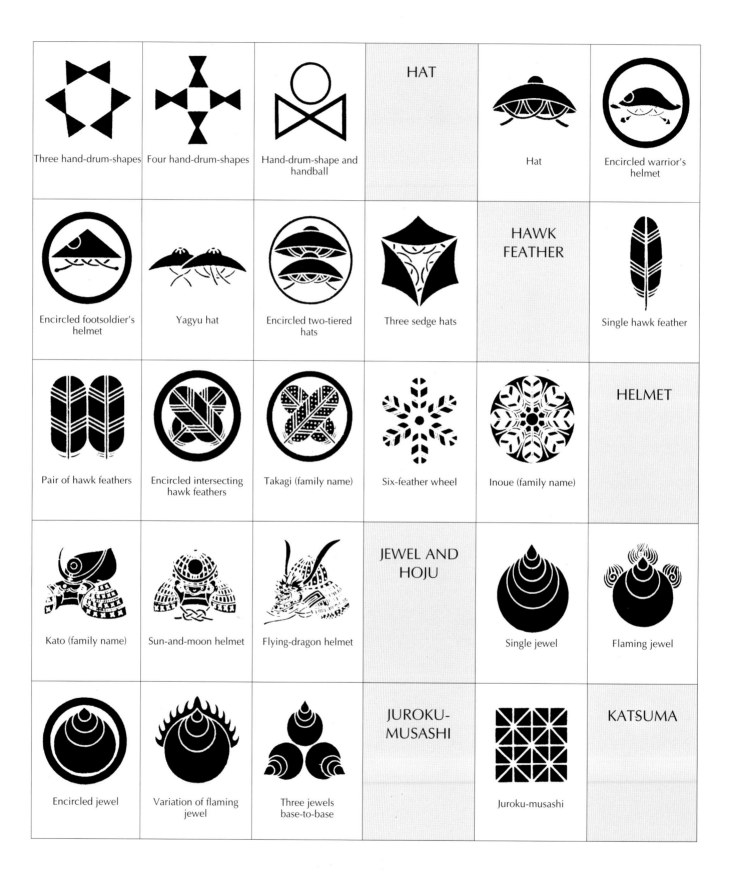

Three hand-drum-shapes	Four hand-drum-shapes	Hand-drum-shape and handball	**HAT**	Hat	Encircled warrior's helmet
Encircled footsoldier's helmet	Yagyu hat	Encircled two-tiered hats	Three sedge hats	**HAWK FEATHER**	Single hawk feather
Pair of hawk feathers	Encircled intersecting hawk feathers	Takagi (family name)	Six-feather wheel	Inoue (family name)	**HELMET**
Kato (family name)	Sun-and-moon helmet	Flying-dragon helmet	**JEWEL AND HOJU**	Single jewel	Flaming jewel
Encircled jewel	Variation of flaming jewel	Three jewels base-to-base	**JUROKU-MUSASHI**	Juroku-musashi	**KATSUMA**

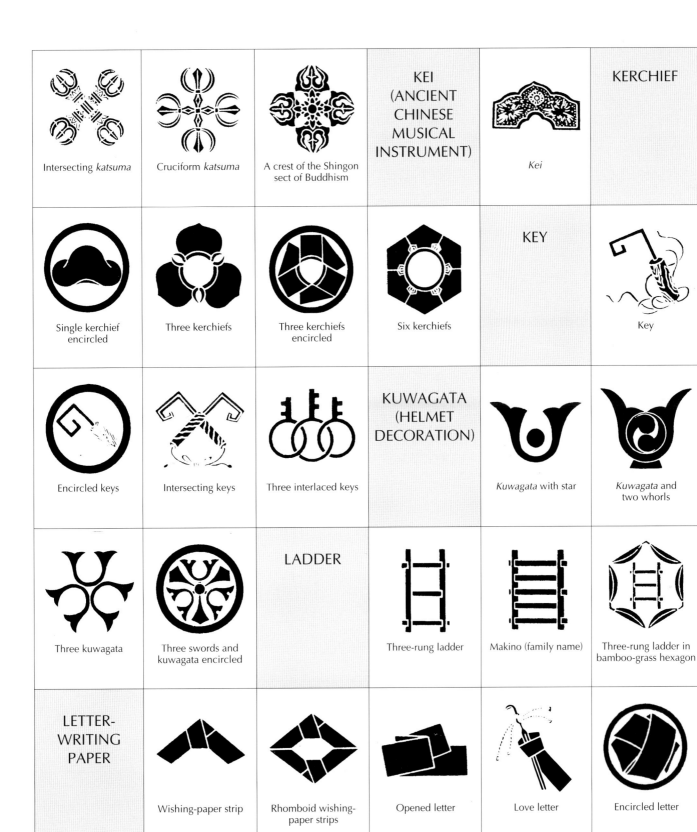

			KEI (ANCIENT CHINESE MUSICAL INSTRUMENT)		KERCHIEF
Intersecting *katsuma*	Cruciform *katsuma*	A crest of the Shingon sect of Buddhism		*Kei*	
Single kerchief encircled	Three kerchiefs	Three kerchiefs encircled	Six kerchiefs	KEY	Key
Encircled keys	Intersecting keys	Three interlaced keys	KUWAGATA (HELMET DECORATION)	*Kuwagata* with star	*Kuwagata* and two whorls
Three kuwagata	Three swords and kuwagata encircled	LADDER	Three-rung ladder	Makino (family name)	Three-rung ladder in bamboo-grass hexagon
LETTER-WRITING PAPER	Wishing-paper strip	Rhomboid wishing-paper strips	Opened letter	Love letter	Encircled letter

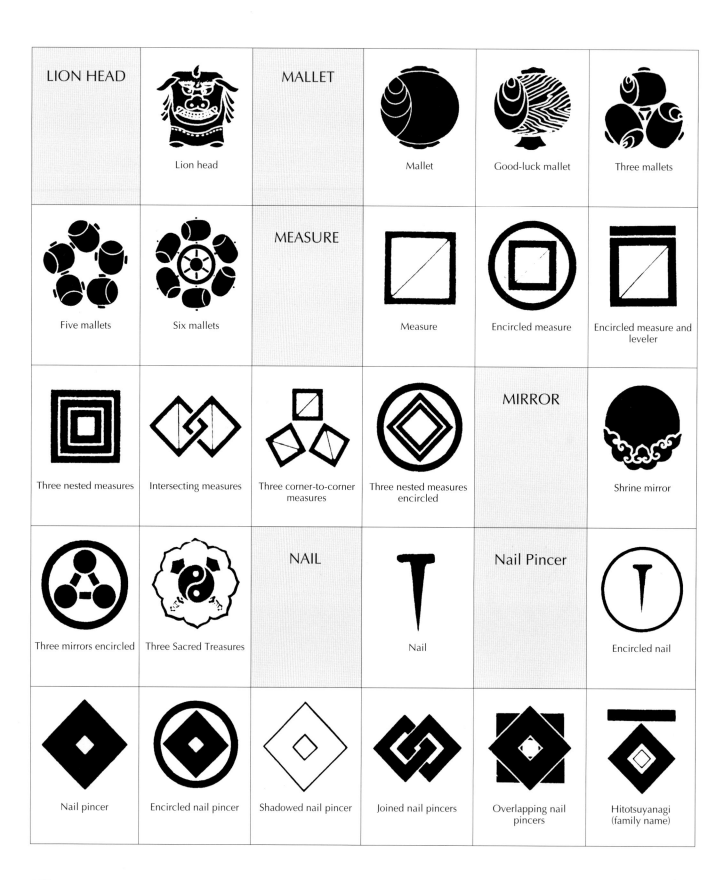

LION HEAD

Lion head

MALLET

Mallet

Good-luck mallet

Three mallets

Five mallets

Six mallets

MEASURE

Measure

Encircled measure

Encircled measure and leveler

Three nested measures

Intersecting measures

Three corner-to-corner measures

Three nested measures encircled

MIRROR

Shrine mirror

Three mirrors encircled

Three Sacred Treasures

NAIL

Nail

Nail Pincer

Encircled nail

Nail pincer

Encircled nail pincer

Shadowed nail pincer

Joined nail pincers

Overlapping nail pincers

Hitotsuyanagi (family name)

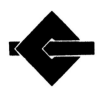	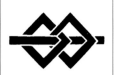	NOSHI (GIFT DECORATION)	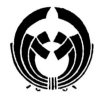	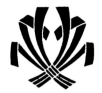	
Nail pincer with lever	Two nail pincers and gate bolt		Encircled standing bundled noshi	Pair of bundled noshi	Intersecting noshi

		OPENWORK BASKET		ORNAMENTAL HAIRPIN	
Intersecting hawk feathers in noshi-ring	Intersecting wrapped noshi		Openwork basket		Encircled hairpin

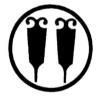					OSHIKI (WOODEN TRAY)
Pair of hairpins encircled	Encircled intersecting hairpins	Three hairpins	Six hairpins	Eight-hairpin wheel	

			PADDLE		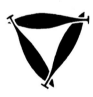
Oshiki	Character "san" (three) within oshiki	Wavy character "san" (three) within oshiki		Encircled intersecting paddles	Three head-to-tail paddles

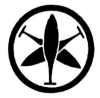			PANPIPES		
Three paddles encircled	Trio of paddles	Three overlapping paddles		Panpipes in tassel-circle	Facing panpipes

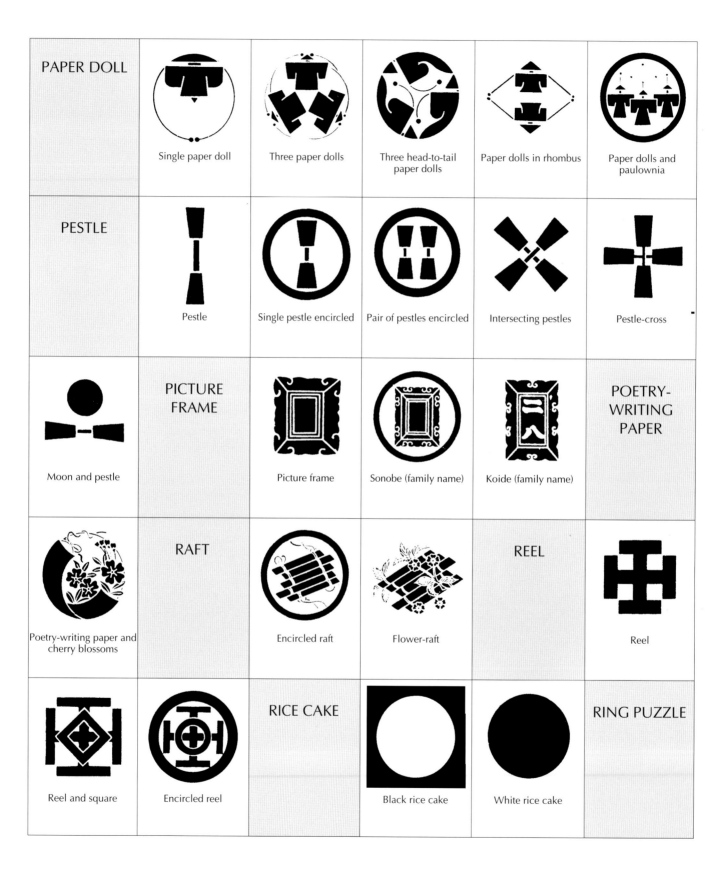

PAPER DOLL	Single paper doll	Three paper dolls	Three head-to-tail paper dolls	Paper dolls in rhombus	Paper dolls and paulownia
PESTLE	Pestle	Single pestle encircled	Pair of pestles encircled	Intersecting pestles	Pestle-cross
Moon and pestle	**PICTURE FRAME**	Picture frame	Sonobe (family name)	Koide (family name)	**POETRY-WRITING PAPER**
Poetry-writing paper and cherry blossoms	**RAFT**	Encircled raft	Flower-raft	**REEL**	Reel
Reel and square	Encircled reel	**RICE CAKE**	Black rice cake	White rice cake	**RING PUZZLE**

			ROLL OF SILK		ROUND FAN
Ring puzzle	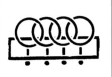 Ring puzzle	Altered ring puzzle		Rolls of silk	
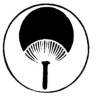 Encircled round fan	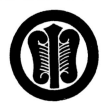 Encircled Chinese round fan	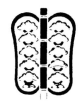 Nakatsu (family name)	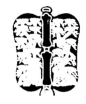 Okudaira (family name)	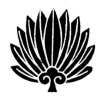 Feathered fan	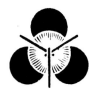 Three round fans
RUDDER	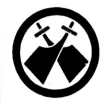 Encircled intersecting rudders	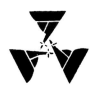 Three rudders	Two reverse-image rudders in octagon	Single rudder encircled	SAIL
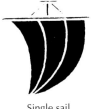 Single sail	Sail in mist	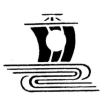 Sail in water	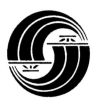 Two-sail circle	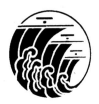 Three sails in waves	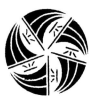 Five-sail circle
Sail in pine needles	SAKÉ CUP	Japanese ginger in saké cup	Three stacked saké cups	Three saké cups	Hoinoshi

SAKÉ PITCHER					
	Saké pitcher	Pair of sake pitchers	Three saké pitchers	Pile of saké pitchers	Five saké pitchers
SCISSORS	Encircled scissors	Two pairs of scissors encircled	Encircled intersecting scissors	Encircled overlapping scissors	SEXFOIL
	Sexfoil	Sexfoil	Mizuno (family name)	Sexfoil	SHOGI PIECE
					Shogi piece
	Shogi piece	Pair of shogi pieces encircled	SHRINE CROSSBEM AND KATSUOGI	Shrine crossbeam	Shrine crossbeam and *katsuogi*
					SICKLE
	Sickle	Encircled intersecting sickles	Four sickles	Six-sickle wheel	Pair of head-to-tail sickles
					SPOOL

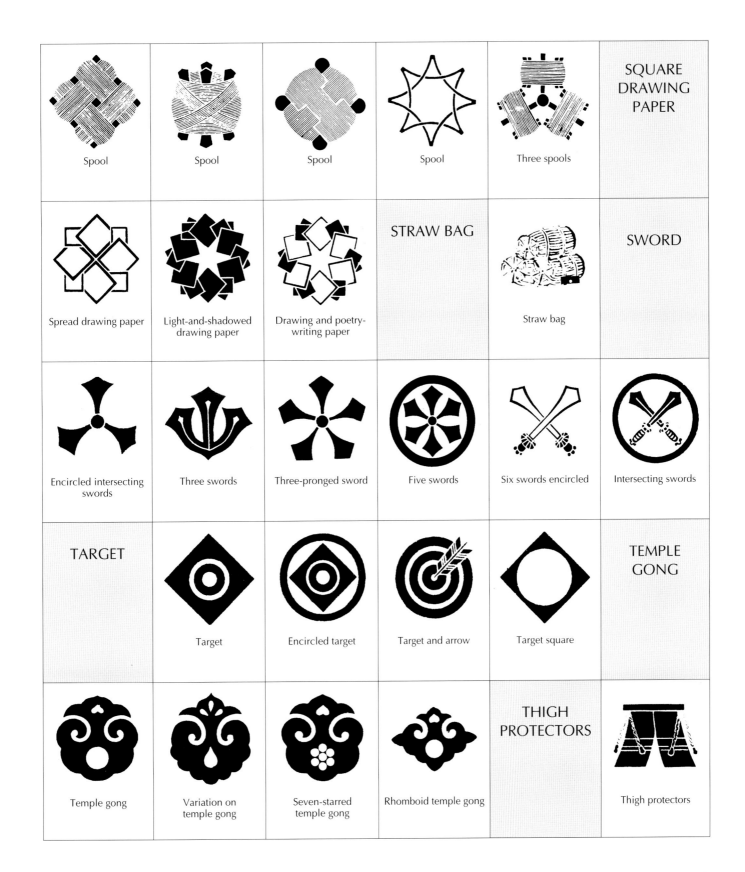

					SQUARE DRAWING PAPER
Spool	Spool	Spool	Spool	Three spools	
Spread drawing paper	Light-and-shadowed drawing paper	Drawing and poetry-writing paper	STRAW BAG	Straw bag	SWORD
Encircled intersecting swords	Three swords	Three-pronged sword	Five swords	Six swords encircled	Intersecting swords
TARGET	Target	Encircled target	Target and arrow	Target square	TEMPLE GONG
Temple gong	Variation on temple gong	Seven-starred temple gong	Rhomboid temple gong	THIGH PROTECTORS	Thigh protectors

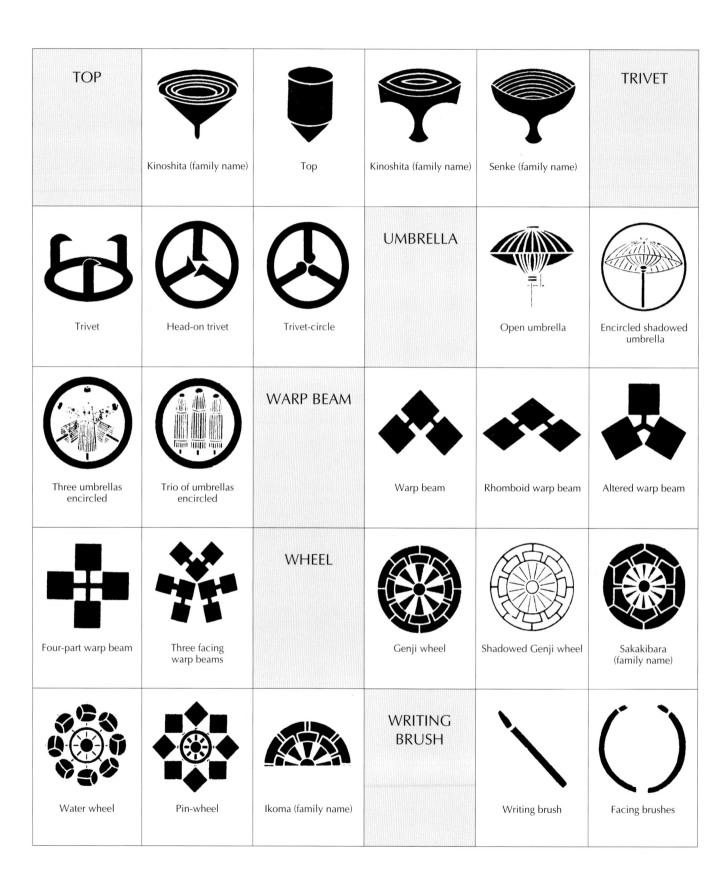

TOP	Kinoshita (family name)	Top	Kinoshita (family name)	Senke (family name)	TRIVET
Trivet	Head-on trivet	Trivet-circle	UMBRELLA	Open umbrella	Encircled shadowed umbrella
Three umbrellas encircled	Trio of umbrellas encircled	WARP BEAM	Warp beam	Rhomboid warp beam	Altered warp beam
Four-part warp beam	Three facing warp beams	WHEEL	Genji wheel	Shadowed Genji wheel	Sakakibara (family name)
Water wheel	Pin-wheel	Ikoma (family name)	WRITING BRUSH	Writing brush	Facing brushes

	ZIGZAG PAPER				
Brush-wheel		Shrine papered-staff	Exorcism staff	Intersecting zigzag paper	Bell and zigzag paper
Three papered staffs					

STRUCTURES

BANISTER		CHANNEL MARKER			
	Banister-circle and hawk		Channel marker	Encircled channel marker	Channel marker and single wave
CRISSCROSS			EMBANKMENT		
	Crisscross	Crisscross		Yasuda (family name)	Pebble-filled basket embankment

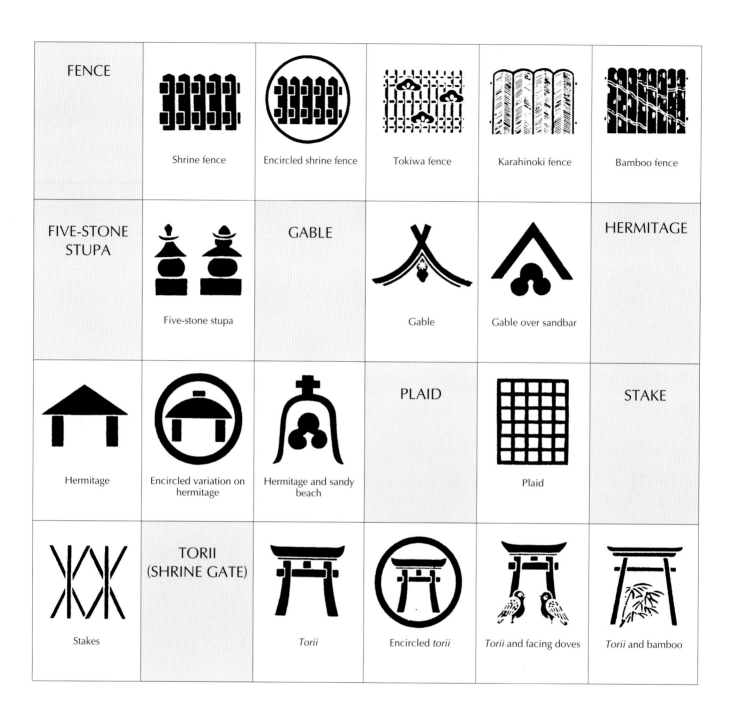

FENCE	Shrine fence	Encircled shrine fence	Tokiwa fence	Karahinoki fence	Bamboo fence
FIVE-STONE STUPA	Five-stone stupa	GABLE	Gable	Gable over sandbar	HERMITAGE
Hermitage	Encircled variation on hermitage	Hermitage and sandy beach	PLAID	Plaid	STAKE
Stakes	TORII (SHRINE GATE)	*Torii*	Encircled *torii*	*Torii* and facing doves	*Torii* and bamboo

TRADITIONAL PATTERNS

BASKET-WEAVE	Basket-weave	CHECKS	Single check encircled	Three checks	Facing doves on three checks
Four checks	Four checks	Four reversed checks	Nine checks	Nine checks	DAPPLED
Titled four spotted squares	Level four spotted squares	Encircled tilted four spotted squares	Three spotted squares	Corner-to-corner four spotted squares	Four spotted checks
Nine spotted squares	DIAGONALS	Diagonals	Encircled diagonals	Niwa (family name)	Woven diagonals

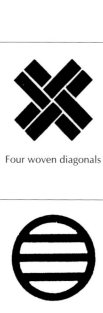

Four woven diagonals

Single bar encircled

Two bars encircled

Two bars encircled

Two shadowed bars
encircled

Three bars encircled

Three vertical bars
encircled

INTERLACED
CIRCLES

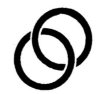

Interlaced circles

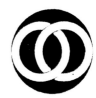

Tilted interlaced circles

Reversed
interlaced circles

Three interlaced
drawer handles

Three shadowed
interlaced circles in
cut-corner square

Series of interlaced
circles

Joined interlaced circles

Circles and square
interlaced

LIGHTNING

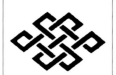

Level lightning

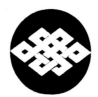

Encircled lightning

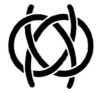

Tilted lightning

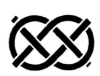

Hexagonal lightning

LOOPS

Treasure loops

Squared treasure loops

Reversed squared
treasure loops

Keman loops

Keman loops

Three loops

MOKKO

178

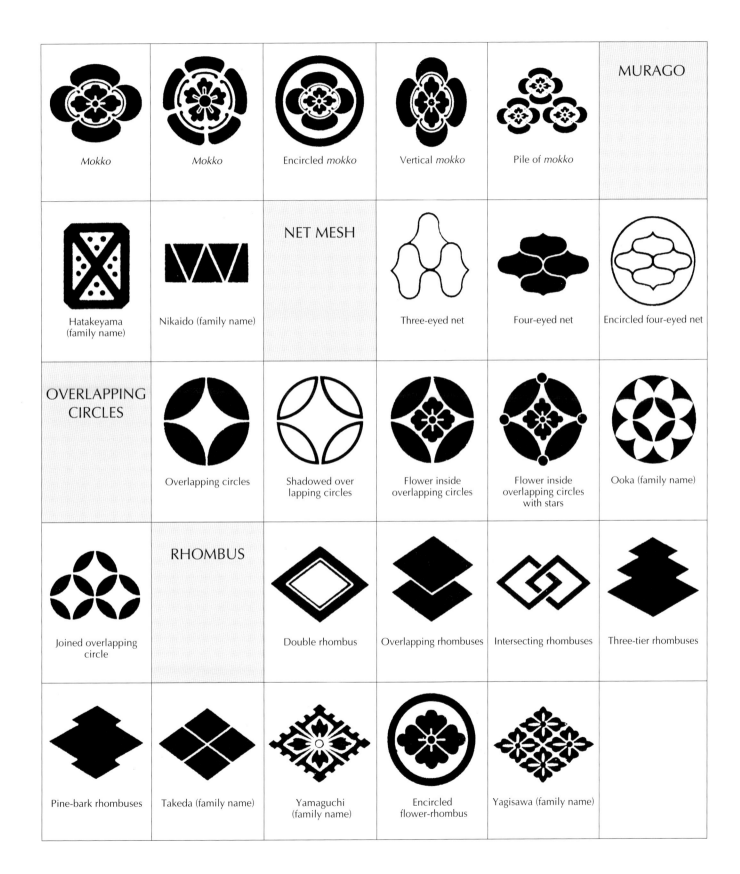

					MURAGO
Mokko	*Mokko*	Encircled *mokko*	Vertical *mokko*	Pile of *mokko*	

		NET MESH			
Hatakeyama (family name)	Nikaido (family name)		Three-eyed net	Four-eyed net	Encircled four-eyed net

OVERLAPPING CIRCLES					
	Overlapping circles	Shadowed over lapping circles	Flower inside overlapping circles	Flower inside overlapping circles with stars	Ooka (family name)

	RHOMBUS				
Joined overlapping circle		Double rhombus	Overlapping rhombuses	Intersecting rhombuses	Three-tier rhombuses

Pine-bark rhombuses	Takeda (family name)	Yamaguchi (family name)	Encircled flower-rhombus	Yagisawa (family name)	

179

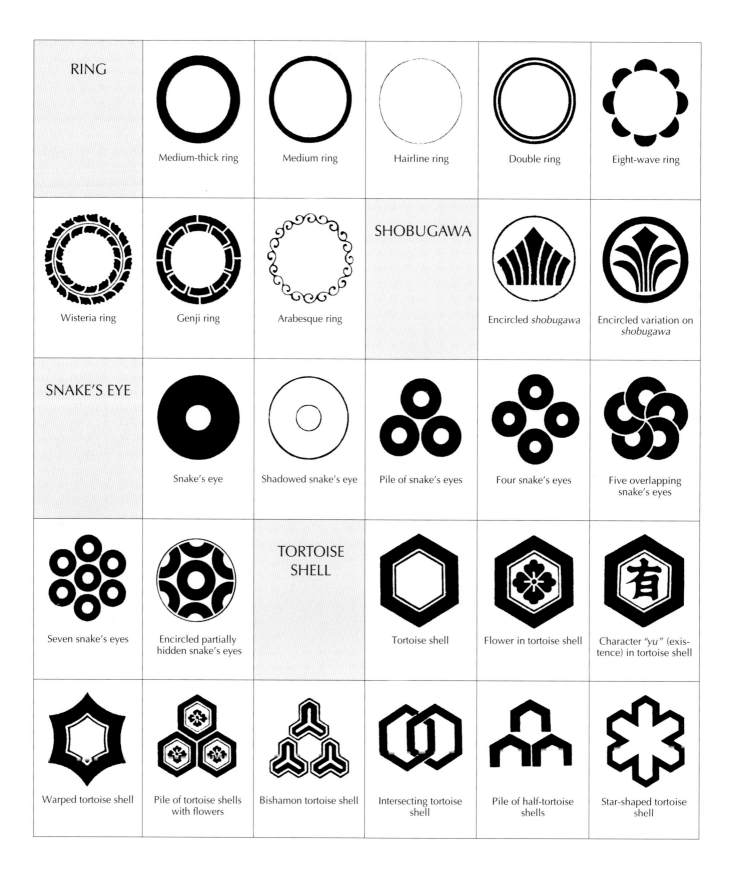

RING

Medium-thick ring

Medium ring

Hairline ring

Double ring

Eight-wave ring

Wisteria ring

Genji ring

Arabesque ring

SHOBUGAWA

Encircled *shobugawa*

Encircled variation on *shobugawa*

SNAKE'S EYE

Snake's eye

Shadowed snake's eye

Pile of snake's eyes

Four snake's eyes

Five overlapping snake's eyes

Seven snake's eyes

Encircled partially hidden snake's eyes

TORTOISE SHELL

Tortoise shell

Flower in tortoise shell

Character *"yu"* (existence) in tortoise shell

Warped tortoise shell

Pile of tortoise shells with flowers

Bishamon tortoise shell

Intersecting tortoise shell

Pile of half-tortoise shells

Star-shaped tortoise shell

TRIANGLE	Single triangle	Akagaki (family name)	Two triangles	Three triangles in hexagon	Hojo (family name)
Piled triplets of triangles	WELL COVER	Well cover	Woven well cover	Encircled well cover	Well cover
Wide well cover	Intersecting well covers	WHORL	Single counter-clockwise whorl	Two clockwise whorls	Two shadowed clockwise whorls
Three clockwise whorls	Long-tail whorls	Itakura (family name)			

CHARACTERS AND MARKS

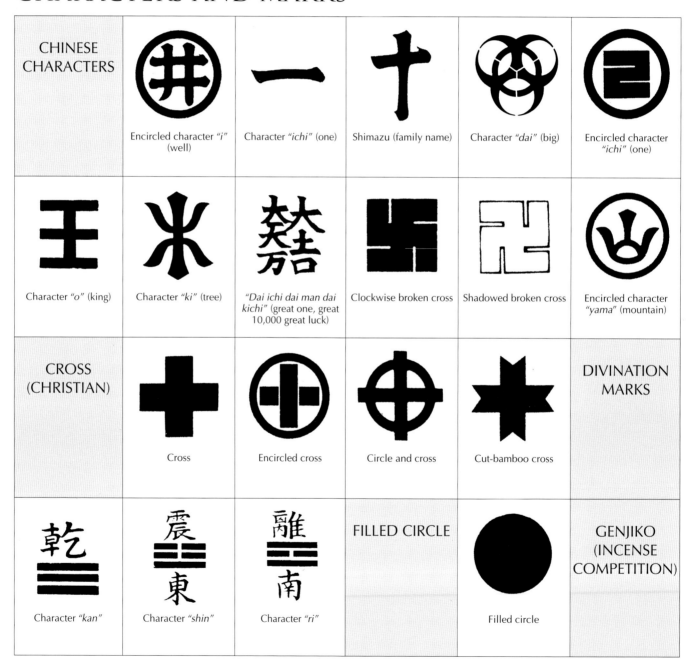

CHINESE CHARACTERS	Encircled character *"i"* (well)	Character *"ichi"* (one)	Shimazu (family name)	Character *"dai"* (big)	Encircled character *"ichi"* (one)
Character *"o"* (king)	Character *"ki"* (tree)	*"Dai ichi dai man dai kichi"* (great one, great 10,000 great luck)	Clockwise broken cross	Shadowed broken cross	Encircled character *"yama"* (mountain)
CROSS (CHRISTIAN)	Cross	Encircled cross	Circle and cross	Cut-bamboo cross	DIVINATION MARKS
Character *"kan"*	Character *"shin"*	Character *"ri"*	FILLED CIRCLE	Filled circle	GENJIKO (INCENSE COMPETITION)

					KUJI
"Kiritsubo"	"Hahakigi"	"Suma"	"Fujibakama"	"Tenarai"	
Rhomboid *kuji*	Encircled *kuji* on two bars	Encircled *kuji*	RICE PADDY BORDER	Rice paddy border	SQUARE
Level square	Finely outlined tilted square	Cut-corner square	Indented-corner square	Square	Overlapping squares
TAI CHI SYMBOL	*Tai chi* symbol	*Tai chi* symbol in pinwheel			

ON JAPANESE PATTERNS

A pattern can be defined as an orderly, and often a repeating, arrangement of points, lines, shapes, and colors. This definition is applicable to many of the patterns that appear in these books—overlapping waves, flurries of cherry blossoms, and certainly the geometric patterns. In many cases, however—for instance when a single plant, animal, or scene is depicted—the distinctions between "patterns" and "pictures" or "figures" are not always clear. A number of the illustrations in this book are perhaps not patterns in the strictest sense, but are generally considered by the Japanese as "true" patterns because they are figures—often stylized—that have traditionally appeared as part of such patterns.

Function

Patterns have played various roles throughout the ages. Early patterns had a communicative function. An early example of a pattern, or what might later become a pattern in the artistic sense, is a drawing of three suns, two people, and a mountain. This sort of sketch, found on many Egyptian papyri, was a sort of preliterate code, which in this case meant, "Meet me at the mountain three days from now."

Early patterns also had a talismanic function. The simple figures—spirals, triangles, and arcs—painted in red on the walls of early Japanese tumuli are thought to have been drawn as a means of warding off evil or ensuring the repose of the soul or its peaceful journey to the land of the dead.

Throughout the centuries and in the present day, however, the primary function of patterns has been decorative. Designers have created innumerable beautiful patterns for clothing, household furnishings, ceramic and lacquer tableware, wallpaper, and other items.

Characteristics

Patterns created in Japan or adapted and refined from imported motifs exhibit certain general characteristics. First, there is an emphasis on nature—flowers, animals, mist, the moon, flowing water, and so forth. There is not always an emphasis on exact representation, however, as long as a beautiful design results: arabesques, Chinese lions, and dragons are all common motifs in patterns, and highly stylized figures, such as those developed by Ogata Korin, exist.

Second, curved lines, nongeometrical patterns, and asymmetrical designs seem to be preferred over straight lines, geometrical patterns, and symmetrical designs. Patterns such as triangles or rhombuses, although seen on early objects, were not extensively developed. Rhombuses were

often combined with flowers and birds, to make the pattern less geometrical. Overlapping circles showed the same tendency: various flowerlike figures were enclosed inside them, or in some cases their own form was stretched into an oblong or similarly distorted shape.

Third, a certain vagueness is preferred to absolute clarity. Mountains are often veiled in mist, and the moon may be hidden behind clouds. Stars are often depicted as circular, rather than as having pointed edges.

Finally, there is an almost incredible variety of motifs, and variations on motifs. Virtually any plant, animal, natural phenomenon, or common object has appeared in a pattern at one time or another. Designs have been freely imported—from China and the Asian mainland a millennium ago, and from the West more recently.

Buddhism was the strongest "foreign" influence, bringing arabesques, *hosoge,* and other figures. All are, of course, revised to a lesser or greater extent to conform to Japanese sensibilities.

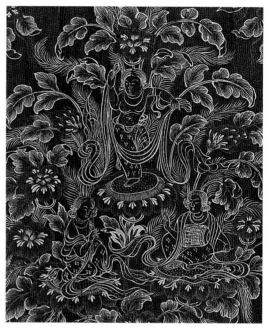

Hosoge and human figures. The child at top dances on a flower; one of the children below plays on a *shakuhachi,* while the other accompanies on a *kakko* drum. Detail of drawing in gold on the lid of box; replica. Original in Shosoin. Tokyo National Museum. Style suggestive of Nara period.

History

Using the same periods into which Japanese history is traditionally divided, let us look at the historical development of patterns in Japan.

Jomon, Yayoi, and Tumulus periods (through the mid-sixth century A.D.): So-called primitive figures including sawtooth shapes, spirals, and arcs were carved into earthen and stone vessels. By the sixth century, arabesques had appeared from the Asian mainland, and more complex figures such as humans and animals were being drawn.

Asuka period (552–645): Buddhism began its spread to Japan, and Horyuji temple in Nara, now the oldest wooden structure in the world, was built. Various patterns with a Buddhist flavor came into Japan, after making their way across the Silk Road. Some of these—lotus blossom, cloud, four-petaled flower, and lion patterns, for example—were very showy. Objects portraying them are preserved at Horyuji.

Nara period (645–794): The influences from the Asian mainland, especially Tang-dynasty China, continued during the Nara period, largely as a result of envoys being sent there from Japan. Many objects that depict the patterns of the day are preserved at the Shosoin, a building that is part of Todaiji (mention of Shosoin in the individual pattern explanations throughout these books implies the early origin of the pattern in question). The following are just some of the tremendous number of patterns imported.

Geometric forms: rhombuses, triangles, tortoise shell, four-petaled flowers, arrow feathers, checks, stripes, plaids, waves

Figures from the sky: clouds, mist, sun, moon

Natural phenomena: mountains, flowing water, rocks

Plants: Peonies, lotuses, palms, coconuts, pomegranates, honeysuckle, chrysanthemums, pine trees, plum blossoms, vines, lilies, wisteria

Animals: peacocks, parrots, ducks, chickens, wild geese, pheasants, lions, tigers, sheep, elephants, rhinoceroses, monkeys, horses, foxes, butterflies, dragonflies, fish, turtles

Imaginary plants and animals: kylins, dragons, *karabana, hosoge*

Human figures: children, hunters, dancers, acrobats, wizards

Implements: musical instruments, utensils

Heian period (794–1185): The Japanese capital was moved from Nara to Kyoto, and the court stopped sending envoys to China. Japanese sensibilities began to influence the appearance of patterns, the most notable example of this aesthetic change is probably the Hoodo ("Phoenix Hall"), the main hall of the Byodoin in Uji, Kyoto, a structure that was originally a nobleman's residence and later a temple. Most of the figures on the inner walls of the hall are *hosoge,* a type of arabesque pattern from the Asian mainland, but with richer coloring and a finer design than were seen in earlier patterns. Such Japanese figures as the triple whorl also appeared during the Heian period.

Kamakura period (1185–1333): This was the beginning of almost seven centuries of feudal government. Two developments with respect to patterns were evident during the period. First, they tended to be more pictorial than before. A prime example is a mother-of-pearl inkstone case found at Tsurugaoka-Hachimangu shrine in Kamakura. Rather than simply depicting chrysanthemums in an orderly fashion, the scene is one of the flowers blooming from a fence. The second phenomenon is that different figures were combined into single patterns. Common combinations were sandbars-and-chrysanthemums and peonies-and-butterflies. Wheel and overlapping-circle patterns were also developed during the Kamakura period.

Muromachi period (1333–1573): Influences from the Yuan and Ming dynasties of China were felt on the artistic works of the period. Many masterpieces of the period were done in *makie,* a process in which lacquering is followed by the application of gold and silver powder.

Momoyama period (1573–1603): The lively artistic sensibilities of the warlord of the period, Toyotomi Hideyoshi, influenced many areas, from castle design to No costumes, resulting in the development of unique new patterns. Kodaiji temple, built for the repose of Hideyoshi's soul, houses excellent examples of items done in *makie* and objects with flower-raft, eulalia, paulownia, and chrysanthemum patterns.

Edo period (1603–1868): This was the period of the Tokugawa shogunate, a time during which many among the common people created new and interesting patterns. Ogata Korin developed his stylized flowers and other figures seen in this volume. The splashed pattern was created during this time, as were humorous patterns used on No and kyogen (No farce) costumes. The creation and use of family crests also became widespread during the Edo period.

Modern period (1968–present): With the arrival of Western influences, new patterns and variations naturally developed, as they continue to do today.

ON JAPANESE FAMILY CRESTS

A family crest is a stylized depiction of a plant, animal, tool, utensil, written character, or other object or symbol used to identify a certain family. Other crests, such as those for temples, shrines, or corporations, also exist. In contrast to patterns—an art form found throughout the world—crests have been used in very few countries. Japan is the only country in the East to have developed them.

History

The overwhelming majority of figures seen in family crests developed from patterns, many of which are seen in this volume. During the Heian period, members of the nobility drew patterns and figures on personal effects, clothing, carriages, and many other objects. Although originally employed simply for decorative purposes, certain figures gradually became identified with certain families, eventually even serving as a means of identification, and essentially becoming their exclusive property. When internecine strife began in earnest toward the end of the Heian period, warrior families developed their own family crests, primarily for use on battlefield flags, armor, and equipment. At that time, the most common motifs in family crests were the first Chinese character of the surname, combined with simple crisscrosses and circles.

The crests of warrior families continued to develop during the ensuing Kamakura period. Theoretically, the four powerful families—the Fujiwara, Genji, Heike, and Tachibana—each had a single family symbol, but in actuality the many branches and sub-branches had their own crests, depicting such figures as rhombuses, gentians, whorls, sparrows-in-bamboo, hawk feathers, wisteria, with plants and birds being the most popular motifs. It was also during the Kamakura period that the chrysanthemum became fixed as the imperial symbol and crest.

The unification of Japan and quelling of internal strife by Tokugawa Ieyasu ushered in the Edo period. During this time, legal stipulations were applied to family crests, one of which was that unauthorized use of the hollyhock, the Tokugawa crest, was strictly prohibited. (The shogunate evidently looked the other way when the chrysanthemum was used, however.) Crests were eventually refined to the neat square and round forms with which we are familiar. Family crests on clothing and carriages were useful not only in identifying the other party in a chance encounter, but also in determining his rank relative to one's own, thus assuring proper etiquette.

Crests East and West

There are interesting parallels between the crests of Japan and those developed in Europe, even though there is no direct relationship between the two. European crests first appeared in the twelfth century, at the time of the Crusades; this corresponds to the end of the Heian period, when Japanese crests first came into use. Crests in Europe were used to identify families, and appeared on armor, clothing, entrances of houses, nobles' carriages, and the like.

There are also, however, some significant differences. First, whereas Japanese crests are almost always black and white (a few light blue ones also existed), European crests use combinations of scarlet, purple, black, green, and other colors.

If there is any unifying motif in the form of Japanese crests, it is the simple circle outline. European crests, on the other hand, usually take the shape of a shield (this is most common) or a helmet, and have such additional motifs as crowns or scrolls attached. Further, European shield-crests are regularly divided into sections; Japanese crests are not. Japanese crests tend to exhibit left-right symmetry, while the European do not. In general, the Japanese form is simpler, and the European more complex, and less uniform.

Another important difference is that whereas crests were used not only for identification but as symbols of authority in Europe, they were not used to represent authority in Japan (even the emperor's crest is a "mere" chrysanthemum). In Europe, therefore, while the number of different crests is considerably greater than that of Japan, only the nobility were permitted to have crests at all, and families without crests outnumber those possessing them. In Japan, on the other hand, the common people of the Edo period eventually adopted family crests.

Today there are a total of about 20,000 family crests extant in Japan.

ACKNOWLEDGMENTS

The publisher wishes to express its gratitude to all of the following people and institutions for graciously granting permission to use the photographic images in the present volume.

Aichi Prefectural Ceramic Museum: plates 3 (p. 22), 5 (p. 29), 7 (p. 47), 3, 4 (p. 51), 4 (p. 77)

Arita Ceramic Museum: plate 1 (p. 48)

Asaoka Hiromi: plate 2 (p. 31)

Domyoji Tenmangu, Osaka: plate 1 (p. 26)

Fujimimura Board of Education, Gunma Prefecture: plates 1 (p. 64), 3 (p. 118)

Fujiokacho Board of Education, Aichi Prefecture: plates 2 (p. 96), 7 (p. 101), 1 (p. 119)

Hikone Castle Museum, Shiga Prefecture: plate 1 (p. 20)

Kusano Shizuka: plate 1 (p. 58)

Kuwana City Museum, Mie Prefecture: plates 5 (p. 39), 1 (p. 106)

Museum of Shinto and Japanese Culture Kogakkan University, The: plates 3 (p. 20), 3 (p. 92), 4 (p. 114)

Nagakusa Toshiaki: plates 6 (p. 15), 7 (p. 19), 7 (p. 25), 5 (p. 43), 4 (p. 64), 1 (p. 78), 5 (p. 91), 9 (p. 125)

Nangomura Museum of History, Fukushima Prefecture: plate 3 (p. 12)

Nara Prefectural Museum of Art: plate 8 (p. 89)

Narabara Shrine, Ehime Prefecture: plate 4 (p. 44)

Obata Kin'ichiro: plates 2 (p. 42), 1, 3 (p. 46), 6 (p. 49), 3 (p. 63), 2 (p. 65), 3 (p. 68), 4, 6 (p. 92), 5 (p. 107), 1, 4 (p. 118)

Sato Teizo: plates 1 (p. 24), 6 (p. 27), 3 (p. 34), 3 (p. 42), 10 (p. 47), 1 (p. 65), 4 (p. 66), 3 (p. 86), 3 (p. 104), 1 (p. 114), 4 (p. 121), 2 (p. 124), 6 (p. 125)

Sue Museum of History, Fukuoka Prefecture: plates 1 (p. 18), 7 (p. 23), 3 (p. 38), 2 (p. 98), 1 (p. 102), 5 (p. 105), 2 (p. 106), 4 (p. 124)

Tobacco & Salt Museum, Tokyo: plates 3 (p. 64), 10 (p. 81), 5 (p. 82), 6 (p. 89), 1 (p. 110), 1, 2 (p. 112), 7 (p. 115), 2 (p. 122)

Tokyo National Museum: half-title page (page 1) and plates 4 (p. 11), 6 (p. 13), 5 (p. 15), 1 (p. 17), 5 (p. 21), 5, 6 (p. 25), 8 (p. 29), 3, 4 (p. 30), 6 (p. 35), 2, 3 (p. 36), 6 (p. 37), 2 (p. 38), 5 (p. 44), 2, 3 (p. 48), 1 (p. 50), 2 (p. 52), 1 (p. 53), 1 (p. 60), 1 (p. 61), 2 (p. 63), 4 (p. 65), 2 (p. 68), 3 (p. 71), 1 (p. 77), 3, 4 (p. 78), 1 (p. 79), 2, 6 (p. 80), 8 (p. 81), 7, 9 (p. 87), 3, 4 (p. 90), 2 (p. 92), 3 (p. 93), 1 (p. 96), 1 (p. 98), 2 (p. 100), 3 (p. 102), 5 (p. 103), 4 (p. 107), 5 (p. 112), 6, 8 (p. 113), 6 (p. 118), 3, 4 (p. 120), 3 (p. 124), 4 (p. 131), page 186

GLOSSARY

Japanese Historical Periods

Jomon: 10,000–200 B.C.

Yayoi: 200 B.C.–A.D. 250

Tumulus: 250–552

Asuka: 552–645

Nara: 645–794

Heian: 794–1185

Kamakura: 1185–1333

Muromachi: 1333–1573

Momoyama: 1573–1603

Edo: 1603–1868

Meiji: 1868–1912

Taisho: 1912–1926

Showa: 1926–1989

Chinese Dynasties

Tang: A.D. 618–c. 907

Song: 960–1279

Yuan: 1280–1368

Ming: 1368–1644

agemaki: women's hairstyle popular in the 1880s and 1890s, in which the hair was formed into a large bun at the top of the head.

atsuita: No robe usually used for male roles. It is made of thick plain weave silk, and its pattern is woven using colored threads.

battledore (*hagoita*): wooden paddle traditionally used in the game of battledore and shuttlecock; there are also decorative versions meant for display.

bingata: textile printing process developed in Okinawa, in which a single stencil is used to dye a piece of fabric a number of different colors.

biwa: short-necked plucked lute, usually having four strings.

chiyogami: type of Japanese paper covered with brightly colored patterns—often small and fine. It is used today for a variety of handcrafts, such as origami or paper doll construction.

choken: wide-sleeved silk coat used mainly for female roles.

daikon: giant white radish.

Dohachi ware: type of stoneware first created by Takahashi Dohachi in the mid-eighteenth century, in Kyoto. Later generations of Dohachi-ware makers also produced porcelain.

dotaku: Yayoi-period bell-shaped ceremonial objects made of bronze, with geometric figures, humans, animals, and other designs cast into their surfaces.

eboshi: cap worn by male nobles and warriors of the Heian and later periods who had completed their coming-of-age ceremony. There were various styles; the nobility covered their *eboshi* with a thin coat of lacquer.

good-luck mallet (*uchide no kozuchi*): lucky object that appears in traditional children's tales, where it is depicted as granting the wishes of whoever shakes it.

gosu: small, round, lidded container of ceramic, lacquer, or metal, used to hold spices, incense, and the like.

guardian dog (*komainu*): mythical lionlike beast, statues of which are often placed in pairs on either side of the gates of shrines or temples, to repel evil.

gyoyo (literally, "apricot leaf"): metal or leather horse decoration in the shape of an apricot leaf.

hagikuso: seaside plant with flowers similar to the Chinese bellflower.

hairpin: long ornamental hairpin called *kanzashi* or *kogai*, sometimes elaborately decorated.

hakama: divided skirt traditionally worn by men on formal occasions. Today *hakama* are worn by people engaging in traditional activities such as kendo (fencing) or kyudo (archery).

hand-drum (*tsuzumi*): hourglass-shaped drum consisting of two leather skins, each sewn onto an iron ring larger in diameter

than the drum body and then laced with cords onto the lacquered wooden drum. It is used in No and kabuki drama.

haori: half-coat worn over other Japanese attire, often as part of a formal or ceremonial outfit.

happi: unlined coat worn by lower-ranking samurai. In No drama, *happi* is used for roles of military commanders.

hibachi: charcoal brazier used as a source of heat.

hoju: spherical jewel slightly pointed at the top, part of Buddhist iconography.

hosoge: arabesque pattern of imaginary plants and flowers.

inkstone case (*suzuribako*): case for calligraphy implements such as inkstone, inkstick, inkwell, and brushes. Since the inkstone case was first made in about the tenth century, it has been one of the most popular items from among traditional Japanese crafts. Inkstone cases are sometimes decorated with *makie*.

inro: small container suspended by a cord and toggle from the *obi* sash. *Inro* were used to hold medicines and were also an important personal accessory for men of mid- to late Edo.

jinbaori: sleeveless half-coat worn by warriors on the battlefield, over their armor. *Jinbaori* patterns were often designed to show off a warrior's military power.

Juroku-musashi: board game involving moving stones over a board divided into triangles and squares, in an effort to eliminate the opponent.

kamishimo: formal samurai outfit made up of a *kataginu* (sleeveless jacket) and *hakama*.

Kanze ripple: highly stylized pattern of flowing water with whorls. The name dates to the Muromachi period, when one of the head families of the Kanze No school began to use this as their official pattern.

karabana (literally, "Chinese flower"): pattern of imaginary flowers, that was originally imported from China.

karahi fence: crest depicting a Japanese cypress fence (*hinoki*) with semicircle shapes at the top.

karanashi: six- or eight-petaled stylized flower used in family crests, probably originating on the Asian mainland.

karaori (literally, "Chinese weave"): type of brocade with elaborate patterns such as flower-rhombuses. In No drama, *karaori* is used by upper-class women or young noblemen.

kariginu: informal costume worn by court noblemen. In No drama, it is used for noblemen's roles.

katabira: unlined hemp kimono for summer. The *katabira*, worn in midsummer, was decorated with patterns that give a "cool" feeling, such as flowing water or snow.

kataginu: sleeveless jacket. There are two types of *kataginu*—one worn by people of the lower classes during the Nara and Heian periods, and the other worn by warriors in feudal times.

katsuma: implement used in Buddhist ascetic practices.

katsuogi: wooden log placed along the ridge of the roof of a Shinto shrine.

kazura obi: hair band used in No drama, for female roles. *Kazura obi* patterns are rich in variation.

kei: flat stone gong suspended in a frame, used as a musical instrument in ancient China, and as a Buddhist implement in Japan beginning in the Nara period.

keman-musubi: loops of braided rope, used to decorate Buddhist implements called *keman*.

kicho curtain: standing curtain used to partition rooms or to block the wind.

kokechi: *shibori* tie-dyeing process known to date from the Nara period or earlier.

kosode: short-sleeved kimono.

Korin figure: highly stylized figure drawn by artist Ogata Korin (1658–1716). Common Korin figures include the Korin plum blossom, chrysanthemum, and paulownia figures.

kuji (literally, "nine characters"): crisscross pattern drawn in the air by people reciting a certain nine-character esoteric-Buddhist incantation.

kukuri–zaru: stylized figure of a monkey.

kuwagata: horn-shaped decorative pieces attached to the front of a warrior's helmet.

kyokechi: clamp-resist dyeing process developed in Japan during the Nara period.

letter box: container used to hold letters. Alternatively, a box used in place of an envelope.

maiginu: No robe used for female dancers.

makie (literally, "sprinkled picture"): process in which a pattern is drawn on an object with lacquer and then, before the lacquer dries, gold or silver powder (or a powder of another color) is sprinkled over the design.

murago: style of coloration in which dark and light areas (of the same color) are distributed unevenly over the cloth or other medium; in family crests, *murago* figures are highly stylized.

Nabeshima ware: porcelain richly decorated with overglazed enamels in various colors that was produced under the strict quality control of Nabeshima Clan Lord in Saga Prefecture beginning in the early Edo period. It was given as gifts to the shogun or the clan lords.

noren: fabric curtain, split into two or more segments, and hung over a doorway. Used in many restaurants in Japan to indicate that the establishment is open.

nuihaku: No robe decorated in embroidery and imprinted with gold and/or silver leaf, used for female roles.

obi sash: the long sash worn with kimono.

Old Imari ware: underglazed blue and white porcelain produced in Arita in Saga Prefecture in the early seventeenth century. The ware largely changed, in the 1640s, to a colorful enameled porcelain. "Old Imari" is used to indicate ware from the earlier period.

Old Kutani ware: porcelain richly decorated with overglaze enamels in strong colors. It is now believed to have been produced mainly in the late seventeenth century, in Saga Prefecture.

omigoromo: formal, ceremonial costume worn by Shinto priests. The shape of its collar looks like a folding fan. In kabuki drama it is used for the roles of warriors, nobles, and lords.

oshiki: square tray with or without beveled corners, with edges made of thin shavings of Japanese cedar or Japanese cypress.

pillow *(makura)*: In the eighteenth and nineteenth centuries, two main types of pillows were used, in combination. These were the *kukuri-makura* (a cylindrical, stuffed, cloth pillow) and *hako-makura* (or "box pillow"; a wooden, box-shaped base). A small *kukuri-makura* was set on top of the *hako-makura*, and the entire pillow-set was then placed under the neck to keep carefully coiffured hair unmussed and intact. In place of wood, ceramics were sometimes used as the material for the base of the pillow.

pleasure boat *(yakatabune)*: roofed boat used for leisurely parties on the water.

poetry-writing paper: special, decorative paper used for writing poetry.

portable shrine *(mikoshi)*: portable Shinto shrine, shaped like a palanquin, and carried along by the two or four long poles on which it rests. Its roof is often elaborately decorated.

roketsu: form of resist dyeing imported from the Asian mainland in the seventh and eighth centuries, in which removable wax is placed on fabric in a predetermined arrangement; the waxed portions resist the dye, leaving a design. The process is essentially the same as batik, but the two seem to have no direct relationship historically.

saké cup basin: bowl filled with water, which was used for rinsing saké cups at parties.

sashinuki: large, formal *hakama* worn by court nobles.

shogi: board game involving two players and forty pieces. It is often called "Japanese chess," and in fact both *shogi* and chess are sometimes thought to have derived from a common ancestor, possibly from India.

Shosoin: the wooden storehouse at Todaiji temple in Nara, which houses many precious ornamental, fine art, and historical objects dating from the mid-Heian period and earlier and including textiles, dance costumes, weapons and armor, ceremonial objects, calligraphy samples, official documents, furniture and utensils, Buddhist altar fittings, musical instruments, and perfumes.

soba noodle cup (*soba joko*): small cup containing the dipping sauce for a portion of *soba* noodles.

sobatsugi: sleeveless coat for roles of soldiers and attendants in a No drama.

splashed pattern (*kasuri*; ikat): kind of cloth, usually of hemp, ramie, or cotton, with hazed patterns of reserved white against a deep indigo ground.

surihaku: No robe decorated with gold and/or silver leaf imprint for female roles.

tiered food box (*jubako*; literally, "stacked-up boxes"): small lacquered wooden boxes, stacked in groups of two, three, or five, and used for storing, carrying, or serving food. These boxes are used now mainly at weddings and at New Year's, for storing and presenting precooked food to guests.

tsuishu: lacquering technique in which red lacquer is applied thickly to an object and patterns are then carved into it.

tsujigahana: traditional dyeing method in which the cloth is first dyed with *shibori* tie-dyeing, and then may be embellished with brush-painted or embroidered figures.

tsutsugaki: method of applying a cold resist or paste using a paper squeeze cone.

wrapping cloth (*furoshiki*): square cloth used for wrapping, storing, and carrying objects.

writing-paper box: box for paper, especially that used for poetry, calligraphy, or drawings.

yoten: coat embroidered in gold thread with dragons, lions, birds, and flowers and used in kabuki drama. It has a fringed hem, which moves to great effect when its wearer dances.

yukata: unlined cotton kimono. Today *yukata* are worn mainly at summer events such as festivals, and are also provided to guests at traditional Japanese inns.

yuzen: starch resist–dyeing process developed during the Edo period.

INDEX

日本の伝統文様
Snow, Wave, Pine

2001 年 6 月　第 1 刷発行
2007 年 1 月　第 3 刷発行

写　真　日眘貞夫
　文　　丹羽基二
訳　者　ジェイ・トーマス
発行者　富田 充
発行所　講談社インターナショナル株式会社
　　　　〒112-8652　東京都文京区音羽 1-17-14
　　　　電話　03-3944-6493(編集部)
　　　　　　　03-3944-6492(マーケティング部・業務部)
　　　　ホームページ　www.kodansha-intl.com
印刷所　日本写真印刷株式会社
製本所　大日本印刷株式会社